Victorians in Camera

To Nell

Victorians in Camera

The World of 19th Century Studio Photography

Robert Pols

PEN & SWORD
HISTORY

First published in Great Britain in 2015 by
Pen & Sword History
an imprint of
Pen & Sword Books Ltd
47 Church Street
Barnsley
South Yorkshire
S70 2AS

Copyright © Robert Pols 2015

ISBN 978 1 47382 334 1

Typeset in Ehrhardt by
Mac Style Ltd, Bridlington, East Yorkshire
Printed and bound in the UK by CPI Group (UK) Ltd,
Croydon, CRO 4YY

Pen & Sword Books Ltd incorporates the imprints of Pen & Sword
Archaeology, Atlas, Aviation, Battleground, Discovery, Family
History, History, Maritime, Military, Naval, Politics, Railways, Select,
Transport, True Crime, and Fiction, Frontline Books, Leo Cooper,
Praetorian Press, Seaforth Publishing and Wharncliffe.

For a complete list of Pen & Sword titles please contact
PEN & SWORD BOOKS LIMITED
47 Church Street, Barnsley, South Yorkshire, S70 2AS, England
E-mail: enquiries@pen-and-sword.co.uk
Website: www.pen-and-sword.co.uk

Contents

Introduction

The Customer Experience

In an image-saturated age, it is easy to forget just how special a photograph could be to our ancestors. After the advent of affordable photography only a very few resisted the appeal of these images or, if they could afford it, of having their own picture taken. 'Our squalid society rushed, like Narcissus, to gape at its worthless image,' sneered the French poet, Charles Baudelaire. But such contempt was rare. For most Victorians the making of a lifelike picture was something to be wondered at.

In 1858 the *London Daily News* judged photography – along with the electric telegraph and painless operations – to be one of 'the three greatest wonders of the age'. During the same year, Mary Day, a professional photographer from Dundee, wrote:

> *Photography! Thou wonder of our age!*
> *Thou puzzler of both philosopher and sage!*
> *Grim death himself cannot triumph o'er thee –*
> *The substance call'd, the shadow's still with me.*
> *What thou createst, then, outlives the life*
> *Of parent, children, husband or of wife.*

The lofty tone of her poem was, however, undermined by its commercial ending:

> *The price is low, your patronage I pray,*
> *I'm your respectful servant,*
>
> > *Mrs Day.*

Day's belief in the wonder of photography was, nevertheless, widely shared. It seemed incredible that, as the *Western Times* put it in 1842, 'in the space

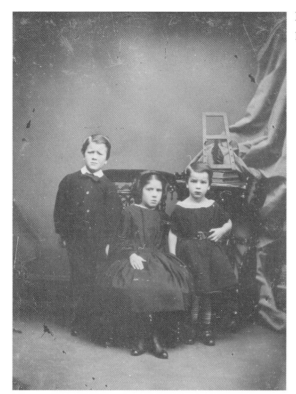

Figure 1: Ambrotype: photographer unknown.

of *twenty seconds!* you may get a correct likeness *printed by the Sun! …* your own natural face, printed in its own natural style, by the light of the blessed sun – for ever.'

What then, in the light of such eulogies, are we to make of the children in *figure 1*, whose sense of wonder seems remarkably inactive? They show bemusement, apprehension and perhaps a hint of truculence, but they appear wholly immune to the magic of the occasion, and their expressions remind us that being photographed was not always an enjoyable event. The *Hampshire Advertiser*, for instance, described the experience in 1862 as being 'treated by a smirking fifth-rate artist for half an hour as something between a convict and a baby'. Even the enthusiastic *Western Times* conceded that sitting for a portrait was 'the purgatorial passage which precedes the paradise of the picture'.

In fact, being photographed was a complex experience: it was an adventure, it was an expense, and it was often something of an ordeal. But even by the

end of the nineteenth century, when the absolute novelty had worn off, it was still a special occasion. This book seeks to relive that occasion, following Victorian customers into palatial studios where artists created exquisite images floating on a silver surface, and into low photographic dens where hucksters turned out murky likenesses on thin pieces of blackened iron.

Victorians in Camera is not a history of early photography; it is an exploration of Victorian photographic portraits from the point of view of their subjects. To this end, it poses a series of questions. What did our ancestors want from their portraits? Where did they go to have them made? What happened when they went to a photography studio? What did they come away with? What did they then do with their photographs? The answers constitute an exploration of what our later age might term the 'customer experience' of Victorian photography.

A word about the chosen timescale is appropriate. There is often something rather arbitrary about dividing history up into reign-shaped chunks, yet in the case of Queen Victoria and photography this is quite legitimate. It was in 1839, the second full year of Victoria's reign, that the first photographic processes were announced, and it was in 1900, the last full year of her life, that the Box Brownie was launched. There were amateur photographers from the earliest days of the art, but it was the Brownie camera that made do-it-yourself photography both cheap and simple enough to become available to the masses. This did not bring about the end of studio photography or even, for a time, a very great reduction in its market. But it did mark the beginning of a new era, with different values and criteria for judging what made a good and memorable family photograph.

The business of making portraits developed in many ways during the reign of Victoria but, despite huge technical advances, certain assumptions and traditions endured. The function of a portrait in the 1890s was not so very different from its function in the 1840s, and the settings and trappings of the studio, though subject to changes in fashion, still served much the same purpose. The Victorian age did, therefore, have its own photographic identity. So, although a sense of historical perspective requires the occasional mention of later developments, this book focuses primarily on the years from the 1840s onwards, when the first commercial studios appeared, to the very beginning of the new century, when the rise of amateur photography encouraged a new way of looking at portraiture.

Something, too, should be said about the words and pictures used as evidence. Sources from mainland Europe and the United States have occasionally been used, since, in many ways, studio practice and experience were remarkably similar across the world. Yet, perhaps more noticeable is a disproportionately large amount of material relating to the eastern counties of England. The reason for this is simple: studios in East Anglia and the East Midlands have been my particular study.

A brief note on old money might also be useful for younger readers, since there will be some mention of the prices of photographs. A pound was made up of 20 shillings (s), a shilling comprised 12 pence (d), and a guinea was the somewhat unlikely sum of £1 1s 0d.

One preliminary matter remains, and that is the agreeable task of recording my thanks. I gratefully acknowledge the permission of The British Newspaper Archive (*www.britishnewspaperarchive.co.uk*) to quote from transcriptions of newspaper sources; the generosity of the Royal Photographic Society in making its Journal Archive (*http://archive.rps.org*) available to researchers; and the unfailing helpfulness of staff in local studies libraries across the eastern counties. Whilst most of the illustrations are drawn from my own collection, I am indebted to the National Media Museum, the Library of Congress, the GNU Free Documentation License scheme, and the Tropenmuseum of the Royal Tropical Institute (KIT), Amsterdam, for additional images. These are identified in their accompanying captions.

My thanks go to John Frearson for giving access to his transcription of James Speight's diary, and to Paul Godfrey for sharing his research on Frank and Bertha Barns. Thanks are also due to those at Pen & Sword who have worked on the production and promotion of this book, and in particular to Eloise Hansen, Jen Newby and Lisa Hooson. Jen's detailed and helpful suggestions have led to a much improved text. Eloise has dealt cheerfully and patiently with both book and author and Lisa has responded kindly to ineptitude.

Finally, I am grateful to my wife, Pam, for her customary support, encouragement and comments. Nobody but the author should be expected to read so many drafts.

Robert Pols,
King's Lynn, November 2014

Chapter One

Market Requirements:
What the Customer Wanted

Having their likeness recorded was far beyond the aspirations of most people when Queen Victoria came to the throne. Only the moneyed classes could employ a painter to depict them in the close-up detail of a jewel-like miniature or show them standing, life-sized, against a vista of parkland. Cut-out silhouettes, admittedly, held some attraction for those of more modest income, but full-blown portraits were the preserve of the privileged few. Then, in the early years of the new queen's reign, the arrival of photography made the unthinkable possible.

A Portrait of One's Own

Initially, the possibility of having a photographic likeness made opened up for only a small segment of the population. Those who would formerly have needed 30 guineas for a painted miniature could now buy a photographic likeness for one tenth of the cost, but that was still prohibitively expensive for most people.

During the 1840s and 1850s, it was the relatively prosperous middle classes who found that, like the gentry, they too could be immortalised. At first, in all but the biggest centres of population, would-be sitters had to wait for a travelling photographer to visit their locality. There were simply not enough affluent customers in many areas to support a permanent studio, so photographers would rent premises in a town, meet the demand from those who could afford their products, and then move on, leaving behind them a proud new portrait-owning class.

Those who had traditionally supported portrait painters also saw the appeal of the photograph. It took minutes, rather than the hours needed to sit for a painting, and – perhaps more to the point – photography was an

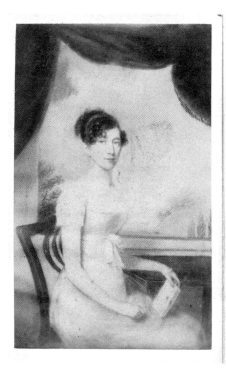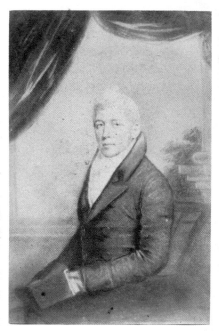

Figure 2: Cartes de visite: H.J. Whitlock, Birmingham.

exciting new technology. In addition, it might produce a more convincing result. As an advertisement for Richard Beard's London studio pointed out in 1855, 'the Photographs ... are equal to the best miniatures with this advantage; that the likenesses are marvellously accurate.' Indeed, in due course photographs became so much the norm for all classes that ancestral paintings were sometimes photographically copied for inclusion in a family album (see *figure 2*).

Over the years, improvements and new processes brought prices down, and the photographic portrait market grew accordingly. In the 1860s, cartes de visite (small paper-based images mounted on card) brought photography within reach of all but the poorest classes, and nobody could pretend that any great prestige was attached to having a picture taken. By this time, if prestige was wanted, it was earned by going to a suitably up-market practitioner.

Nevertheless, photography remained the inheritor of the old portrait tradition, and the visual language of the artist's studio persisted. Customers

demanded – and continued to demand – photographs that spoke a painterly language. Photographers readily obliged. To some of them it was a case of natural progression, since they had begun their careers as painters and had either switched from brush to camera or had learned to use the camera as an additional tool of their trade. Henry Belchambers of King's Lynn was a case in point. In 1851 he was earning his living as a portrait painter, but five years later he was working as a 'photographist' or 'photographic portrait painter'. This career change lasted into the 1860s, but in later years he found it necessary to turn to house decorating and sign-writing to make a living. Others, like Henry Maull of London, were more successful and managed to keep both photography and painting in their portfolio throughout a long career.

The idioms of portrait painting are frequently evident in early photographs. Hodder Roberts (*figure 3*) gazes out of his 1840s photograph with the same calm assurance as the painted subjects of *figure 2*. Some delicate hand-colouring has enhanced his image, so that the painter's art is still, in fact, represented in the finished article. William Harrop (*figure 4*) sits at ease in elegant surroundings. He is backed by an arched colonnade

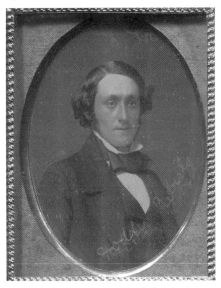

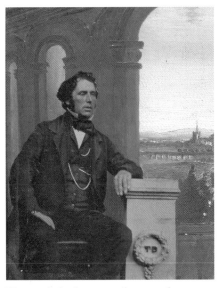

Figure 3: Daguerreotype: photographer unknown.

Figure 4: Ambrotype: photographer unknown.

which suggests a residence of the nobler kind; in fact, the background has been skilfully painted in, and only the plinth, chair and sitter are physically present in the photographer's studio.

Figure 4 is a relatively early example, dating from the years when photographic portraiture had not yet established its own independent idiom. Nonetheless, the practice of setting subjects against a stately background – often one far removed from the sitter's real life – lasted for decades. Book-lined studies, elegant rooms, classical arcades and terraces overlooking parkland all had their day. The details might change, but the trend for photographs echoing the grandeur of paintings was slow to fade, and even at the end of the century it enjoyed a final flourish, in a revived taste for richly panelled interiors.

The skill with which opulent settings were suggested varied considerably. *Figure 5* is a particularly good example. It shows the subject standing

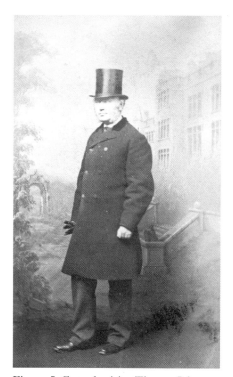
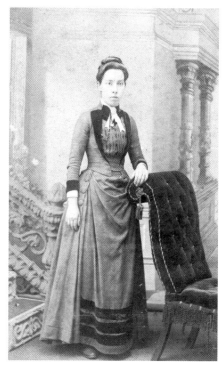

Figure 5: Carte de visite: Thomas Johnson, Leicester.

Figure 6: Carte de visite: J. Fletcher, Aston.

apparently in the grounds of a stately ancestral home. He has just come down the steps from the terrace, and beyond him is an archway presumably leading to a walled garden. The mistiness and the angle of the building create a sense of place far removed from a cramped photography studio.

Also impressive is the interior shown in *figure 6*. A section of ornate staircase is set against a painted backcloth, where perspective is deftly handled to suggest a spacious room. The rich and dignified interior represented in *figure 7* is another well-executed vision of implied ownership, though frequent rolling and unrolling have caused creases in the backcloth and detract from the effect.

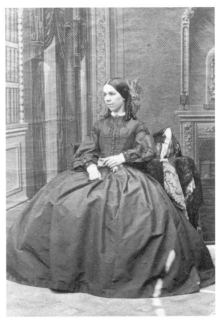

Figure 7: Carte de visite: photographer unknown.

However the settings varied, both in visual detail and in competence of execution, they still connected the sitter, by association, with the grand, aristocratic traditions of the past. Part of the appeal of a portrait was the established convention of presenting subjects in surroundings that echoed and reinforced their sense of distinction.

A Faithful Likeness

Any portrait should, of course, resemble the sitter, yet the obviousness of this requirement ought not to blind us to its significance. A likeness was, at least in the early years of photography, something very remarkable. A painted portrait, even if such a thing could be afforded, took time and skill to produce, and its verisimilitude could not be guaranteed. A cut-out paper silhouette, however deftly done, was no more than an outline. A reflection might distort at worst and was fleeting at best. In contrast, a photograph was a direct image of its subject captured from life, made tangible, and lasting.

The wonder a captured likeness provoked is evident in early responses to photographs. In 1842 the *Morning Post* described a portrait from Richard Beard's London studio:

> *It is a facsimile of nature in one of her ordinary, but perfect moods. The features are well made out, the accessories distinctly delineated, and the combinations harmonious. The likeness, moreover, is striking, and the texture of the skin so infinitesimally beautiful, that were the portrait seen under a high magnifying power every pore and linear intersection would be distinctly visible.*

The same admiration for truth-to-life echoed through the 1840s and 1850s. 'We have several portraits before us, and they are really most extraordinary likenesses,' enthused the *Lynn Advertiser*, when photographer T. H. Ely worked in the town in 1844. In 1855 the *Norfolk News* praised the portraits of William Fisher for 'the most life-like degree of perfection we ever beheld'. A year later, the visit of Oliver Sarony prompted a fulsome response from the *Norwich Mercury*: 'The specimens that have been submitted to us we can, with severe adhesion to the truth, declare to be the most truthful in similitude to the original, and the most highly finished examples we have examined.'

Photographers, naturally enough, recognised that fidelity of likeness was a key selling point, and they promoted their work accordingly. A selection of advertisements by Norwich photographers in the 1850s illustrates the point: John Sawyer promised 'life-like portraits' with 'minute and life-like accuracy of detail'; John Baume strove for 'perfection of likeness'; and William Fisher vowed to 'spare no exertions to ensure accuracy of likeness'. E.D. Rogers guaranteed 'marvellous likenesses' of 'surprising accuracy' that were 'not surpassed for fidelity of likeness', while Susannah Smith offered, rather more prosaically, 'correct likenesses' and, more lyrically, 'beautiful delineations of the human face divine, so very faithful to nature'.

If, from the 1860s onward, fewer promises were made of a good likeness, it was because by that time customers had come to expect nothing less. The demand for portraits that closely resembled their subjects had not disappeared, but this had never been an entirely straightforward demand. Sometimes sitters would deny a likeness, blaming the photographer for

aspects of their appearance that they were reluctant to acknowledge. 'I want to do a large photograph of Tennyson,' complained Julia Margaret Cameron, 'and he objects. Says I make bags under his eyes.'

Such objections to the truth were satirised by C.L. Dodgson (Lewis Carroll) in 'Hiawatha's Photographing', his 1857 parody of Longfellow's poem 'Song of Hiawatha'. After unsuccessful attempts to make portraits of individual members of a family, Hiawatha essays a group photograph:

> *Finally my Hiawatha*
> *Tumbled all the tribe together,*
> *('Grouped' is not the right expression),*
> *And, as happy chance would have it,*
> *Did at last obtain a picture*
> *Where the faces all succeeded:*
> *Each came out a perfect likeness.*
> *Then they joined and all abused it,*
> *Unrestrainedly abused it,*
> *As the worst and ugliest picture*
> *They could possibly have dreamed of.*
> *Giving one such strange expressions –*
> *Sullen, stupid, pert expressions.*
> *Really any one would take us*
> *(Any one that did not know us)*
> *For the most unpleasant people!*

The real issue was a little more subtle than wounded vanity, and it lay at the heart of an anecdote that appeared in the *Aberdeen Evening Express* in 1889:

> *Photographer (to sitter) – 'It's all right, I have taken your portrait.' Sitter (surprised) – 'Oh, I did not know: you ought to have told me when you were taking it, and I would have put on an expression. You have only got me just as I always am.'*

Customers didn't just want portraits to tell the truth, they wanted portraits to tell a palatable and approved truth.

Projecting an Image

It was Victorians of the gentle and aspiring middle classes whose inclinations set the tone of photography, and they wanted their portraits to show them in an advantageous light. They wished, of course, to appear as handsome or as beautiful as could reasonably be managed, but they also wished to be seen as the right sort of people. While this was partly a matter of class, there was more to it: they required portraits to reflect their perceived moral worth as well as their social standing. A photograph, though destined to be a personal possession, was also a kind of public statement that spoke of the sitter's qualities to those who saw it on a wall, on a table, or (from the 1860s) in an impressively bound album.

In broad terms, the virtues that people wished a photograph to reflect were respectability, dignity and moral worth. The subject should appear as someone who adhered to family values and was a model of sobriety and restraint – in short, as a person who was to be taken seriously. In practice, the package of desirable qualities varied according to family position and to the Victorian perception of gender. The more common stereotypes are worth exploring, and two nineteenth century guides in particular will assist that exploration. One is Lewis Carroll, whose Hiawatha parody will once again be drawn on. The other is Anthony Trollope, who is perhaps the most Victorian of nineteenth century novelists, and who, in his descriptions of character, frequently places a finger on the pulse of the age.

At the head of the family, and dominating nineteenth century society, was the mature man. He would have, in theory at least, an air of distinction and authority. This might lead to an impression of sternness, as with the temporarily successful man of the world, Ferdinand Lopez, in *The Prime Minister* (1876). Trollope observes Lopez's 'square brow and bold, unflinching, combative eyes', notes 'the pugnacity of his steady glance', and concludes 'he was imperious, and he had learned to carry his empire in his eye'. Archdeacon Grantly, in *The Warden* (1855), is a successful man of the cloth, and he inspires more affection in his creator, but he too is presented as rather formidable:

In the world Dr Grantly never lays aside that demeanour which so well becomes him. He has all the dignity of an ancient saint … Even with his father-in-law … he maintains that sonorous tone and lofty deportment which strikes awe into the young hearts of Barchester.

Ideally, the dominant male avoided being haughty. He could, however, possess a natural reserve that showed he knew his own worth. Like Trollope's Sir Harry Hotspur, in *Sir Harry Hotspur of Humblethwaite* (1871), his manner might be 'deferring much to others outwardly, and showing his pride chiefly by a certain impalpable *noli me tangere*, which just sufficed to make itself felt and obeyed.' Similarly, Roger Carbury in *The Way We Live Now* (1875), though warm and considerate, is not to be trifled with:

> *He was about five feet nine in height, having the appearance of great strength and perfect health. A more manly man to the eye was never seen. And he was one with whom you would instinctively wish at first sight to be on good terms – partly because in looking at him there would come on you an unconscious conviction that he would be very stout in holding his own against his opponents.*

Central, then, to the Victorian man's self-image was the belief that he was someone of consequence. Whether encountered at the breakfast table, across the cheese counter, or in a remote corner of the Empire, he should have presence. It is this awareness that informs the behaviour of the father of Carroll's invented family, when he steps up to have his portrait taken:

> *First the Governor, the Father:*
> *He suggested velvet curtains*
> *Looped about a massy pillar;*
> *And the corner of a table,*
> *Of a rosewood dining-table.*
> *He would hold a scroll of something,*
> *Hold it firmly in his left-hand;*
> *He would keep his right-hand buried*
> *(Like Napoleon) in his waistcoat;*
> *He would contemplate the distance*
> *With a look of pensive meaning,*
> *As of ducks that die in tempests.*
> *Grand, heroic was the notion.*

The father's hand-in-jacket stance is what Dickens referred to in *Bleak House* as an 'attitude of state'. In the 1850s it was already a cliché but it still had its devotees. Whilst near-comic photographic examples of the *paterfamilias* stereotype can sometimes be found, it is fairer to pick out something a little less extreme. *Figure 8* shows a man of middle years, who looks into the camera's lens with assurance. One large and capable hand rests heavily on a chair, but he doesn't need the chair for support – he could as readily lift it as lean on it. Although his hat gleams and his shoes are polished, he is soberly dressed and there is nothing extravagant about his appearance. His expression is perfectly agreeable, but his gaze is steady and unflinching, accentuating the overall impression of a solidity that is both physical and moral. The photographer has captured just the sort of image that is required by a respectable family man.

The clergyman shown in *figure 9* presents a variation on the male authority theme. At once a man of God and a fine figure of a man, he sits upright and thoughtful. He holds in his left hand a paper he has just been

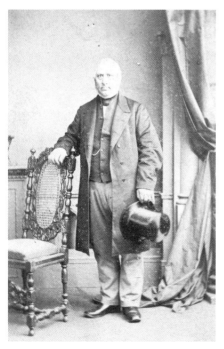

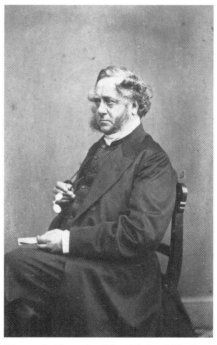

Figure 8: Carte de visite: John Burton & Sons, Leicester.

Figure 9: Carte de visite: Richard Hardey, Hull.

perusing through the pince-nez held in his right, and he is considering its contents. His eyes do not return the camera's stare, but this leads to no loss of authority, for his expression suggests the making of a balanced judgement. He is well dressed – the fabric of his frock coat looks new – yet there is no hint of ostentation. The firm set of his mouth and the healthy vigour of his hair, whiskers and brows give him a patriarchal air.

In *The Warden*, Trollope referred, with tongue in cheek, to the appearance of clergymen: 'Their very gait is a speaking sermon, their clean and sombre apparel exacts from us faith and submission, and the cardinal virtues seem to hover round their sacred hats.' This reverend gentleman is neither walking nor wearing his hat, but his demeanour might be accounted a speaking sermon and his virtues are not to be doubted. One would think twice before crossing him in theological debate.

Mature women, too, had their own kind of status to be visually represented. Within the family the mother was second only to her husband, and in dealing with children, servants, and tradesmen she was invested with his authority. This could become an end in itself, as in the case of Trollope's Lady Carbury in *The Way We Live Now*, whose ambition had been 'To marry and have the command of money, to do her duty correctly, to live in a big house and be respected.' Sometimes the visible results of such an attitude might be a sense of self-importance and a concern to assert status through finery. But such vulgarity was not necessary, as is evident in the character of Susan Grantly, the Archdeacon's wife in Trollope's 1857 novel, *Barchester Towers*, who handles matronly authority in a rather different manner:

> *She never shames her husband; before the world she is a pattern of obedience; her voice is never loud, nor her looks sharp; doubtless she values power, and has not unsuccessfully striven to acquire it; but she knows what should be the limits of a woman's rule.*

There are phrases here – 'pattern of obedience', 'limits of a woman's rule' – that will be distasteful to the modern reader, but our present purpose is to understand the sensibilities of the past rather than to judge them. The underlying idea is of a woman who is capable although never assertive, clothing her strengths in modesty and decorum.

The mother in Lewis Carroll's imagined family belongs to the more demonstrative school of thought:

> *Next, his better half took courage;*
> <u>*She*</u> *would have her picture taken.*
> *She came dressed beyond description,*
> *Dressed in jewels and in satin*
> *Far too gorgeous for an empress.*
> *Gracefully she sat down sideways,*
> *With a simper scarcely human,*
> *Holding in her hand a bouquet*
> *Rather larger than a cabbage.*
> *All the while that she was sitting,*
> *Still the lady chattered, chattered,*
> *Like a monkey in the forest.*
> *'Am I sitting still?' she asked him.*
> *'Is my face enough in profile?*
> *Shall I hold the bouquet higher?*
> *Will it come into the picture?'*

In real-life portraits, however, a more sober image was generally aimed at. A mature woman wanted to appear respectable, sedate and calm; like her male equivalent, she wished to be taken seriously. *Figure 10* is a good example, provided we are not misled by the subject's clothing. Fashion in the 1870s, when the picture was taken, valued contrasts of shape, colour and texture, and was very taken up with bows and frills. This woman dresses well and keeps up with the current styles, but she is not adorned more extravagantly than the custom of the day requires. Indeed, her hair is arranged relatively simply at a time when false hair and hair-pads were all the rage, and in wearing a white cap she displays the mature woman's universal badge of seemliness. She sits thoughtfully, with hands folded in her lap and her glance modestly avoiding the camera; in fact, her eyes seem more focused on private thoughts than on any feature of the room. She is respectable, sensible and quietly confident of her own worth.

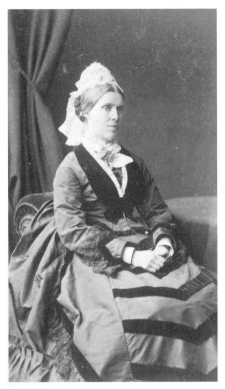 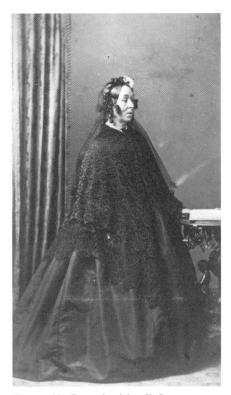

Figure 10: Carte de visite: William Heath, Plymouth.

Figure 11: Carte de visite: E. Lancaster, Chester.

There was a common sub-category in the portraiture of mature women – the widow. If a wife should show dignity, then a widow should show dignity tempered by a quiet but abiding sorrow. For a full two-thirds of Queen Victoria's reign, bereaved women had a regal image of widowhood to emulate, allowing them to form a very clear notion of what was proper.

Most mature widows would have wished to present themselves in the manner of Lady Mason in Trollope's *Orley Farm* (1862): 'The quietness and repose of her manner suited her years and her position; age had given fullness to her tall form; and the habitual sadness of her countenance was in fair accordance with her condition and her character.' The widow in *figure 11* might serve as a model for Lady Mason. She stands, the statuesque embodiment of mourning, with one hand touching a weighty book, which it is tempting to assume is a photograph album open at her husband's portrait.

When attention is turned to men of the rising generation, it becomes a little harder to define customers' image requirements. Many young men simply wanted to project the same kind of image as their fathers (*figure 12*). There was an obvious attraction to appearing mature, responsible and fit to claim a place among one's elders. Nevertheless, if anyone was going to chafe against the conventions of conforming to an image, it was going to be the younger man (or the man who wanted to think of himself as still young). This type of sitter often wished to be a little more stylish, like Trollope's Bernard Dale in *The Small House at Allington* (1864), who 'carried with him an air of self-assurance and a confident balance, which in itself gives a grace to a young man.'

In practice, this desire to follow in but also veer slightly away from father's footsteps often expressed itself in a kind of nonchalance. *Figure 13*, dating from the 1860s, shows how this was achieved. The young man is conservatively dressed, just as his father might have been at that time, in a dark coat and waistcoat, with paler trousers. He carries a top hat and

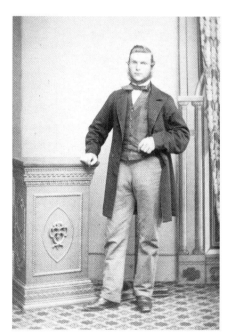
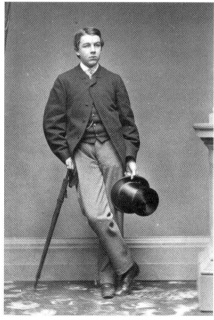

Figure 12: Carte de visite: Henry Newell, York.

Figure 13: Carte de visite: W. Keith, Liverpool.

he wears a watch-chain, like the pillar of society in *figure 8*, yet he seems unperturbed by the process that is taking place, and he leans with deceptive casualness on a tightly and perfectly rolled umbrella, with one foot crossed in front of the other. This cross-footed stance is found time and again in portraits of the younger sort, and it appears to suggest that the subject is at his ease.

Sometimes, one suspects, the pose was adopted to demonstrate the absence of posing stand or head rest behind the elegant figure. (Posing aids – of which, more will be said in a later chapter – were widely used to help subjects keep still during long exposures.) The subtext of this pose would be, in effect, 'I'm young. I don't need outside help to stay steady.' If this was indeed the intention, the ploy fails on this occasion: part of a posing-stand base can be made out behind the young man's right foot, and some kind of adjusting screw is visible by his left instep.

Some young men wished to go a stage beyond the merely stylish and present themselves as romantic or dashing. Lewis Carroll's youth wants a portrait that reflects his artistic nature:

> *Next the Son, the Stunning-Cantab:*
> *He suggested curves of beauty,*
> *Curves pervading all his figure,*
> *Which the eye might follow onward,*
> *Till they centred in the breast-pin,*
> *Centred in the golden breast-pin.*
> *He had learnt it all from Ruskin*
> *(Author of 'The Stones of Venice,'*
> *'Seven Lamps of Architecture,'*
> *'Modern Painters,' and some others);*
> *And perhaps he had not fully*
> *Understood his author's meaning.*

Others, who embraced the latest and more extreme fashions, sought portraits that confirmed their status as 'swells'. The subject of *figure 14* is perhaps not in the first flush of youth, but he is younger than he initially appears. His coat is braided and tightly buttoned, he carries a pair of soft leather gloves,

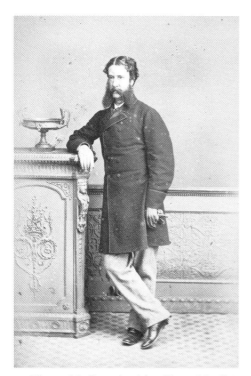

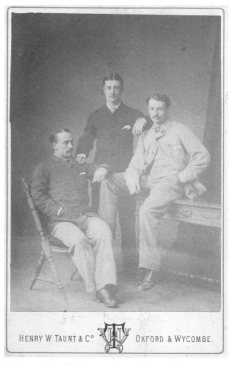

Figure 14: Carte de visite: Henry Maull & Co., London.

Figure 15: Cabinet print: Henry Taunt & Co., Oxford & Wycombe.

and he has adopted the popular cross-footed stance. But his crowning glory is his set of whiskers: he has grown Dundrearies – extensive sideburns as worn by Edward Sothern, when acting the part of Lord Dundreary in the play, *Our American Friend*. The fact that Dundreary was a stage aristocrat of the most vacuous sort did not prevent his whiskers (also known as 'Piccadilly weepers') from becoming highly fashionable among those wishing to draw attention to their languid elegance.

As the decades passed, young men demanded a little more informality in their portraits, especially when they visited a studio with their friends. The young men in *figure 15* are not seeking to show the world their moral worth or social standing; they are recording their friendship and need no approval but their own. A relaxed air is aimed for and partly achieved: one man sits on his chair at an angle, leaning back slightly rather than sitting bolt upright; another is perched on a table, with one bespatted foot just reaching the floor;

and the other resting on the rung of his friend's chair. Hands rest in pockets, on shoulders, on knees. In fact, the insistently negligent deployment of arms and legs might strike us as contrived rather than relaxed, but this group portrait does show a new stereotype finding its way into the studio repertoire.

Young women were not allowed to behave and present themselves with the degree of licence that was available to young men. What they, or their paying parents, wanted from a portrait was therefore more predictable. The older girl or young woman was to be seen as the embodiment of feminine virtues; she should be modest, demure and pensive, for these were the qualities of both marriageable maid and biddable wife.

Even the lively and intelligent Bell and Lily Dale, in Trollope's *The Small House at Allington*, sent out the right signals:

> *But there was, perhaps, more in the general impression made by these girls, and in the whole tone of their appearance, than in the absolute loveliness of their features or the grace of their figures. There was about them a dignity of demeanour devoid of all stiffness and pride, and a maidenly modesty which gave itself no airs. In them was always apparent that sense of security which women should receive from an unconscious dependence on their own mingled purity and weakness.*

Another Trollope heroine provides a telling contrast. Lizzie Eustace, in *The Eustace Diamonds* (1873), is attractive enough but she is too animated: 'Her figure was lithe, and soft, and slim, and slender. If it had a fault it was this, – that it had in it too much of movement ... Her teeth were without flaw or blemish, even, small, white, and delicate; but perhaps they were shown too often.'

The daughter of Carroll's imaginary family follows the older son in the sorry procession, and she has got the message. She knows just what she wants from the photographer:

> *She suggested very little*
> *Only asked if he would take her*
> *With her look of 'passive beauty'.*
> *Her idea of passive beauty*

> *Was a squinting of the left eye,*
> *Was a drooping of the right eye,*
> *Was a smile that went up sideways*
> *To the corner of the nostrils.*

She was not alone in being unable to tell the difference between 'passive beauty' and simpering. In the early 1880s, a reader of *The Girl's Own Paper* sought the advice of its agony aunt on how to present herself for a portrait. Unfortunately the paper printed only its reply and not the original letter, but it takes very little imagination to reconstruct the nature of the query.

> *To 'An Intense One':*
> *A little dumpy girl of 'five feet' could scarcely look well holding a sunflower in her hand – as she suggests – when 'posing for her photograph'. Were we to give an honest opinion, we would suggest her holding a child's coloured balloon by a string, or else a baby's rattle, and wearing a cap and bells instead of the 'daffodils in her hair'.*

Most young Victorian women, however, were well versed in conveying a sense of 'passive beauty'. The subject of *figure 16* provides an object lesson. She is seated, so her copious skirt can be elegantly arranged over its crinoline cage. Her elbow rests on a table, her cheek against her hand – a pose that became something of a cliché – and was employed by many older women too. It had a grace and stillness that was found very proper. The sense of languor is aided by the eyes, which look in the direction of the lens but don't quite focus on it. This diffidence about returning the camera's gaze suggests both that the sitter is not over-bold and that she is caught up in beautiful, unworldly thoughts.

The correspondent of *The Girl's Own Paper* was right in seeing flowers as suitably delicate accessories for young ladies, even though her proposed use of them would have been comic in its effect. In this picture, a flower basket has been included in the setting, though it is unaccountably empty. There are also two books on the table, offering associations of serious and sedentary pursuits. Again, though, there is a slight incongruity, arising this time from the fact that the books have been used to bring the table to a more comfortable height for the leaning elbow.

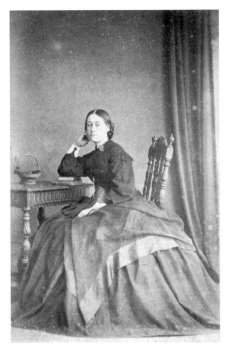

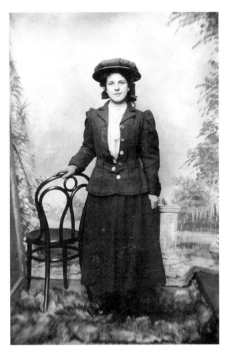

Figure 16: Carte de visite: W.I. Spicer, London.

Figure 17: Postcard: W. Rutter, studio location unknown.

Eventually, at the very end of the Victorian age, some young women claimed a fresh, more positive image for themselves. The New Woman was decisive, self-assertive and capable, and photographers adapted the language of portraiture to the image she wished to project. *Figure 17*, which actually dates from the years just after Victoria's reign, shows none of the submissive and retiring qualities so valued by the subject's mother and grandmother. She is dressed for the healthy outdoors, the hem of her skirt will not drag in the mud, and she faces the camera confidently, looking directly out of the picture and entertaining not the slightest wish to have daffodils in her hair.

The last members of the family to be considered are the youngest, the small boys and girls, and it is at this point that our two Victorian guides fail us. Trollope did not show a great interest in children as people. Babies are fussed over by adults in his novels, infants inherit titles or are caught up in the quarrels of parents, but they are rarely much developed as characters. Carroll's Hiawatha does attempt a portrait of a small boy, the youngest family

member, but his concern is with the difficulty of photographing children rather than with the subject's demand for an appropriate image:

> *Last, the youngest son was taken:*
> *Very rough and thick his hair was,*
> *Very round and red his face was,*
> *Very dusty was his jacket,*
> *Very fidgety his manner.*

Trollope's lack of attention to children is perhaps itself a clue. They were not independent agents. The child in the studio was not the customer: that role belonged to its parents, and the chosen image was their idea of how a child should be seen. In the case of small girls, the decision was quite simple: a girl should be a foreshadowing of the young woman her parents hoped she would become, and she should display the corresponding virtues.

An 1860 photograph of Princess Louisa (*figure 18*) provides an example of how a girl would ideally be portrayed. The Princess is holding a book open, as if she had just paused in the serious business of reading. (It may be taken for granted that the book is suitable, and it is also likely to be improving.) Her head is cast slightly down, so that she has to look up from under her brows, with irises partly hidden by her eyelids. She is looking off-camera, contemplating, perhaps, some inner serenity, rather than focusing on anything in the room. A single flower, a symbol of fragile femininity, has been placed on the plinth beside her. She strikes the viewer as virtuous, modest and pensive, and that package of qualities is precisely what she and the photographer were required to deliver.

Portraits of boys, too, might be called on to foreshadow their future selves, though that was a little more difficult. Submissiveness could easily be depicted by girls, but it could be harder for a mere lad to convey stern authority. Once he had passed beyond the stage of mere infant cuteness, picturing him with boys' toys was one way of suggesting a properly male sturdiness, but *figure 19* manages to create the right impression without the aid of such props.

The sailor suit admittedly helps, but the martial associations of sailor suits were a little compromised by the fact that girls' versions were also

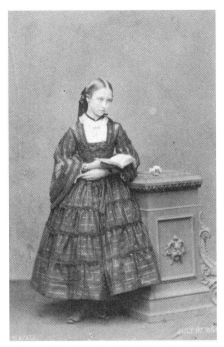

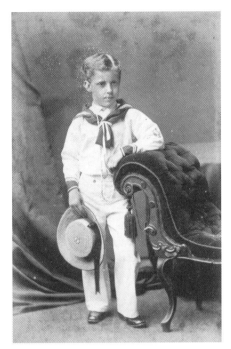

Figure 18: Carte de visite: John Mayall, London.

Figure 19: Carte de visite: Heath & Billingham, Plymouth.

sometimes seen. The long trousers of this particular version, however, give it a more telling effect. It is the boy's stance, though, that is most important. He stands up straight, appearing relaxed but self-assured, and his gaze – though away from the camera – is steady and focused. He looks quite the little man (as his mother no doubt remarked).

A mother's wishful perception of her son could, in fact, have a major influence upon the kind of image that was required. That has to be acknowledged when considering a fashion that became enormously popular with the 1885-6 publication of *Little Lord Fauntleroy* by Frances Hodgson Burnett, at first as a serial, then in novel form. The hero, Cedric Errol (subsequently Lord Fauntleroy), had a sweetness and charm designed to melt the maternal heart. Even as a baby, 'His manners were so good … that it was delightful to make his acquaintance', and he quickly turned into an all-round paragon: 'He had a beautiful face and a fine, strong, graceful figure; he had a bright smile and a sweet, gay voice; he was brave and generous, and

had the kindest heart in the world, and seemed to have the power to make everyone love him.'

Female readers were enchanted, and they paid careful attention to Cedric's appearance, noting 'the bright curly hair which waved over his forehead and fell in charming love-locks on his shoulders'. They also noticed his clothes, which included a fetching white outfit and a cream-coloured suit. The description which, above all, caught his very essence and nestled in their hearts was of 'a graceful, childish figure in a black velvet suit, with a lace collar, and with lovelocks waving about the handsome, manly little face.' He was the perfect son, and mothers on both sides of the Atlantic wanted one of their own. Lacy collars, bows, velvet suits, knee-length breeches and dainty shoes became all the rage, together with long hair that fell, more or less successfully, in ringlets.

Naturally enough, variations on the Little Lord Fauntleroy image became a studio favourite for some years. The boy in *figure 20* has been spared the velvet suit in favour of a version of the sailor's uniform, but otherwise the ingredients are all present. His hair declines to behave quite as winsomely as required, but he has been coaxed into a soulful expression and his sensitive and artistic nature is established by the violin and bow.

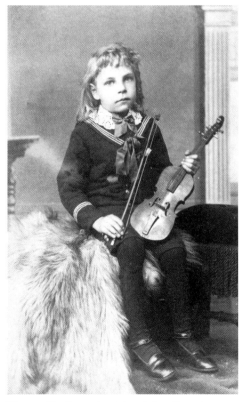

Whilst portraits of small children bring an end to this tour of stereotypical images, it should be added that the stereotypes could also be presented in combinations of sitters. Victorian portraits of couples, siblings or parents with children were called upon to

Figure 20: Carte de visite: J. Smallwood, Birmingham.

show varied permutations of relationship, where ideas of seniority or relative authority contributed to the message the picture was required to convey.

Before the theme of projected images is left behind, it is worth putting it into perspective. The argument is not that every Victorian portrait conformed perfectly to a stereotype, but that stereotypes were an important aspect of the way in which Victorian sitters presented themselves to the world. The photographers, naturally, were the ones who created the standard images in the studio, and in that sense, it could be argued that they, rather than their customers set the agenda. But the secret of producing a successful product is, and always was, to give the public what it wants. In devising a studio language for depicting standard images, photographers were merely bringing into focus the attitudes and values of their day.

To Smile or Not to Smile

One important matter has so far been sidestepped: no discussion of the Victorian self-image can avoid the question of smiling. When looking at portraits from the past, people often remark how forbidding their Victorian relatives appear, but there is an element of myth to this notion of ancestral grimness.

The Victorians were not without a sense of humour: an era that produced the Savoy operas, *Three Men in a Boat*, *The Pickwick Papers* and *The Diary of a Nobody* was not wholly given over to solemnity, and magazines such as *Punch* and the resolutely down-market *Ally Sloper's Half Holiday* made their living by amusing the public on a regular basis. Much of the humour strikes later generations as ponderous (and the taste in puns in particular now seems to place more value on effort than on wit), but the fact remains that Victorians were very ready to be amused.

Nevertheless, the ability to smile was rarely exercised in the photographer's studio. In withholding their smiles from the camera, sitters could point to royal precedent. Queen Victoria was famous for the stern front she presented to the world. In 1888 the *Angus Evening Telegraph* quoted a joke that was circulating in the United States: 'Queen Victoria has been photographed smiling. The photographer brought the pleased expression to her face by promising her the pictures at half-price.'

In reality, the public had to wait three years longer for a portrait of 'Her Smiling Majesty'. In January 1891 the *Aberdeen Evening Express* reported:

Every one has seen in the shop windows the photograph of the Queen smiling, but few know how it was obtained. A reporter, however, has elicited from Mr. Downey, the veteran photographer, the whole story. The "smiling photograph" of the Queen, Mr. Downey says, is his chef d'oeuvre, *for Her Majesty on most occasions assumes a grave and even solemn mien, as if the lens was a dangerous weapon instead of a harmless scientific instrument, and it is, therefore, the grave and solemn mien with which we always endow the Queen. Every lover of a dog will be pleased to hear that it was the dog "Sharp" the collie on the chair, that raised that smile to the Queen's face. "Sharp" altogether declined to sit still, but John Brown would stand no nonsense, and, despite the presence of his mistress, he gave the dog a good shaking. "He won't sit, Brown," said the Queen. "He won't, your Majesty? He maun obey ye, and be complaisant, like the rest of us. He maun sit." And after another shaking "Sharp" sat, and the Queen laughed to see such sport, and Mr. Downey made a great hit, all because of Brown and "Sharp".*

If, however, this royal merriment set a precedent, it was a precedent that would not be widely followed for some years. Even then it was not within studio portraits that smiling became common but in amateur photographs, with their more relaxed surroundings and the changing conventions of a new century.

The Queen's customary solemnity before the camera might certainly have influenced her subjects at a time when royal practice tended to be echoed. When Victoria and Albert posed for carte de visite portraits, their example helped boost the growing popularity of the format; when the Queen dressed her family in tartans, tartans became fashionable; when Alexandra, Princess of Wales, wore a fringe, women all over the country imitated her hairstyle. But there was something more than royal trendsetting that lay behind the nineteenth century's lack of photographic smiles.

One commonly suggested explanation for unsmiling portraits is the length of exposure times: it is easier to hold a serious expression for several seconds than it is to maintain a smile. While this is undoubtedly true – and

the stresses and strains of posing before the camera will be considered in a later chapter – it is still an inadequate explanation. By the end of the nineteenth century long exposures belonged to the past, yet studio solemnity persisted. Another theory is that our ancestors, denied the attentions of today's advanced dentistry, were not keen to display their teeth or the gaps between them. Dentures were, admittedly, a possibility for those who could afford them, but even they could be unsightly. Made from bone or ivory, or recycled from corpses (and known, from their ready availability after military action, as 'Waterloo teeth'), dentures did not always wear better than the originals they replaced. Dental diffidence may well, therefore, have worried some studio customers. The eminent photographer H. P. Robinson recalled a lady who insisted on trying to disguise toothless and sunken cheeks by keeping a biscuit in her mouth while he exposed the plate. Yet this explanation also falls short of a complete answer, as it is quite possible to smile without showing the teeth.

The basic fact, as already established, is that sitters wished to present a suitable image of themselves to the world, and that image did not involve smiling. In fact, over-ready smiling might be considered a little suspect. It has already been noted that Anthony Trollope made it a fault in his anti-heroine Lizzie Eustace that she showed her teeth too often. By contrast, in *Phineas Finn* (1865), Violet Effingham – a thoroughly trustworthy and acceptable young woman – is sparing with her smiles: 'Her teeth, which she but seldom showed, were very even and very white.'

Elsewhere, Trollope gives us to understand that too readily displayed teeth could betoken unreliability. Of Ferdinand Lopez in *The Prime Minister*, he writes:

> *His teeth were perfect in form and whiteness, – a characteristic which, though it may be a valued item in a general catalogue of personal attraction, does not generally recommend a man to the unconscious judgement of his acquaintance.*

The qualities that mattered to the Victorians – dignity, respectability, soundness – were not to be conveyed by vacuous grinning. Sitting for a portrait was an important event, and nobody wanted to ruin the occasion by

appearing to be a moral or social lightweight. As Mark Twain argued, 'There is nothing more damning to go down to posterity than a silly, foolish smile caught and fixed forever,' or, as an unidentified photographer told the *Angus Evening Telegraph* in 1900, 'A smiling picture is likely to border on idiocy.'

This did not necessarily mean that subjects had to look fierce or gloomy, although that was often the end result. Even in the early days of photography it was possible to capture an air of naturalness. When Samuel Oglesby visited Thetford in 1854, the *Norfolk News* praised his portraits for 'an ease of position in the figures, and a pleasing expression of countenance, totally differing from the heavy overcast appearance that generally accompanies works of this kind'. Ten years later, on visiting the studio of Mr Edwards, the *Wrexham Advertiser* identified 'an entire absence of the strained position and painful expression so common in most photographs'.

The notion of 'a pleasing expression' was often raised in discussions of nineteenth century portraiture, yet this did not necessarily entail smiling. In the 1860s, the man in *figure 21* managed to look agreeable whilst stopping just short of a smile but, on the whole, unrestrained smiles (*figure 22*) were rare. Towards the end of Victoria's reign, despite the fact that exposure times had been much reduced, attempts at unequivocal smiling could still lead to unsatisfactory results, as H.P. Robinson observed.

> *The smile, then, being a product of civilisation, is capable of being overdone, and of becoming unnatural, as, indeed, is the tendency of all cultivated things; and it is this false smile that gives the conscientious photographers more trouble than any other phase of expression.*

In many cases, he concluded, 'smiling is best avoided, as it only tends to make matters worse.'

So customers generally followed convention in presenting themselves as serious and worthy, while those photographers who aspired to rise above this orthodoxy sought non-smiling ways of softening the effect and infusing austerity with a little humanity. Just occasionally, the sitters themselves wondered about injecting more warmth into the picture. 'Do you wish me to smile?' asked one client, in a conversation recorded by the *Hull Daily Mail* in 1890. 'A gentle smile might be well,' offered the photographer,

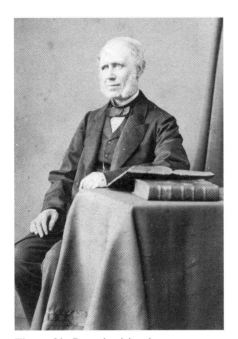 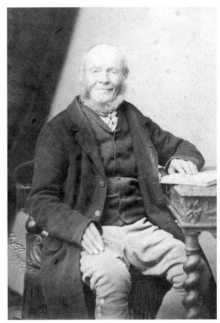

Figure 21: Carte de visite: Annan Brothers, Edinburgh.

Figure 22: Carte de visite: Henry Cooper, Northampton.

dubiously. Then he added, in a line that settles the whole smiling debate for posterity, 'The happiness of life consists not in single flashes of light, but in continuous mild serenity.'

Marking Milestones

Whilst the basic market requirement was a portrait that married a true likeness with a sense of moral worth, customers also arrived at the photographer's studio with more specific agendas. Many of these involved the marking of one of life's milestones. Such photographs remain common. We still tend to commemorate major events with a picture: newborn babies, christenings, starting new schools, leaving home, weddings and anniversaries can all be occasions for bringing out the camera. Indeed, they include the few occasions when we might still visit a studio or hire a professional photographer. But we now take many more pictures between the milestone events in our lives.

For the Victorians, a studio visit was in itself a special occasion, and even towards the end of the reign a considerable proportion of families could not afford to visit a professional regularly, nor to create their own images. A Victorian milestone photograph was doubly memorable – significant both for the event being recorded and for the act of recording it. It is worth looking, therefore, at some of the most common stages of life that the Victorians selected for photographic preservation.

There was some demand for photographs to mark weddings during the nineteenth century, but there was no expectation that the photographer would attend the ceremony. Nor did it follow that the bride and groom would be pictured amongst a crowd of friends and relations. Once a wedding had been agreed on, the couple might choose to go to a studio to have engagement pictures taken. In 1861, stonemason Arthur Peck noted in his diary:

> *March 30.*
> *D.B. had an engaged* [sic] *ring 13s.*
> *April 2.*
> *I and D.B. went to Mr Forscutts had our portraits taken 2 double ones 1 single one of myself. D.B. had hers in a case. 10/6d all together.*

When it came to the actual wedding, it became increasingly likely that a photographic souvenir would be required. There was, after all, a royal precedent. When Queen Victoria and Prince Albert married in 1840, photography was in its infancy and there was no thought of using it to create a celebratory image. In 1854, however, the omission was made good when Roger Fenton was summoned to take pictures of the couple in their wedding outfits, which had been kept in storage for the last 14 years.

But Victorian wedding portraits were, for most of the reign, products of the studio, and on a day close to the ceremony the couple would repair – often, but not always, together – to a photographer's premises to have their portraits made. They wore their best clothes, and sometimes only the careful display of a wedding ring identifies the occasion. White dresses, buttonholes and bouquets were not necessary then, and nor were attendants. Only in Edwardian times did the convention of photographing the whole wedding party become established.

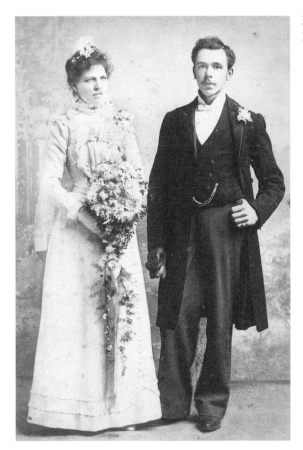

Figure 23: Cabinet print: J. Kennerell, Wisbech.

The couple in *figure 23* (pictured around the turn of the century) stand, therefore, at a watershed moment: they were married at a time when studio-bound wedding photos were still quite usual, but they have elected to attend in their full regalia.

Sometimes the requirements for wedding or engagement portraits had an extra edge. In 1888 J.H. Blomfield recalled for the *Hastings and St Leonards Advertiser* the urgent commissions of eloping partners: 'On one or two occasions the photographer has been called upon in haste to take a negative of young runaway couples on their road to get surreptitiously married, or just after the ceremony.'

Sometimes, too, the photographer was required to show particular discretion:

At another time a young gentleman brought a young lady, of his engagement to whom he made no secret, and they were photographed in a very charming and loving attitude. Six months later the same young fellow presented himself, this time with another young lady, and, having apparently contrived to 'be off with the old love', was most anxious that his present fiancée should not know of his former visit.

Embarrassment was avoided on that occasion, but not on another:

The case of this amorous swain, however, was more fortunate than that of a lady who went with her husband, a very well-known local gentleman, to have their portraits taken. Being shown into the reception room, they enquired for some specimens of photographs from which to choose a style for their picture. The attendant courteously produced a number of cartes, cabinets, &c., and began diligently to exhibit them to her customers. Alas! for the smallness of our little world. Bye-and-bye the lady's eyes became suddenly and fixedly riveted upon a cabinet photograph. She flushed scarlet; her husband also saw the picture, and his face assumed a jaundiced hue. The group before them represented himself, tenderly embracing a lady – not his wife! Poor man! It was his first love, forgotten long ago.

A cynic might see in this anecdote a good reason for so many couples choosing to mark their union with individual photographs.

Another category of milestone pictures related to the stages of growing up. There were conventions about what youngsters wore at different ages, and the promotion from one level to the next could be viewed as a very proper opportunity for a photograph. Small boys were first clothed in dresses, and their eventual entry to the male world of trousers was an important event known as 'breeching'. But full-length trousers were still some years away, and graduating to them, perhaps as part of a suit, was another important rite of passage. For girls, advancing age was measured in hair and hemlines. Little girls wore their hair long, hanging down their backs, and their skirts were, at first, short. Their hair stayed long and their skirts gradually lengthened until, at some point in her teenage years a girl was given her first full-length dress and was allowed to put her hair up.

The passage from one stage to another was often marked by a visit to the studio, though the ages at which transitions occurred were not precisely fixed. The acquisition of a long dress or a grown-up suit might, in large families with limited means, involve waiting until an older sibling had grown out of it. At the other end of the social scale, a girl of marriageable age entered society as a debutante and was likely to be photographed in her 'coming out' dress. Here, too, no exact age was prescribed, and it was not unknown for sisters to come out together.

The lad in *figure 24* looks as if he might be wearing his first pair of long trousers, while *figure 25* shows how girls were also subject to rites of passage. The girl on the left is older than her sisters and has clearly reached the age at which her appearance must reflect this fact. Her hair has been caught up, presumably in a bun, while the other two still wear their hair down. The smallest girl wears a noticeably short skirt; the girl on the right has an ankle-

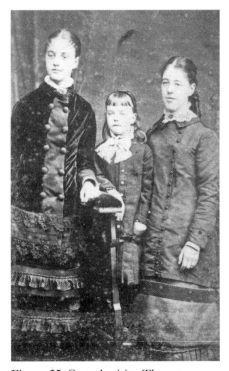

Figure 24: Carte de visite: W.M. Hay, Elgin.

Figure 25: Carte de visite: Thomas Johnson, Leicester.

length dress, with part of the hem just visible in the picture; but the oldest girl asserts her seniority in a dress that hangs even lower and disappears at the bottom of the frame.

The final stage of growing up involved leaving home, and that could provide sufficient reason for a photograph, especially if the subject was emigrating or joining the army. The Speight family of Rugby were themselves photographers, and they developed a tradition of taking 'jape' pictures when sons left to begin work in a distant studio or to set up in business elsewhere. In July 1898 James Speight's turn came, as he was about to take up a position in Norfolk. He was duly pictured in hat and scarf, holding his luggage, beset by the studio's female staff, who feigned tears and mimed their desolation at losing him.

The most momentous milestone of all was death, and the Victorians did not avert their gaze from it. One of the slogans adopted by the earliest photographers emphasised the camera's ability, through the natural action of light, to preserve memories:

> *Secure the Shadow, ere the Substance fade,*
> *Let Nature imitate what Nature made.*

In theory, a portrait could be a consoling reminder of any absent person, whatever the reason for their absence. A sense of this was clearly expressed by Elizabeth Barrett Browning, who wrote of her longing 'to have such a memorial of every being dear to me in the world. It is not merely the likeness which is precious in such cases – but the association and the sense of nearness involved in the thing.'

Admittedly, not everybody felt the same. Vincent van Gogh thought photographs 'abominable' and disliked having them on show, 'particularly not those of persons I know and love'. He compared them unfavourably with painted portraits, which he felt were 'done with love or respect for the human being that is portrayed'. Here van Gogh was in a minority, as most people did – and still do – value photographs of those to whom they have emotional ties.

In practice, however, the encouragement to 'secure the shadow' was often applied rather more precisely, particularly to portraits as a tangible link with

someone who had recently died. It often occurred, in an age of high infant mortality, that the death was that of a baby, of whom no portrait had yet been made. There was, therefore, a demand for *post mortem* photographs. This Victorian taste has often made later generations uncomfortable, striking them as mawkish, if not distasteful. But those later generations have been spared such a high incidence of infant death, and the potential value of such images for bereaved parents has only fairly recently been reasserted.

Post mortem photography was not confined to children, though in Britain they were the most usual subjects. Sometimes, especially further afield in mainland Europe and America, there was a wish to pose the adult dead with their nearest and dearest before consigning them to the grave. In their more open response to death, the Victorians also felt a need to express their sense of loss before the camera.

The most obvious manifestation of this wish can be seen in pictures of people dressed in mourning (*figure 11*), but more elaborate demonstrations of grief were also be called for. In this instance, too, there was royal precedent. As well as summoning William Bainbridge to (very probably) make death-bed photographs of Prince Albert and then committing herself to the prolonged wearing of widow's weeds, Queen Victoria had a number of memorial photographs taken. The famous image of her on horseback, attended by John Brown, was made to commemorate her last ride into the mountains with her husband, exactly two years earlier. Other pictures show her – often with one or more of her children – watched over by a bust of Prince Albert, whose sculpted presence only serves to underline the fact that he is no longer there in person.

Few people could produce statuary to create such an effect, but many had

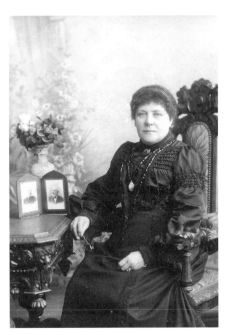

Figure 26: Cabinet print: Alfred Yallop, Great Yarmouth.

photographs that would serve just as well, and including a framed portrait or a family album in one's picture was a very effective way of paying tribute to the dead. The subject of *figure 26* is as much the deceased husband as the wife. Their relationship is underlined by her wedding ring, and she holds the spectacles through which she has just been looking at his likeness. They are, in a sense, being photographed together.

'The Most Absurd Practice of the Day'

There was also a social dimension to the desire for portraits. People gave and exchanged photographs, and sometimes they went to a studio not to be photographed themselves, but to buy pictures of other people. Portraits of the royal family were in particular demand. Images of Queen Victoria were, understandably, very popular, and there was a market, too, for mementos of other members of her family, of whom Princess Louisa (*figure 18*) serves as an example. But two royal figures in particular caught the public imagination. One was Prince Albert, whose death in 1861 was the cause of queues outside photographers' shops, as customers clamoured for souvenirs of him. Diarist A.J. Munby noted that prices rose sharply as stocks dwindled, and that he paid 'four shillings for what would have cost but eighteen pence a week ago'.

The other was Alexandra, Princess of Wales, whose marriage to the future Edward VII in 1863 provoked a huge demand for portraits, as novelist William Makepeace Thackeray recorded:

It would be interesting to know how many hundreds of thousands of photographs of the fair bright face have by this time made it beloved and familiar in British homes. Think of all the quiet country nooks from Land's End to Caithness, where kind eyes have glanced at it. The farmer brings it home from market; the curate from his visit to the cathedral town; the rustic folk peer at it through the little village shop-window; the squire's children gaze on it round the drawing-room table; every eye that beholds it looks tenderly on its bright beauty and sweet artless grace, and young and old pray God bless her.

The royal family was not alone, however, in its appeal to the public imagination. Eminence of any kind could find a market. Benjamin Disraeli (*figure 27*), twice prime minister, was an obvious candidate, but he was just one among the many statesmen, peers, bishops, authors and performers whose likenesses appeared in photographers' and publishers' windows and were snapped up by admirers.

Scanning J. H. Blomfield's catalogue in 1888, a Hastings reporter commented:

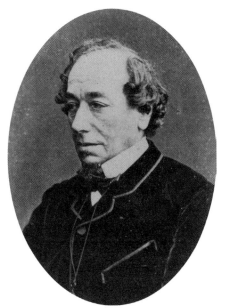

Figure 27: Carte de visite: Abraham Thomas, Gloucester.

Looking at a printed list with which we were ... furnished, there, staring us in the face, were column upon column of names of rank and title, and others, in even greater numbers, of men and women of note ... All professions and callings were represented, besides those classes where professions are unfollowed and unneeded.

Lesser luminaries were also fair game, and local newspapers were known to draw their readers' attention to the latest portraits being offered for sale. In 1856, for instance, the Norwich-based *Norfolk Chronicle* carried one such notice:

Mr. George Dawson – The admirers of this popular lecturer, it will be seen by advertisement, may obtain a most striking likeness of this gentleman, at Mr. Sawyer's Photographic establishment in London Street. The portrait is an excellent specimen of an untouched printed photograph, and was taken by Mr. Sawyer during Mr. Dawson's recent visit.

If the studios had nothing suitable in stock, would-be customers were not above making a direct approach to the object of their admiration. In 1872,

Hablot Knight Browne (who, as 'Phiz', illustrated many of Charles Dickens's novels) replied wryly to such a request, 'Dear Sir, I have not yet had my head taken off. When I do I will send it to you.' Dickens himself was particularly in demand, as he complained in 1856:

> *Scarcely a week passes without my receiving requests from various quarters to sit for likenesses ... At this moment there are three cases out of a vast number, in which I have said: "If I sit at all, it shall be to you first, to you second, and to you third". But I assure you, I consider myself almost as unlikely to go through these three conditional achievements as I am to go to China.*

Clearly, importunate demands for publishable pictures could become tiresome. A columnist of the *North-Eastern Daily Gazette*, imagining himself as a literary lion in 1889, invented a scene in which an insistent photographic team visited his home and pursued him with a camera. 'I crawled under the table – they photographed me there. I pulled the waste-paper basket over my head – they photographed me thus ... It is awful to be photographed for publication against your will, especially when you have only just got up.'

It was, though, a genuine literary lion, Alfred Lord Tennyson, who probably spoke for many other well-known figures when, lamenting his loss of privacy, he complained to Julia Margaret Cameron, 'I can't be anonymous by reason of your confounded photographs.' His sentiments have been echoed by public figures ever since.

But the desire to collect other people's likenesses was not confined to images of the more or less famous. Victorians, like their descendants, were eager to have pictures of family and friends, and this inclination was given an enormous boost by the dramatic success, in the 1860s, of a new photographic format. Cameras had been developed that could record a number of small images on a single large plate. These little pictures, trimmed and mounted on card, were called cartes de visite, and they were no bigger than a visiting card. Several pictures were created at the same time, so a set of duplicate copies came at no extra cost, and cartes could be priced by the half-dozen or dozen. The customer thus received a very affordable picture, plus a set of spares to distribute as wished. It was perfect. Copies of one's portrait could be easily given to friends or swapped.

The craze for exchanging cartes was, at its height, described as 'cartomania', and even when its intensity died down, the practice of distributing copies of an image continued. Not everybody was caught up in the excitement. Anthony Trollope complained, towards the end of the 1860s, that the 'bringing out and giving of photographs, with the demand for counter-photographs, is the most absurd practice of the day.'

Trollope was in a minority, as the virtues of the carte were obvious to the public in general, and some younger studio customers adopted the 'carte-as-currency' culture with the same alacrity as their successors embraced electronic social media a century and a half later. An album maintained by an unidentified (but almost certainly young and female) member of the Jodrells, a north Norfolk family, shows how cartomania could work.

In the early 1860s Miss Jodrell bought, or was given, an album with pre-cut spaces for cartes and with spaces, too, for a labelling system. The album was leather-bound and brass-trimmed, and it could be closed with a lockable clasp. Each of its stout gilt-edged pages had room for a single picture, and Miss Jodrell set about filling the spaces with images of her friends. There were one or two matrons and one young man in her collection, but most of the portraits were of elegant young women. She was perhaps related to some of these individuals, but others were probably friends with whom she had shared the last years of her education.

The labelling scheme had two elements. Above the photograph was a shield-shaped aperture into which the subject's family crest or motto could be inserted. Only a few of Miss Jodrell's friends came from armigerous families, but several had

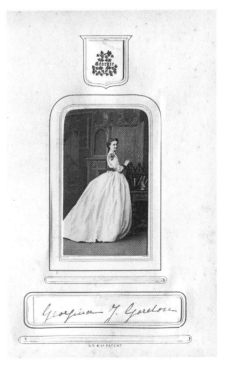

Figure 28: Album page with carte de visite: Lambert Weston, Dover.

provided some monogram or personal device that could be used instead. Below the picture was a space for an identifying label, and Miss Jodrell reserved this for the subject's autograph. In some cases, the subject had written her name on a suitable slip of paper for this express purpose; in other cases, Miss Jodrell carefully cut a signature from the bottom of a letter. *Figure 28* shows the page devoted to Georgina Gordon. It is perhaps not unreasonable to imagine that Georgina might have swapped her way to a similar collection of her own.

Foibles and Fashions

In addition to the common spurs to portraiture already discussed, there were occasionally more personal agendas. One of the more common was the desire for a picture of a beloved pet (*figure 29*). Another was the wish to be immortalised in fancy dress.

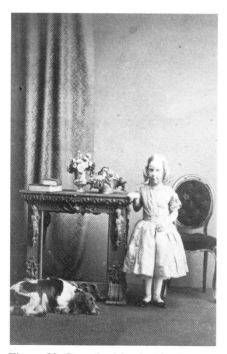 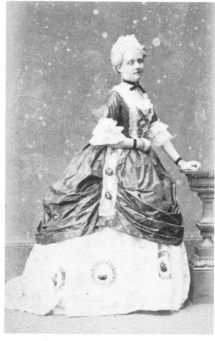

Figure 29: Carte de visite: Jenkins & Payne, Aylesbury.

Figure 30: Carte de visite: Schwarzschild & Co., Calcutta.

Portraits in exotic costume found some favour among the upper levels of Victorian society, though the great majority of people had no occasion to attend fancy dress balls. For many, having enough decent clothes for their everyday needs – with something a little less lived-in for Sundays – was aspiration enough; for some, even that would have represented inconceivable luxury.

Only the grander sort dressed up in strange costumes for special social events, but the grander sort enjoyed it, and they relished the chance to have their sartorial whimsies recorded by the camera. In fact, a fancy dress portrait could be quite consistent with the traditional role of photographs in projecting a suitable self-image. The age and gender stereotypes of Victorian portraiture could be successfully reinforced by the right choice of costume. There was no need to be humble and every chance to acquire an extra degree of grandeur, as demonstrated by the outfits worn at the Devonshire House ball of 1897.

Organised at her Piccadilly home by the Duchess of Devonshire to celebrate Queen Victoria's Diamond Jubilee, the ball was a glittering occasion, and the 700 guests were required to wear allegorical or historical costume from a date no later than 1815. Characters represented included Queen Marie-Antoinette, Queen Marguerite de Valois, the Emperor Charles V, Britannia, Queen Zenobia of Palmyra and the Empress Maria Theresa. Admittedly, the Earl of Rosebery, a former prime minister, went simply as an eighteenth century gentleman, and the Prince of Wales dressed down as the Grand Prior of the Order of St John of Jerusalem, but they were both secure enough in the status they already enjoyed.

Pictures to commemorate the occasion were deemed absolutely necessary, and many guests were photographed in their costumes, either before leaving for Piccadilly or on their return. To ensure that no opportunity was missed, it was arranged that James Lafayette should set up a studio tent in the grounds, complete with a backcloth representing the actual garden that lay outside its canvas walls. Lafayette was kept busy until 4 am.

The Calcutta ball attended by the subject of *figure 30* may have been a less grand affair, but it, too, was organised for a select class – the administrators of the Raj. The portrait met the requirement to add a sense of elegant social distinction to the usual virtues of dignity, seemliness and quiet womanly

charm. This, like most customer requirements, was probably unspoken; there was no need to give voice to what was implicitly understood.

Specific requests would, however, have to be made by customers with really out-of-the-ordinary requirements. In 1881 the *Dundee Courier* reported a new fad that was apparently catching on in America: 'A New Freak of Fashion, – Do you know the latest fashion? asks a New York correspondent. No. Well, it is for a young woman to have a photograph taken of her hand, and to present it as a souvenir to her intimate friends.' Having described one sitter's firm instructions on the subject to a photographer, the paper concluded that young ladies could now 'enjoy the pleasure of giving their hands to many beaus, while reserving the flesh and blood reality for the one they love best.'

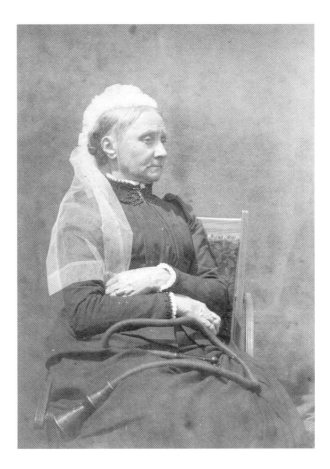

Figure 31: Cabinet print: photographer unknown.

No less single-minded was the subject of *figure 31*, who seems to have decided that her ear trumpet must be included in her portrait. Its folds do, to a degree, echo the positioning of her forearms, but the kinks in the rubber speaking-tube undermine any compositional advantage that might arise. The trumpet could easily have been put to one side for a few seconds, and the fact that it was not suggests that the sitter specifically wished it to be there.

If special agendas and individual foibles sometimes brought variations to the routine market requirements, time and new technology eventually caused changes too. The end of Victoria's reign was marked by the arrival of the Box Brownie and a great boom in the already developing amateur photographic market. The need to suggest dignity and worth would survive in the professional studio, but the rise of the amateur ushered in a competing set of values. People were photographed in comfortable, familiar surroundings by people they knew and felt close to, and they responded by asking for something new in their photographs.

The studio portrait would continue to assert traditional values, but the growing number of amateur snapshots confronted the viewer with a different set of propositions, asking them to look at where the picture was taken, what the subjects were doing and how happy they appeared to be. The smile, pioneered ten years earlier by Queen Victoria herself, would at last come into its own.

Chapter Two

Making a Choice:
How the Customer Selected a Studio

As time passed, the Victorians were faced with an increasingly wide selection of photographic establishments offering a range of services and product quality. Yet, in the early years – throughout the 1840s and for a good part of the 1850s – there was relatively little choice for most clients: either a studio existed locally, or it did not; either they could afford a portrait or they could not. Moreover, if there was a studio nearby, it was often set up merely on a temporary basis by an entrepreneur who would soon move on after serving an affluent few who had awaited his arrival with impatience. Inevitably, as in so many other fields, the capital fared best, enjoying the earliest opportunities and a quickly growing choice of studios.

Early Opportunities

The first photographic studio in Britain was launched in March 1841 by Richard Beard, a former grocer, who had snapped up the English rights to the new process of daguerreotype photography. His business was located on the well-lit top floor of the Royal Polytechnic Institution in London's Regent Street – an address that exuded scientific credibility – and the studio attracted much excited attention. In June, Beard found himself facing competition from Antoine Claudet, who had set up a competing operation in Adelaide Street, just off the Strand. Claudet, a Frenchman, had been taught the process by its inventor, Louis Daguerre, and his personal daguerreotype license allowed him to operate independently of Beard's monopoly. The studios prospered; both proprietors later established themselves in new premises, and both businesses survived into a second generation. Others soon followed in their footsteps, and by 1855 at least 80 studios had opened

in the capital. Some of these enterprises were short-lived, since a mixture of scientific, artistic, social and business skills was needed for success, but Londoners had a choice from the very beginning.

Their provincial counterparts were less well provided for. Beard controlled the English rights for the daguerreotype process used by early commercial studios, and his plan was to sell licences covering specific counties or large towns. Licensees bought an exclusive right to use the process within a stipulated area, and this had market implications for the customer.

Some areas, seen as less commercially attractive, had to wait several years for the arrival of a photographer; other areas might receive a series of short photographic visits to selected centres of population, without seeing a long-term studio established. There was, initially at least, no local competition. Therefore the opportunity to buy one's own portrait was, for a while, a slightly hit-or miss affair – what a later generation might term a 'post-code lottery'.

By the end of 1841, many of the more fortunate inhabitants of Plymouth, Bristol, Cheltenham, Liverpool, Nottingham, Brighton, Bath and Manchester had experienced their first encounter with a camera. So, too, had residents of Dublin and Edinburgh, but their cities fell within the scope of a different patent. All of these places had one thing in common: they could offer the hopeful licensee either a large or a moneyed population. Exeter, Scarborough and Oxford were soon added to the list, along with Birmingham and a selection of Yorkshire towns.

Other licences were less eagerly snapped up, and it took the rest of the decade for photography to reach areas seen as commercially unpromising. The inhabitants of Leicester had to travel to Nottingham to be photographed until their own studio opened in 1844. The people of Sunderland waited until 1845, and those of Harrogate until 1847. Essex was probably the last area to be licensed, and it was not until 1850 – or possibly 1851 – that a studio opened in Colchester.

Even then, the arrival of photography in these areas might amount to no more than a passing visit. The citizens of King's Lynn, for instance, had their first opportunity to be photographed in February 1844, but the Norfolk licensee moved on after five weeks, and a further seven and a half years passed before another professional photographer tried his luck in the town.

Where the local market could support a permanent business, buildings were adapted or even newly erected to serve as long-term studios. In Nottingham, Alfred Barber gained permission to carry out an extensive conversion of two attic rooms in the city's Subscription Library, turning them into something not unlike an observatory.

> *The roof he has had taken off at considerable expense, and a circular wooden roof substituted, in which a window is formed with the glass coloured a light blue. The most singular feature of this roof is, however, its being capable of revolving with the sun, by means of cog wheels and machinery, which have been erected for the purpose.*

Making the most of the available light was vital for photographers in the days before electricity, but the sun's direct glare was not desirable and the blue glass helped to soften and diffuse its impact. Barber's arrangement was evidently successful, since the studio was used by a series of photographers until the mid-1880s, and the roof mechanism survived until the 1930s.

Many of the first studios were, however, of a more ad hoc nature. Photographers planning to visit the remoter parts of their area would seek temporary premises with a sufficiently well-lit room to suit their purpose, along with a space that could be blacked-out to allow the necessary work with light-sensitive chemicals. There was no need for anything too grand. When T.H. Ely, the Norfolk licensee, decided to leave Norwich for the more rural parts of his domain, he advertised for rooms in the smaller towns: 'It is necessary there should be a Sky and Side Light. A Green-house would be suitable.'

Only one daguerreotype could be produced at a time, but by the early 1850s, when Beard's licences expired, the new 'wet-plate' method of photography had become available. This process created negatives from which multiple copies could be made, and its inventor, Frederick Scott Archer, had made no attempt to control its use. As a result, more studios began to appear, and they too, were often fairly makeshift. In King's Lynn, William Bullock set up for business in part of his father's grocery emporium, while William Pridgeon adapted a space at the back of his clock-making and jewellery shop.

Other early photographers, recognising that travelling to find new markets was to be a feature of their working lives, created mobile studios. Oliver Sarony spent the years between 1846 and 1856 travelling from town to town in what a Cambridge journalist described as 'two remarkably neat houses upon wheels'. These horse-drawn carriages had been converted for photographic purposes, and could be used in tandem as a studio, supported by front office and shop, or set up as discrete operations in different locations. In September 1854 one was attracting customers in Wisbech, while the other was stationed several miles away at Long Sutton.

They could also provide their clients with more than just portraits. In Cambridge, in 1856, Sarony announced: 'Mr. S. has fitted up one of his Splendid Carriages as a Photographic School, where instructions and Complete Sets of Apparatus may be obtained.' Pupils at this date were likely to have been relatively few in number. Amateur photography remained mainly the province of the gentleman scholar and the affluent dabbler until the last years of the century. But early students were augmented by the occasional opportunist who took lessons as a business investment and planned to set up as a professional.

Whilst 'splendid' was Sarony's own choice of epithet, it is clear that the carriages were indeed quite impressive. Shifting them between locations was no small undertaking, as arrangements for one move demonstrated:

Ten horses wanted to convey Mr. Sarony's Photographic Portrait Rooms, from Parker's Piece, Cambridge, to Stamford, Lincolnshire. Mr. S. is willing to contract with one or more parties, but not for a less number than Four or Six Horses.

The transport problem was solved in a different way by an American photographer, William Shew. In 1851 he converted a railway carriage that could be towed around the country by locomotive, parked in sidings and used as a travelling studio. At one stop, in Alta California, the locals mistook the carriage for part of a travelling menagerie and were disappointed not to find an elephant inside it.

Before long, new or improved photographic processes brought prices down, and even quite small communities could support their own resident

photographer. New permanent studios, many custom-built, became widespread as the 1850s progressed and were common by the early 1860s. Even towns of a modest size could host two or three businesses, and the presence of multiple photographers created competition. Customers no longer had to grab the chance of a portrait when a travelling photographer presented himself; an increasing number of people could now afford to become customers, and they could choose where, in an expanding market, they wished to take their patronage.

Going Upmarket: The Attractions of the High-end Studio

As in so many areas of Victorian life, social class and money were important factors in the photographic world. Customers patronised the studios they considered appropriate to their station in life and which offered portraits within their price range. The market quickly developed to accommodate both a higher and a lower end.

Some people gravitated to the most luxurious establishments as a matter of course. When 24-year-old Maria Cust, the wife of a barrister in the Indian Civil Service, sat for her portrait, her diary entry recording the event was short and simple: '1857. April 2. My photograph taken by Claudet.' As the daughter of a clergyman with titled connections, Maria was a member of the upper echelons of society who had already been visiting studios for some 15 years, so no further comment was needed. The only detail she felt worth remarking on was the photographer's name, which transformed a picture into a status symbol.

By this time Antoine Claudet had moved on from Adelaide Street and was in fashionable Regent Street, occupying a studio that he called his 'Temple of Photography'. He had improved the daguerreotype process and, after photographing many of the great and the good, he had been appointed 'Photographer-in-ordinary' by Queen Victoria. Claudet would have been seen as an entirely appropriate sort of photographer for a barrister's wife to patronise, and he was sufficiently grand for his name to be worth a mention.

A similar taste for more prestigious photographers is shown by the album of Miss Jodrell discussed in the previous chapter. Her family and friends were of the gentry, and they routinely chose studios of some distinction.

Most frequently represented in the album are the Southwell Brothers, photographers who had attracted royal patronage to their Bond Street studio and built an impressive client list spanning aristocratic, political, clerical and theatrical circles.

There are also examples from Regent Street studios (all with distinguished customers to their credit); there are cartes de visite by Lambert Weston of Dover, Hennah and Kent of Brighton and George Hawkes of Stonehouse (all of whom boasted sitters of at least ducal status); there is a portrait by Thomas Hart of Plymouth (a Fellow of the Society of Artists and a regular exhibitor at the Royal Academy). In addition, pictures from studios in Rome, Paris and Brussels demonstrate that their subjects had the means and time to travel.

Fashionable London studios could be very grand, but on the outside they were often somewhat understated. In the 1860s, Camille Silvy's studio at 38 Porchester Terrace was a coolly distinguished town house. Beyond a low wall, topped with a wrought-iron fence, a broad flight of steps led up to an imposing front door. The impression the building gave was of a gentleman's residence, with no suggestion of anything as vulgar as a shop, yet behind the coolly classical façade were rooms designed to echo the wealth of the patrons who entered them. One of these, 'The Queen's Room', was set aside for the monarch, should she ever grace the studio with a visit, and furnished in Gothic Revival style, like the new Houses of Parliament. Its ornaments included a silver equestrian statuette of the queen and her gilded marble bust embellished with enamels and mosaics.

Silvy also had photographic distinction to recommend him: he was one of the first photographers – probably the very first – to produce cartes de visite in London, and the images he made could be strikingly dramatic (*figure 32*). His offer of social distinction was another important consideration for affluent customers selecting a suitable photographer, and certainly no gentleman or lady would object to being seen ascending the steps to his door.

Nonetheless, a shop front was not necessarily a deterrent to such high-end customers. When James Lauder opened his Lafayette studio in New Bond Street in 1897, he emblazoned the studio's name and credentials on the façade and devoted the ground floor window to displaying his work, in an unequivocal assertion of his trade. But as Lauder had already built up a

distinguished clientèle for his Dublin studio, and had been summoned to Windsor to photograph the royal family, no further recommendation was needed. Society embraced him with enthusiasm and he went on to become a highly successful photographer of London's elite. Later, in the Edwardian era, he exploited a princely niche market by providing opulent portrait settings which satisfied the tastes of visiting Indian maharajahs, sirdars and ranis.

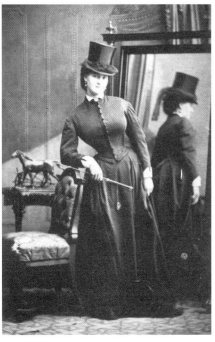

Figure 32: Carte de visite: Camille Silvy, London.

Such society photographers were, of course, accomplished professionals, but their studio arrangements were not always perfect. Although Baker Street – where the high-born and the high achievers of the day queued to be photographed by Elliott and Fry – was a good address, the road has a north/south alignment, and there were problems with access to natural light. Sometimes it was necessary to rely heavily on illumination from an overhead window, although this, Fry assured visitor Henry Baden Pritchard in 1880, 'was never used in taking gentlemen with bald heads.'

While lighting was the practitioner's typical problem, the clients had other matters on their minds. Elliott and Fry's Baker Street premises were liberally hung with expensive contemporary art that cost – so Pritchard suggested – huge sums to insure, let alone acquire. Conspicuous expenditure on furnishings and décor was always reassuring to the public, yet more importantly, the studio had photographed all the best people.

Few photographers could list such a comprehensive range of eminent subjects, including members of the royal family, Otto von Bismarck and the Shah of Persia; yet Elliott and Fry were all-rounders when it came to eminent names. They attracted politicians, Prime Minister William

Gladstone among them; musicians like Franz Liszt and Clara Schumann; artists such as Lord Leighton, William Morris and Sir John Millais; writers of the stature of Rudyard Kipling and Thomas Carlyle; and everyone from Shakespearian performer Ellen Terry to manly heroes like the English Channel-swimmer Captain Webb. Customers who could afford the studio's high prices naturally wished to purchase the right to be numbered among its subjects. The celebrated and the wealthy gave their allegiance to Elliott and Fry in the mid-1860s and continued to do so for 100 years.

Outside London, too, studios aimed to appeal to the high end of the market, although some did so in a fairly restrained way. For instance, when John and Thomas Spencer opened their new Leicester studio in 1863, they presented themselves – routinely enough – as artists, but the studio's main emphasis in advertisements was on their investment in quality.

J. & T. Spencer respectfully announce that they will, Next Week, open their new Photographic Gallery, which has been constructed, regardless of Expense, upon the most approved principles. The Gallery is easy of access, and combined with it, is a Reception Saloon and Waiting Room, Private Dressing Room, and every arrangement for the Comfort and Convenience of their Customers. J. & T. S. have availed themselves of the recent great and important improvements in Photographic Art to secure the best apparatus and accessories. First-class artists are employed, and portraits of every description are taken daily upon the most reasonable terms. Portraits coloured by experienced artists.

They had, according to their marketing material, spent heavily on comfortable accommodation, up-to-the-minute technology and skilled staff, and 'reasonable terms' did not

Figure 33: Carte mount: John Burton & Sons, Leicester.

mean 'cheap'. In fact, the Spencers' prices were very similar to those of their Leicester competitor, John Burton, who launched his own new studio the following month. (*Figure 33* shows the building as it appeared in the 1880s.) Burton's pitch attempted to make his customers feel important as well as ably provided for. He grandly named his premises the Midland Photographic Rooms and listed 'Her Majesty the Queen, H.R.H. The Prince of Wales, H.R.H. The Princess of Wales, and the Nobility of Leicestershire and the Adjoining Counties' as his customers.

Burton addressed his advertisement to 'the Nobility, Gentry, Clergy … in the Town and County of Leicester', and he promoted his studio as an art gallery and a fashionable social venue:

> *John Burton & Sons … have adapted their Premises as a Salon for the Exhibition of Photographic Art Productions of every Class. The access to the Gallery has been made more convenient, and the Salon has been furnished and fitted with all the requisites for a Photographic Lounge.*

A local reporter, impressed both by the studio and, perhaps, by having enjoyed a free meal, was fulsome in its praise:

> *That Leicester is eminently prosperous, few are bold enough to question. We see arising on every hand huge structures which indicate the vast increase of trade, and the multiplication of wealth in our town. Among the other evidences of this enviable state of things is the opening of the New Photographic Art Saloon of Messrs. John Burton and Sons. They have by some kind of fairy transformation converted their old shop into a most beautiful room, decorated and furnished with true artistic taste – the mirrored walls covered with specimens in every style of that art of which they are such well-known and admired exponents … We can sincerely say that we can scarcely imagine a more pleasing way of passing half-an-hour than a lounge in Messrs. Burtons' Art Saloon. A dinner in the new rooms in celebration of the opening took place on Saturday, when a large body of the admirers of the firm partook of their hospitality.*

Both the Spencers' and the Burtons' businesses stood the test of time, but John Burton had made a particularly well calculated appeal to the upper section of the market.

Also in 1863, a photographer named John Sawyer opened premises in Norwich. The building Sawyer chose had been designed specifically as a photographic studio, and it was intended to impress. The *Norfolk News* responded with enthusiasm:

> *It is built in the Italian style, and … the sharply-cut enrichments, the fine proportions, the beautifully-formed capitals and mouldings, and the exquisite manner in which every detail has been carried out, mark the structure as one of the most chaste and beautiful business establishments yet erected in Norwich. Nor have less taste and spirit been evinced in regard to the interior.*

The ground-floor shop was 'lofty, well lighted, warmed and ventilated', while a 'handsome staircase' led to a carpeted reception room with 'elegantly draped' windows. Here patrons could admire examples of Sawyer's work and browse copies of *The Times* and *Punch* – reading matter carefully chosen to appeal to the better class of client. This environment deliberately flattered the customers and nurtured their sense of self-importance.

Sawyer, incidentally, also celebrated his opening with a free meal, but, rather than invite dignitaries, he chose to treat those artisans whose skills with brick, stone, plumbing, glazing, plastering, painting and ironwork had enabled him to cause such a local sensation:

> *On the completion of the building, Mr. Sawyer gave a supper, inviting the whole of the workmen, to the number of 65, who sat down in the portrait gallery to a plentiful supply of beef, mutton, veal, ham, plum pudding, &c., assisted by a couple of casks of Young's best beer. Speeches, toasts and songs alternated, and the time passed quickly and most agreeably.*

Any sizeable town was likely to support a photographer who catered specifically, though perhaps not exclusively, for its gentry. When W. T. Pike sent his staff to investigate Derbyshire photography businesses in the early 1890s, they showed a proper appreciation of the success that various studios had had in

attracting distinguished clients. The 'distinctly high-class photographic and art studio' of William Statham of Matlock Bridge was praised for drawing in 'a very superior class of patronage', while David Latham of Buxton was noted as photographing 'many of the nobility and gentry of the district, amongst whom may be mentioned the late Duke of Devonshire.'

More ordinary – but still respectable – studios also sought to position themselves in similar ways, suggesting that their clientèle was select, their rooms impressive and their products appealing to the middle classes. That was understandable and, in a sense, quite reasonable. No businessman could be asked to declare himself of the second rank; no photographer could be expected to woo customers with the notion that, if they could afford no better, then his studio would do.

The fact was that, for less affluent customers, a middle-of-the-road studio was as upmarket an establishment as they could aspire to, and there was every reason to encourage them to feel good about the choice they had to make. For these reasons, in 1863 George Baldry assured the 'Nobility, Gentry and Public generally' of Norwich that 'no expense has been spared in the erection of a most suitable Studio'. The assurance had limited impact, as in 1865 Baldry was declared bankrupt. William Britton of Barnstaple appealed in 1855 to 'The Nobility, Clergy and Inhabitants generally of this City and County', promising further improvements, 'regardless of expense'. Messrs Stowe and Ladmore of Hereford announced in 1863 to 'all who may honour them with a visit' that their new glass-house had been 'fitted up regardless of expense'.

If limitless expense was constantly invoked as an appeal to the discerning, the promise of spacious premises was also frequently made. S. Firth declared in 1863 that his newly erected Glass Room was 'the most commodious in Leicester'; Sawyer's 'lofty' ceiling has already been noted; and a sense of multiplied space was surely intended in Burton's mirrored walls. Elbow room and liberal investment were important factors in winning the custom of even the more modest classes.

There were some clients, though, for whom a personal visit to even the grandest studio was a step too far. Royalty set the precedent by summoning photographers into its presence, and doubtless many of the more exalted patrons cited by proud professionals had been photographed in their own homes.

Going Downmarket: Options for the Less Affluent

Inevitably, many customers had to settle for the lower end of the market. During the 1850s and increasingly throughout the 1860s, the cheaper studios brought photographic portraits within their reach. This, the *Daily Telegraph* conceded in patronising tones, was quite as it should be:

> *There is no reason why the cook or the housemaid out for a holiday, the policeman off duty, the lacquey* [sic] *anxious to see his plush and powder transferred to glass and paper, should not 'have their picture done' as well as the dashing officers and brilliant ladies who crowd the studio of a Mayall, a Watkins, a Claudet or a Lock.*

Some of the humbler studios were set up by opportunists, hoping to make a quick profit in a growth industry, and often these practitioners had minimal skills and little experience; to them photography was simply the latest trade they had turned their hands to.

The American writer Nathaniel Hawthorne invented just such an operator in his 1851 novel, *The House of the Seven Gables*. His imagined photographer represented a type that was readily recognised by readers: 'Though now but twenty-two years old … he had already been, first, a country schoolmaster; next a salesman in a country store; and either at the same time or afterwards, the political editor of a country newspaper.' He had gone on to become a travelling salesman, to practise dentistry ('with some success'), and to give lectures on Mesmerism.

> *His present phase, as a daguerreotypist, was of no more importance in his own view, nor likely to be more permanent, than any of the preceding ones. It had been taken up with the careless alacrity of an adventurer, who had his bread to earn. It would be thrown aside as carelessly, whenever he should choose to earn his bread by some other equally digressive means.*

Many photographers, however, were serious about their trade, though not all found it easy to make a profit from it. Sidelines were not unusual therefore, and another American writer, James F. Ryder, looking back to the 1850s, commented:

It was no uncommon thing to find watch repairers, dentists, and other styles of business folk to carry on daguerreotypy on the side. I have known blacksmiths and cobblers to double up with it, so it was possible to have your horse shod, your boots tapped, a tooth pulled, or a likeness taken by the same man.

There was nothing uniquely American about such multi-tasking, and it was not unreasonable for Ryder to conclude, 'Verily, a man – a daguerreotype man, in his time, played many parts.'

Nor did the practice end with the decline of the daguerreotype. In Oakham, Rutland, during the 1890s Thomas German was repairing sewing machines in addition to taking pictures, while Arthur Knighten was also cutting clients' hair and selling them tobacco – a haircut, one suspects, could sometimes have been a useful prelude to making a portrait. Throughout the Victorian age, even established and respectable professional photographers continued to hedge their bets by making watches, selling fancy goods, dealing in poultry, and pursuing a host of other business activities.

When customers visited the poorer studios, they often found them rather basic and cramped. Henry Taunt, an Oxford photographer, was distinctly dismissive of the facilities offered by competitor Edward Bracher in the 1850s and 1860s:

It was a poor little place with a very narrow winding staircase lit with a gas jet in one place and very steep up; first to the specimen room into which everybody was asked, then into the dressing room above that and lastly up into the gallery. None of the rooms were large enough to swing round the proverbial cat.

Amongst the least palatial studios were the outlying branches of well-established photographers set on building a small local or regional empire – a common aspiration in the last two decades of the century. In the 1880s John Burton of Leicester took his business out into Loughborough and Melton Mowbray and over the county borders into Oakham and Burton on Trent.

Rather than being full-time operations, these shops opened for one or two days a week, usually including market day, when the best business

might be anticipated. On Tuesdays the Melton Mowbray and Burton on Trent branches were opened; Oakham took its turn on Wednesdays; the Loughborough studio was manned on Thursdays; on Fridays Melton Mowbray supported a second day of business, for a while at least; and on Saturdays Burton on Trent received its second visit of the week.

Such branches would be no better staffed or equipped than their percentage of profits within the overall business warranted. When Jasper Wright of King's Lynn expanded his business at the end of the 1890s, he took a young assistant, James Speight, to help with the running of his outposts. The Hunstanton branch, a seaside studio near the pier, opened mainly on a seasonal basis; the Swaffham venture, referred to by Speight as 'a small branch studio', was used only on Saturdays for the market trade; and the Fakenham operation was housed in what Speight described as 'a little place built on some allotments.' These were viable studios producing acceptable results (and even, in the case of Hunstanton, attracting the local gentry), but there was no hint of grandeur about them.

Burton's and Wright's were chains on a small local level, but in the later years of the century much larger chains often provided a very effective service to the lower end of the market. Vast numbers of customers had their likenesses made by a branch of one of these photographic giants, which used industrial economies of scale to provide affordable portrait opportunities on a national basis. By far the biggest chains were those of A. & G. Taylor and Brown, Barnes & Bell.

By the mid-1880s, the business of Andrew and George Taylor was huge, extending not only across Britain but into France and the United States. They boasted of royal patronage, but their main target was the mass market, and their avowed aim was for their portraits to be found in every home in the kingdom. They pioneered the idea of the club system, offering a large coloured and gilt-framed portrait, plus a dozen cartes de visite, for £1 10s. Given the cost of framed enlargements, this was relatively inexpensive, and the cost was kept low by the use of factory techniques at their Forest Hill works.

Photographic writer Henry Baden Pritchard visited the plant in 1880 and, when his 'blinking eyes penetrated the gloom' of the enlarging room, he 'became aware of animated beings busily moving to and fro'.

It was like the lower deck of a ship – dark and vague, and with wooden machinery on every hand, the active ship's crew going about its work quickly but quietly … As your eyes get accustomed to the darkness, you begin to perceive all the clever arrangements that exist for rapid and accurate working. There are no less than twenty-four lenses in use, and, in consequence, twenty-four enlarging stands; the lenses and cameras are let into the roof, or, at any rate, depend therefrom, so that the collodion plate for the enlargement only requires to be laid down in a horizontal position to receive the image.

Despite cost-saving production methods, the price of their enlargement plus cartes package was beyond the reach of low income customers. But the club system overcame this difficulty, allowing the cost to be paid off in small weekly instalments collected by the Taylors' agents.

Though less extensive than A. & G. Taylor, the chain of Brown, Barnes & Bell constituted its biggest rival. The partnership was formed in Liverpool in the 1870s, and its operation gradually spread across England, Scotland and Wales. They too offered club enlargements, and they too had a central processing operation. Their Mount Pleasant works had 'a score of employees in the printing department alone,' and many more in the retouching and mounting rooms. Pritchard interviewed one of the partners, who confirmed, 'We may not go in for the very highest class of work … Our motto is, "Go ahead," and we do go ahead as much as we can.' Pritchard went on to sum up the Brown, Barnes & Bell marketing strategy: 'In short, the firm's object is to cater for the million, and not for the few; their ambition is to do good work of a good class and at a moderate cost.'

It would be inappropriate to claim high artistic standards for the Taylors or for Brown Barnes & Bell, but Pritchard was right: they produced decent, unpretentious portraits for hordes of customers who wanted an affordable photograph. Their aggressive marketing methods – poaching customers and undercutting prices – may have been unpopular with independent photographers, but they did provide a product of reasonable quality, which is more than can said of many studios at the lowest end of the market.

At the beginning of the 1850s, when wet-plate photography offered a cheaper alternative process to the daguerreotype, photographic 'dens' began to appear in city streets. By cutting corners and peddling grossly inferior

products, unscrupulous operators could offer an alleged likeness to the naïve and unwary possessor of a few pence. As social investigator Henry Mayhew discovered, timid customers who questioned the quality of a portrait could be cajoled or bullied into believing that it would improve with time. One of the back-street photographers he interviewed, having totally failed in his first attempt at portraiture, gave the customer 'a black picture and told him it would come out bright as it dried'. Another sitter was assured, 'It will become better as it dries, and come to your natural complexion'.

On one occasion observed by Mayhew, the practitioner didn't even bother to promise future improvement but relied on a simple assertion of quality, despite the murky evidence of a bungled picture: 'There! There is your likeness, if you like! Look at it yourself; and only eightpence.' Mayhew went on to learn that some sitters, whose portraits had been a total failure, even had spare photographs of previous subjects palmed off on them.

By 1861 such dens were sufficiently common as to attract the attention of a leader column in the *Daily Telegraph*.

When we find photography associated with the lowest ruffianism and blackguardism, and made the medium of imposture and extortion, we are apt to grow somewhat out of patience with the proprietors of popular cameras and the manipulators of 'portraits for the million' … Our censure is directed against the low dens of cheap photography, with which even the most respectable of our thoroughfares are becoming infested … There is the 'professor' or 'manipulator' or 'focusser' or whatever he may call himself who keeps in the doghole he terms a 'studio', who executes vile libels on humanity which he misnames portraits … These cheap photographers are many of them the very scum and offscourings of humanity – fellows who have not wit enough to be skittle sharpeners, and not courage enough to be prizefighters.'

When Mayhew visited a den in Bermondsey, he found a former travelling showman had set up 'a booth built up of old canvas' in a vacant corner of a furniture dealer's yard.

Into this yard he had driven his yellow caravan, where it stood like an enormous Noah's ark, and in front of the caravan (by means of clothes-

horses and posts, over which were spread out the large sail-like paintings (show-cloths), which were used at fairs to decorate the fronts of booths), he had erected his operating-room, which is about as long and as broad as a knife-house, and only just tall enough to allow a not particularly tall customer to stand up with his hat off: whilst by means of two window-sashes a glazed roof had been arranged for letting light into this little tent.

Mayhew then moved on to another den nearby, 'which had originally formed part of a shop in the penny-ice-and-bull's-eye line – for the name-board over 'Photographic Depot' was still the property of the confectioner, so that the portraits displayed in the window were surmounted by an announcement of 'Ginger beer 1d, and 2d'. The former sweetshop, like the yellow caravan, evidently served as a darkroom, while 'the portraits were taken in a little alley adjoining the premises, where the light was so dismal that even the blanket hung up at the end of it looked black from the deep shadows cast by the walls.'

These ramshackle arrangements were passed off as studios to customers who could aspire no higher. Other cut-price photographers had no fixed studios at all and simply travelled from place to place looking for custom. Some of these practitioners, like the operators of dens, were certainly disreputable, but many were not and they brought the possibility of a cheap photograph to the relatively poor, to out-of-the-way locations and to open-air events. Their work was often unremarkable, but they were performing a service that many customers were glad of.

In fact, itinerant photography had perfectly respectable origins. The earliest licensees of the daguerreotype processes had often moved from place to place in order to find customers who could afford a portrait; and they had been followed by the likes of Oliver Sarony, whose splendidly appointed carriages represented itinerancy at its grandest. Once fixed studios became commonplace, however, the role of the peripatetic operator lost its status.

Nevertheless, for a time the travelling photographer retained the advantage of mobility. He needed a camera, a tripod and some sort of portable dark box in which to coat the plate with light-sensitive chemicals and process it after exposure. That dark box might be a small caravan, a tent, a neatly designed cupboard on wheels (*figure 34*), a covered barrow or even a converted pram. Thus equipped, he was free to go wherever custom could be found: he could

seek out remote areas with no nearby fixed studio; he could supply portraits to those who could still not afford mainstream photography; and he could turn up at the seaside or at fairs. This freedom of movement gave him access to a wider range of customers, allowing him not only to cater for the lower end of the market but also to sell his services to those who were a little better off, and who would on other occasions visit a studio.

Figure 34: Kodak print: photographer unknown. (*National Media Museum*)

Such customers might be willing to accept lower quality for the sake of immediacy, agreeing to buy a picture of themselves standing outside their own home or a souvenir of an enjoyable day out. *Figure 35* appears to have been taken outside a customer's house, with the brickwork framing a cloth background hung up over a window or door, while *figure 36* shows a similarly makeshift arrangement in a garden. *Figure 37*, on the other hand, clearly falls into the 'day-out' category, and its mood shows how these informal holiday pictures taken by travelling photographers were precursors of the more cheerful and relaxed snapshots of the early twentieth century.

Whilst itinerant photographers provided customers with welcome purchasing opportunities, the service they offered should not be romanticised. Photographer Paul Martin caught both the seediness and the excitement of the occasion, when he recalled a boyhood experience of being photographed by an itinerant in the 1870s.

A friend and I had been to a fair near Battersea Park, and on our way home a man pounced upon us and wanted to take our photograph. 'Surely you have ninepence between you,' he said. We told him we had not, but nevertheless he placed us against a fence and told us we would make a fine picture. 'If you have got sixpence that will do,' he exclaimed, and disappeared into a kind of

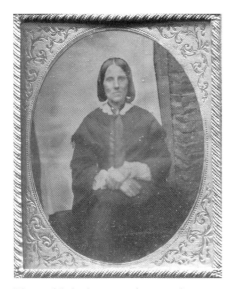

Figure 35: Ambrotype, photographer unknown.

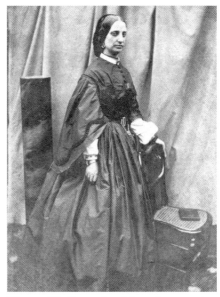

Figure 36: Carte de visite: photographer unknown.

portable dark room. Before long he came out with something hidden under his coat and vanished under the black cloth that covered his camera. What he did underneath I don't know, but he bobbed up and down a good deal, and when he reappeared he asked us to keep perfectly still. We did, and after a moment he came out from the cloth and disappeared head and shoulders into his other sanctum.

Before long he came out with a piece of glass covered with a white scum, and, pouring something over it from a small bottle, the cloudiness cleared off. He then placed it against his faded black coat sleeve for us all to admire. We hardly had time to look at it before he dried the glass, and coating it with black put it into a metal frame round which was a wooden frame. At last it was all over and we were able to pay our sixpence, take it away, and feast our eyes on it.

One final downmarket possibility remains to be mentioned. The photo-booth would not become familiar until the end of Edward VII's reign, when small adhesive-backed self-portraits could be taken in what were known as 'Stickyback' shops. But the forerunner of these cheap self-imaging

facilities appeared in the 1890s in the form of automatic tintype kiosks, where customers sat in an open-air shelter, facing the camera, and fed their coins into a slot.

The tintype, a process much favoured by itinerants, was a picture on a thin sheet of metal. The back of a German example (*figure 38*) shows such a kiosk and offers an explanation: 'Latest invention. Once a coin of the correct value has been inserted, this mechanical work of art provides everyone with his photograph, in a frame, within about three minutes.'

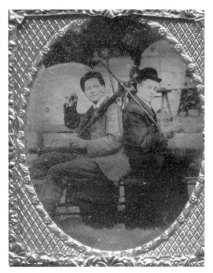

Figure 37: Tintype: photographer unknown.

Figure 38: Bosco Ferrotype mount: Conrad Bernitt, Hamburg.

Specialist Facilities

Social class and money were not the only factors to be considered when choosing a photographer. Some studios attracted sitters by catering to a niche market. The most profitable specialist areas, predictably, focused on the activities and professions of the gentleman. Best known within this field was the chain of Hills and Saunders, founded in the 1850s by Robert Hills, a hairdresser and wigmaker from Oxford, who saw what profit could be achieved by targeting the sons of the gentry. Here was a sector of society that attended public school, went on to university, and then, in many cases, became army officers. Hills and Saunders' strategy, therefore, was to open branches in towns with a concentration of these young men.

Figure 39 shows how effectively this plan led to a chain of studios dedicated to serving fledgling officers and gentlemen and their families. At the time this mount was designed, the firm was serving Oxford and Cambridge, the public

Figure 39: Carte mount: Hills & Saunders, Cambridge.

Figure 40: Carte de visite: Hills & Saunders, Cambridge.

school populations of Eton, Harrow and Rugby, the garrison at Aldershot and the nearby Royal Military Academy at Yorktown, Camberley. Later there were a succession of London studios and another at Sandhurst. The young man in *figure 40* was, therefore, making precisely the studio choice that might be expected of him.

Other individual studios aimed to capture similar niche markets. Some photographers followed their clientèle out to India and specialised in making portraits of the soldiers and administrators of the Raj; *figure 41* shows a portrait from the Calcutta studio of Bourne and Shepherd. Some photographers concentrated on specific professions back in Britain.

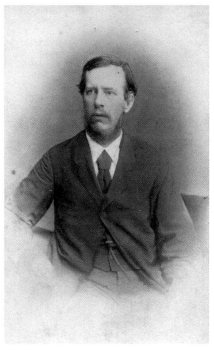

Figure 41: Carte de visite: Bourne & Shepherd, India.

Figure 42: Carte mount: Samuel Walker, London.

As part of his appeal to the upper end of the market, Samuel Walker of Regent Street aimed at the higher levels of both temporal and spiritual hierarchies (*figure 42*). The clergyman and his wife who appear in *figure 43* both have a pensive air. Perhaps they are lost in devout thoughts or perhaps they are savouring the distinction of being photographed in the studio patronised by the bishop. John Vanhear of Portsea, by contrast, targeted the martial market and professed himself photographer to both the army and the navy, while another military specialist, William Perry of Hythe, gained a more precisely defined client group as photographer to the British Army's School of Musketry.

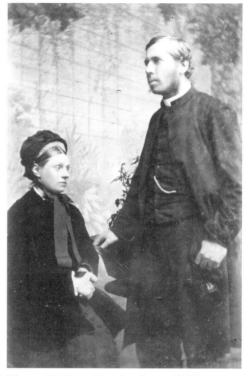

Figure 43: Carte de visite: Samuel Walker, London.

Less formal specialisation also occurred on the basis of political, religious or social bonds. A Methodist photographer, say, might find other members of the congregation choosing his studio, while a photographer who also engaged in local politics might find a significant number of clients with similar leanings on his list. This tendency may generally have been the result of affinity, rather than a deliberate business pitch and therefore little documentary evidence of such customer clusters exists. One exception is the occasional incorporation of masonic symbols into the design of photographic mounts.

Another kind of niche market related to hard-to-photograph subjects. Small children and animals were the stuff of nightmares for early photographers, as it was so difficult to keep them absolutely still for the long seconds needed to make an exposure. Fidgety subjects led to blurred plates and required the photographer to start the whole process over again, which wasted studio time, entailed extra expense, and ate into profits.

As late as the mid-1880s, when exposure times had been much reduced, a photographer's complaint about babies was quoted in the *Aberdeen Evening Express*:

> *We often wonder what has given the average photographer that wild hunted look about the eyes and that joyless sag about the knees. The chemicals and the indoor life alone have not done this. It is the great nerve tension and mental strain used in trying to photograph a squirming and dark red child with white eyes in such a manner as to please its parents.*

Some photographers charged extra for infants, and it is easy to see that Victorian parents might have been better disposed to studios that were avowedly child-friendly. Professionals willing to offer child photography as a speciality were therefore very welcome, and many claimed that niche, promising to charge no more for infants than for other sitters (*figure 44*). In 1878 Sylvester Parry of Chester went so far as to dedicate one of his rooms to this branch of the work, explaining that 'The Additional Studio has been erected specially for the production of Children's Portraits and Groups, and is lighted by an arrangement which secures instantaneous results, Children being photographed in the short space of One Second during the summer months.' In fact, he was prepared to make this studio available to hyperactive subjects of any category, assuring the public that 'Dogs and Pet Animals can also be taken by appointment.'

Figure 44: Carte mount: Herbert Barraud, London.

Specialist animal photographers were not common, since fewer pet owners than parents took their treasures to be photographed. Some photographers, expressed a willingness to undertake animal work, but certain creatures presented more of a problem than others. Cats and dogs could be brought into the studio, and the dog in *figure 29* has kept at least as still as its little mistress. But horses needed a separate space of their own. When Parisian photographer Adolphe Disdéri set up studios in London in the 1860s, he established an extra equestrian business at Hereford Lodge on the Old Brompton Road.

A hint of what such a facility might have consisted of is given by an 1874 redevelopment scheme, when a number of plots and properties in Bury St Edmunds were sold off, including John Clarke's photography studio:

Preliminary Notice of Sale of Important Freehold Properties, embracing a considerable area of Land adapted for Building Purposes, in the immediate vicinity of the Cattle Market ... In Cemetery Road. The Garden, Stable, and Photographic Studio, in the occupation of Mr, J.W. Clarke

This suggests that Clarke could offer an open space for photographing horses, backed up by a studio building for the necessary processing. In addition, there was accommodation for the animals to be rested and groomed before facing the camera – the equivalent of the waiting rooms provided for human subjects to primp and prepare themselves.

One further type of niche studio deserves a mention. Department stores were becoming a prominent feature of the retail landscape in the later nineteenth century, and it was inevitable that someone would seek to draw photography into the 'under-one-roof' system. If customers could buy food, clothes and furniture all in the same shop, why should they not have their portraits made there as well? When the idea for a new store was floated in Ipswich, a studio was a key feature of the grand plan.

Important Notice. The Household Commodities Supply Company, Limited, will open their stores at 32, Brook Street, Ipswich, on Tuesday, the 9th of March, 1875, with an entirely New and Superior stock of well-selected Goods ... Arrangements are in progress for an Early Opening of the

Gentlemen's Outfitting Department, and as soon as possible the spacious and elegant Photographic Saloon will be ready, when high class Portraits and Works of Art will be produced, under the management of an efficient and experienced Artist.

How convenient this was for customers is hard to say. Buying new curtains, sitting for a portrait and stocking up on groceries probably constituted occasions for separate shopping expeditions. It was, however, undoubtedly attractive to the owners and shareholders of department stores, and the idea would take a firm hold during the following century.

Shopping Around

It may appear that choosing a photographer during the nineteenth century was simple enough: customers sought a studio within their price range, which also fitted (or flattered) their sense of self-worth. Beyond that, where opportunity arose, they might consider turning to a photographer who specialised in serving their particular profession, interest or social niche. But choices are never that simple. Individual photographers were naturally concerned to differentiate themselves, which conversely made customers' decisions even harder.

The key to differentiation in a competitive market, it might be argued, is to ensure the customer cannot quite compare like with like. Look at the selection of prices offered to customers by Leicester's superior class of studios in 1867. John Burton was offering ten cartes for 10s. So was Thomas Johnson, yet Johnson was allowing two different poses to make up the ten pictures. Johnson seemed, therefore, to give the better deal, and he also gave customers the option of buying fewer than ten cartes, charging half-a-crown for the first carte, and a shilling per carte thereafter. That meant, say, that eight photographs could be had for 9s 6d. Was it worth saving sixpence? Or was it better to pay a mere threepence each for two extra cartes? Certainly there was no point in buying nine copies, since they would have cost sixpence more than the full ten.

Meanwhile, John and Thomas Spencer, another Leicester firm, had just altered their prices and were charging 10s 6d for a set of cartes. That sounded a little more expensive, but they were selling in batches of a dozen.

Lower down the local photography market, Henry Hancock and E.C. Allee were both offering six portraits for 4s 6d. If customers wanted two, or three, or a dozen photographs, however, and if their arithmetic was adequate, they would go to Hancock rather than Allee for the best bargain.

Then there were special offers to weigh up. Sometimes it was a simple matter of a photographer cutting his prices, like E.D. Rogers of Norwich in 1857:

Marvellous Likenesses for Little Money! The vast number of applications which have been constantly made to Mr. Rogers for Portraits of a much lower price than those which he has hitherto executed, induced him some months since to institute a course of experiments with the view of meeting these requirements, being unwilling to commence the cheaper kinds of Pictures till he could produce specimens very far superior to any which have yet been offered to the public. This object he has at length most successfully accomplished, and he is now enabled to guarantee Portraits of the most surprising Accuracy and Beauty, from One Shilling Upwards.

Other schemes were more ingenious. When William Wodehouse set up a studio in King's Lynn in 1859, he distributed money-off coupons giving potential customers reductions of up to 50 per cent. In the late 1870s his successors, Christopher Wallis and Victor Manders, ran promotions offering three extra cartes free with every dozen. Wodehouse was following a growing trend among photographers. By the 1850s, prospective customers throughout Britain were deluged with lively and competitive advertising campaigns in local newspapers. This advertising reached a high level of intensity in the 1860s and 1870s, and even at the turn of the century photographers still vied for custom.

Nor were announcements in the local paper the only way of appealing to customers and gaining visibility. Studio windows were full of enticing samples of work, and photographers' display boards were also sometimes hosted by other shops. The photographs themselves had the photographer's name and studio address printed on the backs of their cardboard mounts, supplemented by a wealth of trade information: prices, opening hours, latest processes, success in exhibitions, and even medals won in competitions.

Since the mounts were attached to photographs already bought by existing customers, their advertising value might be questioned, but the Victorian craze for exchanging pictures should be borne in mind. Every time a portrait was given to a friend or relation, a new opportunity arose for spreading the word.

How did all this vigorous self-promotion benefit the prospective customer? The practice of appealing to the client's sense of social importance has already been touched on. This routine ploy stressed the distinguished company a new customer would join, by listing particularly eminent patrons and, perhaps, adding a depiction of the Prince of Wales' feathers or a coat of arms (*figure 45*). Alfred Knighton of Kettering carried the practice to extremes in his sixteen-strong list of celebrities (*figure 46*), mentioning not only the Princess of Wales but also a duke, two earls, a viscountess and an assortment of lords, ladies and gentry. The other popular way of making customers feel among the chosen few was to address them in flattering terms, whether they

Figure 45: Carte mount: M. Guttenberg, Bristol.

Figure 46: Carte mount: A. Knighton, Kettering.

had any pretensions to gentility or not. When William Freeman of Norwich bought the photographic business of the departing Oliver Sarony in 1856, he petitioned the citizens in a suitably humble manner:

> *Mr. W. Freeman, Jun., in succeeding Mr. Sarony, most respectfully solicits the Nobility and Gentry of Norfolk and Norwich for a renewal of the patronage bestowed upon his predecessor, and he assures the Ladies and Gentlemen who may honour him with their commissions, that he will spare no exertions to ensure accuracy of likenesses, combined with an artistic finish, which a long experience in the Fine Arts will essentially assist him in accomplishing.*

Sarony himself was an accomplished flatterer and, shortly after leaving Norwich, was assuring the inhabitants at his next stopover that their tastes in photography were as refined as those of the Queen herself:

> *Her Majesty in fact knows well enough that in the fine art as in every other matter the best productions will always secure the best prices, and that bad works are dear on any terms. The people of Lynn have manifested the same appreciation of high talent.*

But though prices and the rhetoric of exclusivity were reliable selling points, there were other ways in which operators could catch the customer's attention. Many of these had to do with the comfort or convenience of the studio. Most studios were situated on an upper floor, to make the most of the available light, and the need to climb several flights of stairs was a deterrent to elderly or infirm clients.

Unsurprisingly, therefore, E. Denny of Exeter was keen to mention 'Studio on ground floor' as an attraction of his premises. Advertising in the *Western Times* in the winter of 1887, he was also at pains to remind the public that his studio was 'heated with hot water for the comfort of sitters'. Other photographers, like Herbert Barraud of London's Oxford Street (*figure 44*), invested in machinery to solve the upper-floor problem and installed 'a lift constructed on the most approved patents which will be found a great advantage to sitters as no stairs have to be ascended'.

Many studio improvements resulted from technical advances or from investment over a period in a growing business, and they came, therefore, in the later years of the century. In 1890 a correspondent of the *Derby Daily Telegraph* compared her trip to a modern London studio with a visit in earlier years:

These new premises in Regent Street are but an extension of the old ones, so well known, though the contrast is great between the airy, beautiful chambers now used as operating rooms, to which we ascended in a well-managed lift, and the uncompromising glare, heat and general bareness and discomfort of the studios into which us used to climb at the risk of wind and limb, to be baked and blinded, only a few years ago when we sat for our portraits before a great camera in a London studio.

When electric lighting became available in a locality, it became another factor for customers to consider when weighing up the attractions of a studio. The first studio equipped with electric lighting opened in 1877, but the general adoption of electricity for photographic work was a slow process. Some towns did not have mains electricity until the end of the century, so photographers either had to wait for progress to reach their corner of the country or invest in their own generator. There were also photographers who preferred the effect of natural light to its harsher alternative.

Nevertheless, those who had access to electricity were anxious to convince the public of its virtues. The firm of McLure, MacDonald & Co of Glasgow declared on its mounts:

Electric Light Photographic Artists. By the Electric Light, Portraits and Fancy Groups are taken Almost Instantaneously, by Day or Night, irrespective of weather, with all the clearness and brilliancy of the finest American and Continental photography.

One way or another, photographers tried to identify any conceivable customer interest and appeal to it. Clients fascinated by technological developments, for example, were no doubt intrigued to learn that C. and T. Hall were 'Sole licensees for Wakefield and district for the Vander Weyde and Ferranti-

Turner patent processes.' Chester patrons of a delicate constitution, on the other hand, would have been relieved to know that Silvester Parry's 'Chemical Rooms are so constructed that the Studios are completely free from the smell of chemicals.'

Announcements in newspapers and on photographic mounts did not constitute the only routes to attracting customers' attention. There was always the direct approach: touting for passing trade or using cold calling to win business. The notorious photographic dens employed street-corner representatives to drum up trade by shamelessly accosting passers-by on city streets. When Mayhew visited the sweet-shop-turned-den described earlier in the chapter, he found the photographer's aide outside, working in the manner of a fairground barker and shouting, 'Hi! hi! – walk inside! walk inside! and have your c'rect likeness took, frame and glass complete and only 6d.! – time of sitting only four seconds!'

In Thackeray's novella, *Lovel the Widower* (1860-1), the narrator revisits a street where he formerly had lodgings and finds a photographer has set up shop:

> *And this gentleman with the fur collar, the straggling beard, the frank and engaging leer, the somewhat husky voice, who is calling out on the doorstep. 'Step in and 'ave it done. Your correct likeness, only one shilling', … he is only the chargé d'affaires of a photographer who lives upstairs.*

These touts provided a ready source of comic material for *Punch*. One cartoon showed two rival dens, one promising 'likenesses warranted Kerrect' and the other offering 'an Exact likeness & a rasher of Bacon for 6d.' On the pavement in front, competing doormen vied for the custom of an elderly and alarmed lady, and one of them cried, 'Now Mum! Take off yer 'ead for sixpence, or yer 'ole body for a shilling!' In another cartoon, above the ambiguous caption, 'Step in, and be done, sir!', a leering cat solicited the patronage of an unconvinced mouse.

The *Daily Telegraph* voiced its disapproval of the practice without any mitigating humour:

To every one of these cheap photographic studios is attached one or more hired bullies called 'door-men', whose vocation it is to prowl up and down before the portal of the unwholesome temple of black art, to thrust villainous portraits into the faces of passers by; to make use of filthy and ribald talk to the giddy girls who stop to stare at the framed display of portraits; to exchange blackguard repartee with 'the door-men' of some neighbouring and rival studio; and, if need be, to assist their employers in ejecting, pummelling and otherwise maltreating troublesome customers.

House-to-house cold calling was generally less intimidating. Much of it was conducted by agents on behalf of the large photographic chains, though independent local photographers sometimes also used this approach. In such cases some kind of 'club' or easy-payment system was the common inducement to lower-income customers.

But the canvassers were not always to be trusted. In 1889 James Young appeared before the Aberdeen Police Court on a charge of fraud. His employer, photographer Henry Gordon, had given clear instructions as to what kinds of pictures could be taken and what they would cost, but Young had gone about offering distinctly lower prices. Customers gave orders and handed over money – which went straight into Young's own pocket. He subsequently told the court that he had understood the first payment on an order was his commission. Since he had passed none of these orders on to Gordon, he failed to convince the court and was sentenced to a fine of 30 shillings or a week's imprisonment.

Young was quite leniently treated. A year later, in Nottingham, William Gabb was tried in a similar case of obtaining money by false pretences. Photographer George Ellis had taken him on as a canvasser, promising to pay commission in two stages.

He was to receive 5 per cent on obtaining orders and 15 per cent when the money was paid. Prisoner brought in some orders, and received the sums of 16s. and 10s. on account of them, but it was afterwards ascertained that the orders were bogus ones … The jury found the prisoner guilty, and he was sentenced to nine months' imprisonment with hard labour.

The other kind of cold caller was the itinerant photographer, and he, too, might often be treated with suspicion by householders. It is agreeable, therefore, to notice the enterprising and perfectly genuine appeal made to prospective clients by a travelling photographer in 1895, as reported by the *Arbroath Herald*:

> *The latest method the itinerant photographer has discovered for turning an honest penny is somewhat ingenious. He haunts cemeteries, and with his camera photographs all the new gravestones that are erected. Then, having obtained the address of the relatives of the dead person, he posts a copy of the photograph, with the intimation that he is willing to supply 'a dozen souvenirs of the late departed for 5s 6d.' The number of orders this photographer receives is stated to be surprising.*

Timing the Visit

Though there was always some business available for itinerants, most portraiture was carried out indoors. Yet, once a studio had been chosen there remained the question of when to go there. This might, with the grander studios, mean making an appointment or sending a servant to do so on your behalf. In many cases, however, it meant just turning up and, if necessary, waiting. The reason for photographers opening branch studios on market days was, after all, that those were the days when customers were most likely to appear.

The most obvious answer was to choose a bright summer day, since for much of the Victorian age – and in some studios for all of it – photographers took pictures by daylight. An excess of bright, glaring light, nevertheless caused its own problems for photographers. What is more, they needed to ply their trade all year round to make a living from it and so, even in the early days of photography, practitioners were trying to convince customers that it was not necessary to await fine weather. In 1843, during the middle of winter, T. H. Ely, Norfolk's daguerreotype licensee, was informing the public that pictures could be 'taken in a few minutes, in all weathers'.

Sitters remained wary, and reassurance continued to be necessary. In 1855, as autumn approached, Owen Angel of Exeter reminded patrons that portraits were 'taken daily, in all weathers'. Through the winter of 1866/1867

William McLean of Hunstanton ran an advertisement designed to overcome any reluctance on the part of prospective sitters: 'He has, at considerable expense, purchased powerful Lenses for the dull days, and with his present arrangement can guarantee a first-class Portrait quite equal to one taken in the brightest days in Summer.'

The weather could potentially affect more than just the use of the camera. Printing pictures from the negatives also required sufficient daylight, and a series of grey days could slow the rate at which positive images could be produced from the glass plates. In December 1860, when demand for the new cartes de visite was causing a marked increase in business, John Sawyer of Norwich felt obliged to apologise for the fact that work was taking longer than usual to complete:

> *Cartes de visite. J. R. Sawyer begs to acknowledge the very considerable patronage he has received in the above new style of portrait – he regrets that the late dull weather has prevented the punctual execution of orders to some extent.*

This was merely a processing problem, and Sawyer was soon reminding clients that overcast conditions presented no serious obstacle to making negatives. 'The successful taking of Photographic Portraits is very little affected by the state of the weather. Some of the best Photographs are produced on cloudy and even rainy days, the actual sunlight being by no means necessary.'

There were, in fact, photographers who argued in favour of subdued lighting. When visiting Valentine Blanchard's Regent Street studio in 1880, Henry Baden Pritchard was struck by the gloom. 'Instead of being light, it is dark. Indeed, there is little doubt that Mr. Blanchard employs less illumination than most of his brethren; he objects to flood his models with light.' Blanchard explained that direct sunlight was not only unnecessary, but also undesirable: 'I consider … that the most perfect lighting a photographer can have is when the sun is obscured by a white cloud, and I endeavour to imitate this phenomenon in my studio.'

On the whole, any time of year was acceptable for a visit to a studio, but the time of day did matter; whatever the quality of the daylight, it was still

needed, and studio opening hours reflected the fact. During the 1850s and early 1860s many studios opened for business at 10 am, while closing times varied according to the time of year. In December 1860 Sawyer ended his working day at 2 pm, but during the following spring he was taking portraits until 4 pm. In the autumn of 1860 E. Silby, also of Norwich, was putting away his camera at 3 pm, but as the next spring approached he extended his working day by another hour.

A few photographers were more conservative. Sybilla Bennett of King's Lynn declared, in 1854, that 'The hours for obtaining the best pictures are from ten until two'; and in the January of 1855 William Nichols of Cambridge started taking pictures at the surprisingly late hour of 2 pm (though he then soldiered on in the growing gloom until 4 pm). The cycle of the year had a natural impact on business hours, and by 1864 William Mayland of Cambridge was building an element of seasonality into his advertised schedule, with 'hours of attendance: from 9 until 4 in winter, and 6 in summer'.

Increasingly, from the early years of the 1860s, studios opened at 9 am rather than 10 am. A recognition that the light was strong enough earlier in the day may have played some part in this, but longer business hours were perhaps also a response to increasing demand during the carte de visite years. Closing times, too, were affected: studios stayed open as long as the light allowed. From 9 am until dusk seems to have become a common formula, which lasted for decades. In 1862, for example, John McDonald of Dunfermline advertised 'Nine till Dusk' as his business hours, as did T.L. Taylor of Chester in 1878, John Crossland of Burnley in 1880, and St George Springthorpe of Ipswich in 1888.

With the advent of electricity, evening photography became possible whatever the time of year. In 1888 Joseph Kerby of Ipswich advertised 'Portraits by the Electric Light, Guaranteed equal to the best day work,' in a studio that was open 'every Evening till 9 o'clock'. Electricity justified premium prices, and Kerby's cartes taken by daylight cost 7s a dozen, whereas twelve taken by electric light cost 10s 6d. The adoption of electricity by McLure and MacDonald of Glasgow has already been mentioned. They used it both to establish a regular late closing time and to court a niche market, advertising that, 'The Studio (situate on the first floor) is open from 9 a.m. till 7 p.m., or later by appointment, for Sitters in Ball and Fancy Costume.'

Electricity extended a photographer's hours of activity and appealed to an evening trade (*figure 47*), but daylight remained the natural option for much of a studio's routine work, with electricity perhaps used to improve the lighting in overcast conditions (*figure 48*). For the customer, therefore, there was always a choice of visiting times, and this widened in the later years of the century. It is probably significant, however, that photographers continued to reassure customers about dull-day portraiture until well into the 1860s. It suggests that in the earlier years, at least, studio business was affected by the public's reluctance to go to the studio in poor weather or in the winter months.

Timing, then, was one of many factors to be considered by sitters, and some deliberated over their choices for longer than others. But however decisive or dilatory the customer, the time must come for making their selection and stepping into the photographer's world.

Figure 47: Cabinet print: Star Photographic Co., London.

Figure 48: Carte mount: London Stereoscopic & Photographic Company, London.

Chapter Three

The Studio Experience:
The Customer Faces the Camera

Being photographed, and especially being photographed for the first time, was a major event in the average Victorian person's life. It entailed making an effort to look presentable, reception into unfamiliar surroundings, a waiting period, and entry into an operating room full of strange sights and smells. Then came the uneasy ritual of being posed, and the long moment of immobility when the responsibility for success suddenly passed from photographer to sitter. It was an occasion for both excitement and unease.

Prelude to a Portrait

Before a visit to a photographer's studio a customer's first concern was what they should wear. The natural inclination was to put on one's Sunday best and, in dressing as well as they could, people were simply following the instinct to appear respectable before the camera. Work-wear was rarely an option, unless the sitter was a military man, academic or clergyman. In such cases, professional trappings carried a sense of identity and added weight, or even lustre, to the image about to be captured for posterity. Most occupational costume, however, spoke of subservience. Photographs of labourers in rough everyday wear or servants in livery are not very common and were generally taken at the behest of employers. Few sitters wished to present themselves at the studio in less than their best attire. Barrister and social investigator A.J. Munby, who zealously arranged the taking of many portraits of working women dressed in their grime, complained that 'Prints of girls in their best clothes appear undistinguishable in style and material from those of the middle and upper classes.'

Munby's attitude arose from his preoccupation with labouring women and, in particular, with Hannah Cullwick, a domestic servant whom he eventually married. His fascination with the visible evidence of drudgery, though untypical of his class, had a curious parallel in the disapproval with which employers conventionally viewed servants who aped the fashions of their supposed betters. But the inclination to dress well for a photograph was entirely natural and wholly in accordance with Victorian notions of a portrait's significance.

In the early days of photography, however, the instinct had to be tempered by technical considerations. Until well into the 1860s the light-sensitive coatings of photographic plates gave a rather eccentric rendering of colour. Some pale tones looked unnaturally dark, while some darker hues appeared curiously pale. In 1865 Dr Scott, the president of the Exeter Graphic Society, explained the problem to his fellow members.

> *Now a lady going to have her portrait taken in a yellow dress, would naturally think it would come out of a lightish hue, and she would be very much surprised to find it came out almost black … Hence if a lady wishes to appear in any particular tone of dress, it is of great importance that the proper colours are selected, and not such colours as will produce dark for light and the contrary. Again, gentlemen in blue grey dresses come out very light, and are generally much too light for the dark coats which are often worn with such colour, giving a violence in contrast that gives an unpleasing aspect to the photographic picture.*

Red and pink, like yellow, seemed unnaturally dark in photographs, and in 1857 *The Photographic Journal* offered a theory to account for the fact:

> *Mr. Stokes has shown that the scarlet and crimson dyes obtained from safflower, madder and cochineal are strongly fluorescent, and this no doubt is one reason why soldiers' uniforms, and red articles of female attire are so perplexing to portrait photographers.*

White also, as Dr Scott observed, created difficulties.

It is very common to see ladies going in dark dresses, with long floating ribbands, or cap strings of white or blue, large white collars and cuffs, &c., producing pictures of such violent opposition, and blotches of white far larger than the face, that this feature has to be sought for in the picture to be found out, so much is it thrown in the shade by the parts of the dress that I have mentioned … For this wearing of ornamental borders, white collars and cuffs, long floating cap strings, with white handkerchief in hand, is the ruin of many portraits that might otherwise be passable. All those white objects come out as so many spots in the picture, frequently entirely without any shadow to give us folds and texture in the material, and spoiling in every respect the effect of the picture.

Although Scott perhaps overstated the problem, it was certainly true that an exposure long enough to bring out facial detail could result in white areas of the picture becoming overexposed and burnt out.

The solution to all these problems of colour, in Dr Scott's view, was to provide the sitter with clear instructions:

It may be difficult for a photographic artist to interfere with the dress of a sitter but yet as sitters cannot be expected to know the capabilities of the art, it is certainly due to his patrons as well as to his own reputation, that he should be particular in insisting on parties wearing such dresses as are best calculated to produce satisfactory results.

Photographers were inclined to agree with him, and it was common practice during the 1850s and 1860s to advise customers on how to present themselves for the camera. In the early 1850s John Mayall of Regent Street offered the following 'Suggestions for Dress':

Ladies are informed that dark silks and satins are best for dresses; shot silk, checked, striped, or figured materials are good, provided they be not too light. The colours to be avoided are white, light blue and pink. The only dark material unsuited is black velvet. For Gentlemen, black, figured, check, plaid, or other fancy vests and neckerchiefs are preferable to white.

Such guidance from photographers remained common in the 1860s: Désiré van Monckhoven decried the wearing of red, yellow and green; Marcus Aurelius Root judged plain-coloured dress to be most appropriate; and John Sawyer insisted that 'dark and neutral colours are the best.'

Some photographers went beyond issuing sartorial advice in their advertisements or handbills and incorporated instructions on dress into wider-ranging booklets for would-be clients. In about 1862 George Washington Wilson of Aberdeen published *A Dialogue on Photography, or Hints to Intending Sitters*, in which he proscribed blue, pink, white and lilac for dresses as they tended to 'cause the face to look dark by contrast'. He was prepared to countenance some white trimming around the wrist and throat, 'but it ought to be as little as possible'.

Wilson was copied a year later by Frederick Bannister of Carlisle, who brought out *How to Sit for your Photograph, What to Wear, &c.*, which he sold for three pence at his studio or four pence by post. In Montreal, towards the end of the 1860s William Notman wrote *Photography: Things You Ought to Know*, in which he dealt with make-up as well as clothing: 'The temporary use of some white powder for a red countenance, or of some cosmetic to darken light eyebrows, moustache or beard will be found useful. These will be supplied if asked for and assistance given to apply them if necessary.'

In the light of such contemporary advice it can be seen that the woman in *figure 16* has prepared sensibly for her visit to the studio. Her dress, though dark, still allows some play of light to give a three-dimensional look to its folds. (This is why black velvet was undesirable: it was so densely dark as to appear entirely flat.) The white trimmings at neck and cuff are

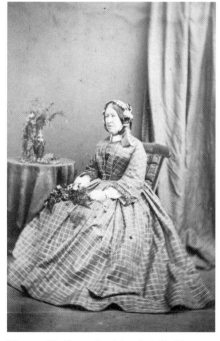

Figure 49: Carte de visite: J. & E. Short, Lyndhurst.

distinctly restrained, and the paler band on her skirt makes for a pleasing but not over-dramatic contrast with the main fabric. The subject of *figure 49* has also dressed appropriately. The check material of her dress is not too pale and its colours have come out well enough to establish a visual interest. Her bonnet and collar trimmings do not detract from the detail of her face, though it might be argued that she shows a little too much white fabric at the cuffs.

Photographic emulsions were gradually improved, so that, from the 1870s advice on dress was less necessary. When the subject was raised, it was more likely to be in the context of achieving a natural effect. Overdressing, rather than dressing in the wrong colours, was now likely to be the cause of concern for photographers. At the beginning of the 1890s, Henry Peach Robinson of Tunbridge Wells deplored 'the entire change of the ordinary costume on the part of the sitter when preparing to sit for a portrait'. Photographers, he argued, should:

suggest, wherever opportunity serves, the importance of preserving the usual and familiar appearance in the arrangement of dress, &c., in all cases where the portrait is to be prized as a likeness of the sitter, rather than preserved as a memento of some special effect of costume.

An unidentified photographer, quoted in the *Dundee Courier* in 1898, showed a similar preference for unfussy clothing and relaxed appearance. He advised a young man 'not to wear a striped or spotted tie, one of plain dark colour being preferable', and to choose 'a coat that fitted well, without so much regard to its newness'. An important element of his theory was that a sitter should feel comfortable, and he even extended this idea to matters other than dress:

A young man came here the other day … and sat for his picture. Three or four proofs afterwards submitted to him he rejected, because, as he complained, they looked to him just as he felt at the time of sitting – hungry. It seems he had come to the studio, about two in the afternoon, without having eaten anything since a light and early breakfast, and his condition betrayed itself in his expression. I told him to try again after a satisfying meal, and it is a fact that the second picture scarcely looked like the same person.

Arriving at the Studio

Suitably attired, the customer would arrive at the studio, but at that point entering a room where photographs were actually taken might still be a fairly distant prospect. The more ambitious studios, whether in the capital or the provinces, were made up of a suite of rooms. Some of these were equipped for professional activities: coating plates, developing, printing, retouching, colouring, mounting and framing – though exposure to light for printing could also be managed under controlled conditions out of doors, in a yard or even on a roof.

Other rooms were there to accommodate – and often also to impress – the customers, and there might be a reception room, a waiting room, in addition to one or more dressing rooms. The exact combination and arrangement depended on the space available, and the facilities might be spread over more than one floor.

Respectable provincial studios could offer tranquil and pleasant surroundings. When Stowe and Ladmore erected their new glass house in Hereford in 1863, they were able to assure the public that their 'Studio, Waiting and Dressing-rooms being comfortably warmed and heated, are equal to the London establishments.' R. Jeary of Norwich took care to have 'all the papers of the day constantly in the reception room for the use of visitors whilst waiting'. Henry Peach Robinson's Tunbridge Wells studio, visited by writer Henry Baden Pritchard in 1880, was conveniently housed over one level and agreeably wholesome: 'The whole of Mr. Robinson's establishment, so far as the public is concerned, is on the ground floor. The reception room opens into a small gallery, fresh and green with ferns, out of which lead the dressing rooms, while further on is the studio.'

The grandest operations offered a luxurious and, for some customers perhaps, an intimidating experience, and Pritchard's 1880 tour of studios at home and abroad took in some impressive examples. At Elliott and Fry's Baker Street premises he found an insistence on photography's status as a true art form.

The visitor walks upstairs from the vestibule, and finds himself in a gallery of paintings and photographs. The pictures, too, are of such a character as

to at once attract attention ... Mr. Fry, who courteously acts as cicerone, is evidently a lover of the young Scotch school, for we meet, also, with some fine sea studies of Colin Hunter, Peter McNab, and others. It is only when we leave the first gallery and proceed to the second and third, that we come among photographs. It is nearly all larger work ... "We try to show what photography can do in vying with painting in the production of large artistic portraits," said Mr. Fry.

At Oliver Sarony's Scarborough studio, Pritchard was overwhelmed by the sense of princely luxury, with 'rich divans and velvet lounges, lofty mirrors and gilded tables' exuding a sense of 'good taste and costly elegance'. When he moved on to the Lafosse studio, just outside Manchester, he found himself in a world of medieval splendour where he walked between 'shining casques of steel and polished breastplates ... to a panelled room in which there is much exquisite carving'.

There was a baronial air, too, about the studio of John Fergus in Largs, where the gallery was 'a fine lofty hall, with a Gothic roof, built of polished pine'. While there, Pritchard made a quick sketch of the layout (*figure 50*), showing the gallery, corridors, five dressing rooms ('all elegantly appointed') and three studios. Clients waited in the gallery, before traversing a corridor to enter a dressing room, which they then left by a second door to find themselves in one of the studios. Customers would be hard pressed to find

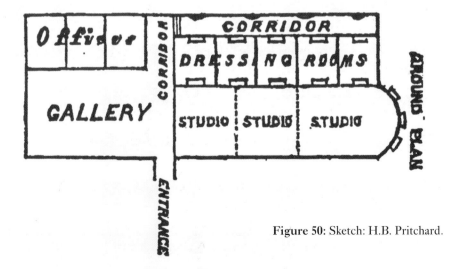

Figure 50: Sketch: H.B. Pritchard.

fault with the arrangements, but if they really wished to cavil, they could perhaps turn up a discriminating nose at the single waiting area: after all, Babending and Monckhoven's studio in Vienna even provided a separate waiting room for servants.

The downmarket photographic chains could also create some sense of occasion for their patrons, as Pritchard found when he went to the Bold Street branch of Brown, Barnes and Bell in Liverpool. 'The rooms', he reported, 'are not only elegantly and comfortably fitted up; they are so full of interesting pictures, that half-an-hour is interestingly spent within their walls.' Careful thought had been given to managing the studio's high turnover of customers:

> *There may be said to be three reception rooms, one above the other, on the ground, first and second floor; so that, if there are many customers waiting, this circumstance is not rendered too obvious to the last comer, who might be frightened away if he saw the full extent of the queue.*

Eventually, however, the preliminaries were over. The sitter had passed through reception, waited in imposing surroundings, made any necessary adjustments to hair, face and clothing, and was finally ready to move into the studio proper, the 'operating room' where the portrait would be taken.

The sitter now entered a strange and possibly disconcerting world. Lit, perhaps, by tinted windows in the wall and ceiling, the studio contained a wealth of curiosities – screens, hangings, improbable items of furniture and, most important of all, a hefty box on a stout stand. In 1841 *The Spectator* described the client's first impressions of Richard Beard's operating room, the first ever commercial studio in Britain:

> *The visitor is introduced into an apartment lighted from above, and having a flat roof of blue glass, which subdues the glare of the sun's rays without materially diminishing their luminous intensity; the livid paleness of complexion visible in the faces of the persons assembled, and the effect on the eye from the sudden change in the hue of light, cause a strange sensation, which after a while is agreeable.*

The significance of the phrase 'after a while' should not be overlooked, as a blue-lit glass house was an eerie environment. Irish writer Maria Edgeworth's abiding memory of her visit to Beard's studio was of 'a *snapdragon blue* light making all look like spectres'.

Sight was not the only sense to be assailed on a visit to a photography studio. It was not easy to keep the chemical smells from escaping the nearby darkroom. Iodine, sodium thiosulphate, ether, gun cotton, alcohol, pyrogallic acid, chlorine and potassium cyanide were just some of the raw materials of the early photographer's trade, and they made their presence known. These chemicals had a long-term effect on the photographers who used them, too, and visitors were often greeted by a professional exhibiting an unhealthy pallor, proffering a stained hand and breathing heavily. Some even bore the scars of dark room explosions.

Over the years, of course, studios became less daunting. The spread of pre-prepared photographic plates from the late 1870s, for example, brought a major reduction in the in-house handling of chemicals. The public, too, became more accustomed to photographic studios, and familiarity bred a degree of nonchalance. But throughout the Victorian period, for the first-time sitter at least, entering the operating room was a momentous experience.

A Woman's Touch: Female Studio Employees

There's every chance that, by this time, the customer would have encountered one or more female members of staff, perhaps in the reception area or attending ladies in the dressing room. Others may have been behind the scenes, engaged in printing, finishing or mounting the images, yet women were also to be found in the operating room, both assisting in posing the sitters and taking the photographs.

In an age known for its disregard for women's abilities, photography showed some appreciation of their skills. It has been estimated that in 1861 6.6 per cent of workers in photography were women, and that the proportion had risen to just over 25 per cent by 1901. These figures can be misleading, as they include all kinds of workers, drawing no distinction between the principals of a business and their humblest employees. In figures based on census returns such a distinction would, in any case, be difficult to make. A

purely personal impression, untested by statistics, is that male employees might refer to themselves as 'photographer', when female employees would settle, more scrupulously, for 'photographic assistant'.

Certainly, in the large studios, many women were hired to undertake the exact but repetitive tasks involved in processing and finishing, while men were more likely to be found in supervisory roles or working behind the camera. But most studios were relatively small-scale operations, often run as family businesses, and women were more likely to play an important part in these. Girls helped in their father's studios; wives shared in the day-to-day business, ran a branch studio, or took over when their husbands became ill or died; mothers handed over the reins to their children when they were ready to retire.

In other words, many women worked in the business as a family member, in exactly the same roles as men. Some, admittedly, kept their name above the door only until it could be replaced by that of a son; but others operated under their own name for decades and built a strong local reputation.

Nineteenth century customers, it appears, liked to have women around, sometimes simply because they were reassuring chaperones for female clients. In 1865 John Sawyer assured prospective customers that his Ipswich studio had 'Dressing Rooms and Lady Attendants', while in 1878 Silvester Parry reminded his Chester patrons that he had 'Lady Assistants always in attendance'. Sitters, especially female sitters, often appreciated a woman's input when they came face-to-face with the camera.

In 1890 an anonymous contributor to the *Derby Daily Telegraph* recorded her conversation with a photographer who lacked a female arranger: 'How delightful it would be to have an artistic lady in your studio, who would attend to all these little matters and pose your sitters to the best advantage before you immortalise them on your sensitive plate.'

Even in the lower-class photographic dens, a woman's customer-facing skills were well understood. Henry Mayhew came, in his social investigations, upon a back-street operation where the proprietor was standing back while his wife took the picture.

"You see," said he, "people prefers more to be took by a woman than by a man. Many's a time a lady tells us to send that man away, and let the missus

come. It's quite natural," he continued; "for a lady doesn't mind taking her
bonnet off and tucking up her hair, or sticking a pin in here or there before
one of her own sect, which before a man proves objectionable."

London photographer Elizabeth Garet-Charles was used to the more refined
area of St John's Wood, and she put forward a similar point of view when
interviewed for the *Windsor Magazine* in 1897.

A woman prefers to be photographed by woman. You see a strong morning
light is horribly realistic; it shows up ones little deficiencies so, or it accentuates
the beginnings of a wrinkle here and a crowsfoot there. Now every woman,
be she of the old or new variety, likes to feel that she is being seen to the
best advantage – in the presence of man. Therefore when she is posed by a
critical male, who notes all her weaknesses of complexion or feature, she feels
ill at ease, she loses whatever of naturalness she has, and as a consequence
the resulting picture (save the mark!) is more suited to a chamber of horrors
than to a Regent Street showcase.

She could, perhaps, be accused of simpering and demonstrating that
women, when not being patronised by men, sometimes insist on patronising
themselves. But it may be fairer to see her as reflecting her profession's
practical understanding that women could deploy particular skill in the
arranging and photographing of clients.

Photographers William and Sarah Dexter of King's Lynn, for example,
were very well aware of the contribution that Sarah made to the business.
The Dexters worked together in the studio from the 1850s until their
joint retirement in favour of their son in 1881. Over the years the business
was known by a number of names, including 'Mrs Dexter's Photographic
Rooms', 'Mr and Mrs Dexter', 'Messrs Dexter' and, eventually, 'Dexter
and Sons'. But there was never any doubt as to whom the public saw as the
key figure in the partnership, and Sarah's importance was acknowledged at
strategic moments of the couple's joint career. When they moved to a new
and more spacious studio, they announced, 'To ensure a good Photograph,
strangers are requested to ask for and see Mrs. Dexter, who is always in
attendance at the gallery.' Later, during a period of particularly cut-throat

competition, Sarah was once again seen as their unique selling point: 'Persons wanting a really good likeness, should ask for and see Mrs. Dexter, of twenty-five years practical experience in Photography, who personally attends upon all sitters, no assistants being allowed in the gallery.'

The awareness that female photographers could be good for custom persisted into the new century. When, in the Edwardian era, Frank and Bertha Barns set up a studio in Great Yarmouth, it was Bertha's name that was used to draw in clients. Frank came from a family of photographers and had many years' experience, but the business was promoted as 'B.E. Barns, The Lady Photographer'.

There were also women who worked entirely independently, like Elizabeth

Figure 51: Carte mount: Elizabeth Higgins, Stamford.

Higgins of Stamford (*figure 51*), who ran a studio in her own name for four decades, enjoying a long and busy career. It may be that some customers sought out female photographers. There are indications that one Lancashire family, whose album was examined during the preparation of this book, had a preference for visiting female photographers when possible. That seems, at any rate, to be implied by the frequency with which pictures by Alice Moss and Margaret Robinson (both of Ashton under Lyne) are found in the album, and by the inclusion, too, of cartes by Alice Bardsley (also of Ashton under Lyne) and Eleanor Holmes (of Lytham). If customer preference was indeed at work in this instance, it was surely based on the whole package of service, value and product, rather than simply on not letting a man see the sitter's wrinkles.

The Ordeal

Despite the enticing prospect of a portrait, stepping into the operating room was, for some customers, the beginning of an unpleasant interlude. Men of letters were prominent among such clients. 'I hate sitting for a photograph,' insisted Anthony Trollope, while Alexandre Dumas declared, 'I have a horror of photography, and the horror extends to include all photographers.' Wilkie Collins complained, 'Having a tooth out, having your hair cut, and having your photograph taken are the three great trials of mortal life,' and Thomas Carlyle described submitting to a portrait as 'a kind of inferno'. Carlyle was, admittedly, describing the experience of sitting for that most exigent of photographers, Julia Margaret Cameron.

Even some operators acknowledged the artificiality of the occasion. Henry Peach Robinson, a photographer with both an international reputation and a small-town studio, summed it up very fairly:

> *The sitter is placed in a chair, very often of unusual construction – perhaps low in the seat, possibly straight-backed, and mediaeval; he is then arranged so as to bear a given relation to the position of the camera, and to the arrangement of the light; his hands are place in approved form; his head is fixed in a rest; he is directed to gaze at a certain spot, and he is then invited to look pleasant, and sit perfectly still.*
>
> > *"Quiet as a stone,*
> > *Still as the silence."*
>
> *He becomes at once conscious of the vital importance of the moment; if he is doubtful of his steadiness, he makes a special effort, with a look of ferocious agony, to sit perfectly still; if he is more anxious about the expression than about his steadiness, he probably puts on an insufferable smirk. In either case a portrait with nothing of familiar likeness is the result.*

Little wonder then, that subjects often looked ill at ease. In 1883 an article in the *Sheffield Evening Telegraph* looked back to the early days of photography, when a studio was a threatening place:

The great difficulty of the photographer was to persuade clients that the process bore no resemblance to the operation of having a tooth drawn. One may conceive that it took some time to undeceive people in that respect. The camera became an alarming object, when the artist threw a black cloth over his head and converted himself, as it were, into one large glass eye. The patient was told not to move – a terrifying injunction. He was earnestly entreated not to wink, and the result was that tears constantly flowed into his eyes until the craving for winking became a madness. His head was fixed in an engine designed to steady it, but which in reality appeared as if it was meant to crush it, and in this posture he was told to look happy, and to think of something agreeable.

That, according to the writer, was how things were in the bad old days. But Robinson's comments date from the last decade of the nineteenth century, by which time exposure duration had been significantly reduced. In truth, the idea of portraiture as an unpleasant ordeal persisted for decades. In 1866 an occasion arose when photography was, in effect, considered the equivalent of punishment: two gypsies, charged in Worksop with the unlawful possession of a pheasant, were discharged on condition that they submitted to having their photographs taken.

Forty years later, and five years into the reign of Edward VII, a macabre joke in *Punch* showed that the associations of portraiture with pain had not been forgotten. Campaigners had been petitioning for photography to replace decapitation as a means of identifying soldiers who had died in battle, and *Punch* suggested that anyone who had suffered at the hands of a photographer would object to this proposal 'on humanitarian grounds'. It may be that *Punch* was trying a little too hard, as, when that joke was made, the nature of photography was already changing. Studio portraiture was becoming a more comfortable experience: exposures were shorter and ingenious devices to aid (or enforce) immobility were no longer needed. Studio photographers were professionals and knew what they were about.

In the early twentieth century, sitters were more likely to undergo a photographic ordeal at the hands of enthusiastic amateurs who, knowing they needed to keep the light behind them, habitually forced their subjects to squint uncomfortably into the sun. The serious amateurs were, perhaps, the

worst. Many Box Brownie owners simply pointed the camera, clicked and hoped for the best. Those who had invested in expensive equipment kept their subjects waiting with streaming eyes, while they composed pictures, judged distances and deliberated over settings.

The age of the amateur also heralded another form of trial. The camera, now easily portable and widely owned, had become intrusive. 'There is a photographer in every bush,' complained writer Samuel Butler, 'going about like a roaring lion seeking whom he may devour.' Bathers at the seaside came to feel especially vulnerable, and as early as 1889 the *Liverpool Echo* was reporting a case of holiday harassment:

> *At a sea-side resort a lady was going down to the margin of the sea, and just as she reached a favourable spot, an amateur photographer set his camera and took her likeness. The husband was standing by, and he seized the photographer, and his camera as well, and then there was a lively quarrel over the matter, which the law and costs alone can settle.*

The notion of the photographic voyeur soon became familiar enough to become a music hall joke, with Dan Leno popularising a song entitled 'The Detective Camera' in the 1890s. During the following decade Bert Brantford recorded 'You Mustn't Do That, Naughty Boy', which included a verse about a small boy, recently given a snapshot camera, who was watching his sister's friend swinging in the garden:

> *When somehow she let go her hold*
> *And went flying away through the air,*
> *I thought I'd snapshot her before she came down.*
> *My sister said, "Well, I declare!*
> *You mustn't do that naughty boy …*
> *It's impossible while she is up there in space*
> *Turning somersaults, for you to snapshot her face.*
> *The idea, naughty boy! The idea!*
> *The result she would far from enjoy.*
> *Well, she couldn't put that in her album, you know.*
> *You mustn't do that, naughty boy!*

Back in the nineteenth century studio, however, a photograph was something to which the subject had given consent, and the operating room was where the ordeal would take place.

In the Operating Room

The customer was usually struck at once by the expanse of glass. The first requirement of a studio was good natural light, and for this reason many were found on an upper floor or even erected on a flat roof. That light had to be managed, as Charles Dickens's weekly magazine, *Household Words*, explained to its readers in 1853:

> *A diffused mellow light from the sky, which moderates the darkness of all shadows, is much better suited to the purpose of photography than a direct sunbeam; which creates hard contrasts of light and shade.*

North-facing windows proved helpful in this respect. Some light from above as well as from the side was also desirable, and photographer N.G. Burgess set out his criteria in a practical handbook of 1861. He believed that 'a skylight is much more to be preferred than any side-light', arguing that it should be 'not more than ten or fifteen feet from the sitter in the highest point, and falling over in such a manner that the lowest portion of it shall be five feet from the floor'. Above all, he added, 'there should be a good volume of light on the drapery.'

William Hanson, writing in *The Photographic Journal* in 1866, considered the ideal size of windows. Dismissing the case 'in favour of small apertures', he cited personal experience: 'On very dull days I have not found a 23-feet aperture too much in a room 29 feet long.' He added that the incoming light could be regulated by the use of blinds, as in his own studio, which was 'provided at each end with a green cloth blind capable of being drawn forward over the glass 6 feet, so that the 23 feet may at any time be diminished to 11 feet, if necessary'.

Other photographers had to work in much more complicated environments. In 1865 the same magazine reported the lighting arrangements of an unidentified practitioner, whose curiously-shaped glasshouse had been built on a roof around an array of chimney pots:

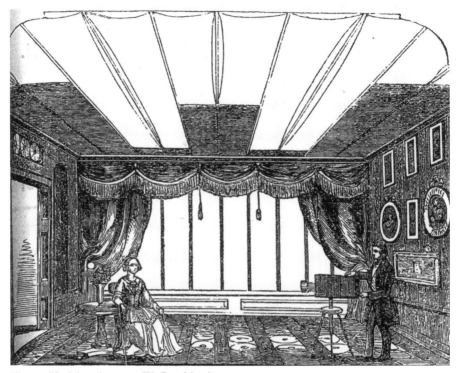

Figure 52: Advertisement: W. Cox, Northampton.

He says he don't care for the form of the room or where the light comes from; he forms on the instant just the light he wants by putting the sitter into a moveable box just large enough for one, and then he puts a sort of tent round, with very narrow blinds on each side, almost like wide ribbons; these he draws down one at a time until he gets such an effect of light and shade as he wishes.

A more conventional arrangement is evident in *figure 52*, which shows the Northampton studio of William Cox in 1867. One wall is given over to tall windows with curtains that can be adjusted from both the top and sides, while a glazed ceiling is furnished with a selection of opaque and translucent blinds. An operating room depicted in Edward Estabrooke's *Photography in the Studio and the Field (figure 53)* shows that similar light–control systems were still in favour 20 years later.

Sometimes a little more light, or light from a different direction, was required, and this could be provided by reflection. At is simplest, reflected light could be directed by a white screen, and *figure 54* shows how American photographer F.B. Johnston achieved this feat in apparently domestic surroundings and by the most ad hoc of methods, in the 1890s. On home ground, however, a photographer could adopt more ambitious systems, such as the mirror mechanism used three decades earlier by Robert Cornelius in his Philadelphia studio (*figure 55*).

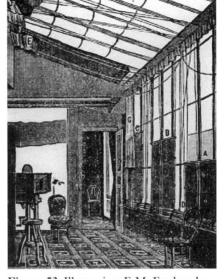

Figure 53: Illustration: E.M. Estabrooke.

Having been impressed by the studio's expanse of glass, the customer would go on to observe the collection of furniture, hangings and equipment used to create a background environment for the planned portrait. An 1890s picture of a studio in Medan, Indonesia, (*figure 56*), set up by Dutch photographers Stahelle and Kleingrothe, shows an area of their operating room where furniture and items of set decoration are ready to be employed in creating a miniature world for the sitter to inhabit.

The earliest, simplest and most enduring type of background was a plain wall or backcloth, to which could be added a heavy drape and an item of furniture (*figure 57*), but from the 1860s onwards painted backgrounds became increasingly popular. Favourite subjects changed over the decades: scenes of lofty rooms and book-lined studies started to show glimpses of a

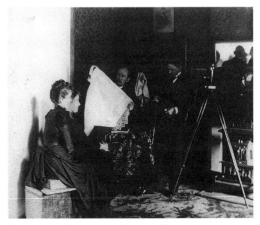

Figure 54: Cyanotype, Frances Benjamin Johnston. (*Library of Congress*)

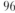

(Fig. 8.)

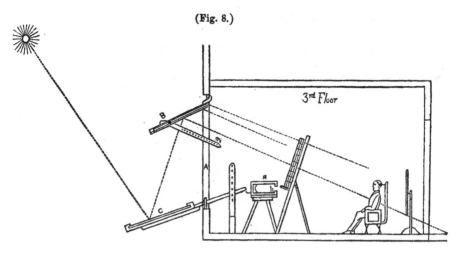

3rd Floor

Figure 55: Sketch: Marcus Aurelius Root.

wider world beyond a window or French door (*figure 58*); then the open-air settings of terraces, gardens and parkland began to be depicted (*figure 59*); next, wilder and more romantic outdoor imagery became fashionable, with rugged moors (*figure 60*), woodland glades and distant ruined castles. It could, in fact, be argued that photographic backgrounds made – over a shorter period of time – the same journey from classical to romantic taken by other art forms.

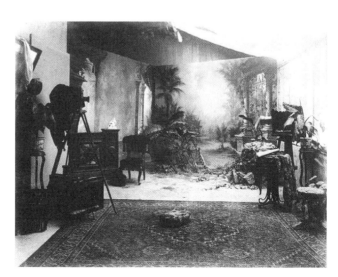

Figure 56: Albumen Print. (*Tropenmuseum of the Royal Tropical Institute (KIT), Amsterdam*)

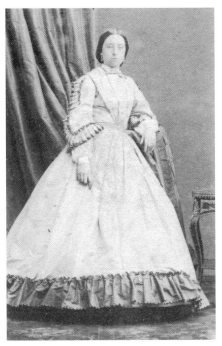

Figure 57: Carte de visit: A.A.E. Disdéri, Paris.

Figure 58: Carte de visite: R. Wingfield, Worcester.

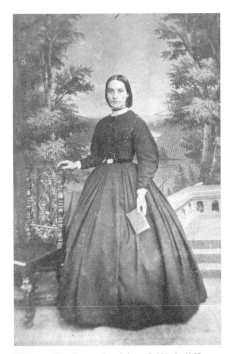

Figure 59: Carte de visite: G.W. Ayliffe, Kingston upon Thames.

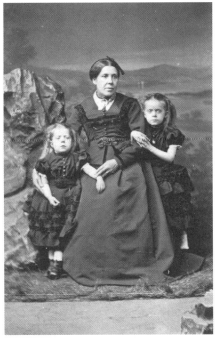

Figure 60: Carte de visite: James Bowman, Glasgow.

Many photographers ordered their backcloths, bespoke or off-the-peg, from specialist suppliers, often buying from such overseas companies as L.W. Seavey of New York and Engelmann and Schneider of Dresden, who were in demand across the world. But there were also photographers who commissioned backdrops locally or painted their own. When Henry Baden Pritchard visited Henry Peach Robinson's Tunbridge Wells studio in 1880, he was struck by the absence of outsourced work. 'Mr. Robinson's studio,' he declared, 'is remarkable from the fact that it does not contain one of Seavey's backgrounds. The backgrounds here are all prepared by our host.'

At a time when backcloths were becoming more impressionistic, Robinson was creating his scenes by working with wet chalks on wet canvas and then softening the effect with a clothes brush. 'Just took me an hour,' he remarked breezily, pointing at a recently finished seascape with rocks.

At the Hills and Saunders' London studio Pritchard found that their manager was also reluctant to use backcloths from the major suppliers:

Mr. Cowan has no great faith in Seavey's backgrounds: his own, he tells us, are, for the most part, painted for five shillings a-piece, by an old hand who had been a scene painter in his day. Rather than the conventional drab-grey usually affected in backgrounds, a warm brown or brownish-grey is the tint preferred.

Pritchard casually refers to one more detail that must have made the studio seem a disconcerting world to first-time sitters. The elegant interiors, verdant parks and leafy groves before which they were about to pose were all rendered entirely in monochrome. They had not been painted for the human eye, but for the eye of the camera. There was little point, therefore, in essaying natural hues which, like unsuitably coloured clothing, would register idiosyncratically on the photographic plate.

Successful photographers quickly built up a selection of backcloths, allowing their customers the novelty of choosing a setting to their taste. Pritchard found 26 backgrounds in just one of Elliott and Fry's three operating rooms in Baker Street, and he was given to understand that, for every one accepted for studio use, two were rejected.

Few businesses could hope to offer such a selection, but it is clear that sitters were keen to have a choice. In 1862 Dunfermline photographer John McDonald was anxious, both to give advance notice that he had ordered a set of backcloths and to confirm their arrival:

> *Mr. McDonald begs to intimate that he has received, as formerly announced, the Series of Artistic Backgrounds. The Photographs taken with the above can be seen at No. 120 High Street, and a comparison of which is respectfully invited, side by side, with those that emanate from any other first-class Establishment.*

It was thought necessary, too, to bring in new scenes at reasonably frequent intervals. John Sawyer opened his new premises at 46 London Street, Norwich, in October 1863; three years later he announced that the studio had 'just been furnished with some very artistic new backgrounds and accessories'; then, in the spring of 1868, he revealed that the studio had 'just been furnished with a new series of artistic backgrounds, painted under Mr. Sawyer's inspection by eminent London artists'. Custom-made scenes offered clients a degree of exclusivity, and Sawyer's preference for them is confirmed by the fact that one of his backcloths showed Norwich Cathedral.

While only a minority of studios offered the opportunity to pose in front of a local landmark, customers still had a range of options to choose from. The photographer's full range of backgrounds might not, however, have been immediately evident to them. Items of such a size created a storage problem, and few studios had enough wall space to display their entire stock. Yet, by 1880 Alexander Bassano of Bond Street, so Pritchard discovered, had devised an elegant solution to the problem:

> *In the principal studio – 26 feet in length – there was but one background. But it was a long one. It measured no less than 80 feet, and was mounted on perpendicular rollers like a panorama. Its handiness was obvious. As it was deftly passed in review, the tint changed from warm to cold, the scene from outdoor to indoor, and, in a word, progressed through every phase.*

At Porchester Terrace, Hills and Saunders had a vertical equivalent of the same notion, along with other storage methods: 'There is one with rollers top and bottom, an endless panorama; others moving in grooves, as if they were wings at a theatre; and a third description that is hinged, and acts like a practical door.'

One common practice was to wind each backcloth on a separate roller fixed to the ceiling, and to pull it down, like a blind, when required. But Oliver Sarony adopted the opposite procedure for his Scarborough studio: 'The backgrounds are ingeniously contrived to rise from below, and so well balanced are they, that with one hand you can change the scene without difficulty.' There was one drawback to the various roller systems, however: the constant furling and unfurling caused wear and tear to the canvas, and sitters could occasionally find themselves sitting in front of a crumpled backcloth (*figure 7*).

It seems, though, that customers were prepared to tolerate an imperfect illusion and to exercise a willing suspension of disbelief. What else could explain the fact that the line where backcloth met floor was often undisguised?

Sometimes a photographer was at pains to be consistent, as in *figure 61*, where a sandy-looking floor-cloth and papier mâché rocks allow a transition to the sea behind. (The use of seaside backdrops was not confined to holiday locations, as this Northampton example demonstrates.) Nonetheless, the sort of casual disregard for realism shown in *figure 17* was not unusual.

Once a background had been decided on, additional furnishing and properties had to be considered, in order to increase the elegance of the setting, the notional verisimilitude of the scene or the comfort of the client. Handbook writer N.G. Burgess reviewed some of the options seen as desirable in the early 1860s:

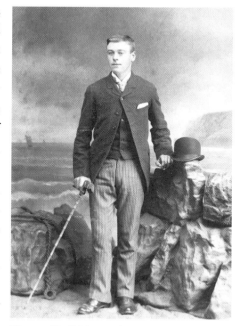

Figure 61: Cabinet print: W.H. Parkinson, Northampton.

Some have a pedestal, or a pillar or column represented, with the subject resting the hand gracefully upon the one or the other. A chair somewhat ornamented, or a portion of a sofa, may be introduced with good effect. A beautiful feature of these cartes de visite is the introduction of a balustrade, which must be painted of a dove colour. An urn made of wood, or plaster of Paris, coloured the requisite tint, adds much to the beauty of the picture. Any article of furniture which may be used in the drawing room would always be in good taste.

To this list might be added bookcases, desks, small tables, plinths and posing stands (for elegantly leaning on). In later years, fences, gates, stiles, hummocks, and rocks were added to the possibilities. Poorer studios might make use of two-dimensional painted bookcases, furniture or shrubbery (*figure 62*), but for upmarket practitioners only the genuine article would do. Pritchard noted that Bassano's studio, for example, was wholly without examples of the property-maker's art: 'Another point that struck us in the studio was the presence of nought but real furniture. The tables, chairs and bookcases were real, the piano was real, the Persian carpet was real.'

Whether genuine or not, the set-dressing items still needed to be deployed with judgement and taste, and some photographers filled their pictures as over-zealously as the Victorians often crammed their drawing rooms. The client 'wants a likeness', insisted American photographer Edward Estabrooke, 'and not a picture of tables, chairs, flower-pots, busts, etc., etc., *ad nauseam*.' He was writing in the early 1870s, but the problem he discusses was not new. As Dr Scott had complained in his 1865 address to the Exeter Graphic Society:

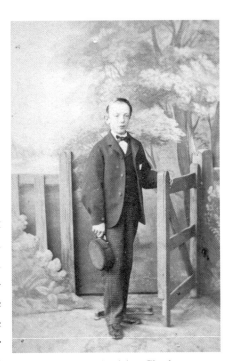

Figure 62: Carte de visite: Charles Hamilton, London.

It often becomes a question whether or not the artist intended to give portraits of balconies, columns and chair-legs, the sitter merely being an auxiliary ... The mistake appears to be that many persons think it possible to make a picture more pleasing and impressive by filling it with beautiful objects, but this is not the case.

Six years earlier still, Henry Peach Robinson had taken much the same line when writing for the *Journal of Photography*. Advising against 'the introduction of too many accessories', he enjoined photographers to 'let everything be subordinate to the head', and concluded, 'Nothing can be admired that has not something better to recommend it than a crowd of useless ornaments.'

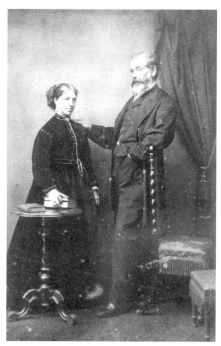

Figure 63: Carte de visite: M.F. Barrett, Lowestoft.

Despite such sound advice, sitters still sometimes found themselves surrounded by clutter. The background of *figure 63* is simple enough, and lacks the cornucopia of busts, ferns or table decorations that appear in some other pictures. Yet the woman seems hemmed in by the occasional table; the man is jostled rather than supported by the chair on which he is leaning; and a further chair or stool edges into the picture from the right, as if impatient for its own turn to be photographed.

Chairs were a versatile part of the studio's equipment. Subjects could sit on them, or stand beside them and steady themselves with a hand or elbow resting on a wooden or upholstered back. Though fitting naturally into interior scenes, chairs were so useful that they also turned up in simulated gardens and glades, regardless of probability (*figures 17 and 59*). Some of them were brought into the studio simply as attractive examples of their kind, but others had been designed specifically for photographic use.

Photographic suppliers offered posing chairs designed to give steadying support to the lower part of the back or made to be adjusted according to the height of the sitter (*figure 64*). On some models, the back rest could be turned horizontally though 180 degrees, to provide a convenient support for leaning on. Still others had a fitment to which a small headrest could be attached. Edmund Saul Dixon, a contributor to *Household Words*, encountered one when visiting the studio of two lady daguerreotypists in the early 1850s.

ANTHONY'S POSITION CHAIR.

"*It feels very much like going to have a tooth drawn," said I.*

"*You would have thought so, if you had been here the other day," replied the elder artiste. "An English lady became quite nervous when she sat down in the chair, and as soon as it was all over, she burst into tears, and threw herself into her husband's arms.*"

"*The chair does look formidable with that head-rest fixed to its back, and might be taken for a milder mode of garrotting criminals. I will venture, nevertheless. Will that do, ladies?" I asked, trying hard to assume a careless countenance and an easy attitude.*

ANTHONY'S SLIDING-BACK POSITION CHAIR

Figure 64: Illustration: E.M. Estabrooke.

The mention of headrests shifts the focus of attention from managing the customer's surroundings to managing the customer's own person.

Posing the Sitter

In an age when exposures were measured in seconds rather than in tiny fractions of a second, it was vital that the sitter should not move while the lens was uncovered and the sensitised photographic plate exposed to the light. Any small movement would result in a blur, and even a blink could produce an impression of curiously clouded eyes. The point was made emphatically by Dr Scott, when he read his paper to fellow Exeter scholars in 1865:

> *In taking photographs the first requisite of a successful picture is perfect stillness. Unless we have this we get a confused mass of meaningless shadow. But living objects have always great difficulty in remaining perfectly still for any length of time, and, indeed, before people were required to sit for their portraits they hardly knew what perfect stillness meant.*

Some sort of steadying apparatus for photographic subjects was clearly desirable, just as it had long been for those sitting for painted portraits. In particular, there was a need to keep the head very still. The devices used for this purpose were referred to as 'posing aids', 'headrests' and 'neck-clamps'. The third term, with its harsher overtones, was more often used by customers, who had experienced the uncomfortable effects of these devices, than by photographers.

The simplest kind of headrest was a free-standing, height-adjustable pole with a horseshoe-shaped prong, which would support the sitter's head from the back, like the Success and Centennial models shown in *figure 65*. More advanced models were designed to address posture at the small of the back or the shoulders, and it has to be acknowledged that the state-of-the art Spencer headrest (*figure 66*) appears to have been a fearsome beast. Clearly, some styles of rest were very cumbersome, and this prompted practical advice from Edward Estabrooke to fellow photographers: 'The purchaser can very soon make up his mind as to his choice, after attempting to drag a sample of each kind across the room.'

The rationale for using such aids, as set out in an 1866 issue of *The Photographic Journal*, was hard to argue with:

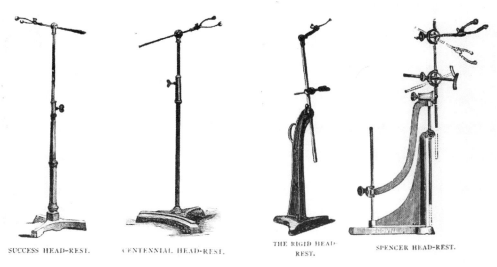

SUCCESS HEAD-REST. CENTENNIAL HEAD-REST. THE RIGID HEAD-REST. SPENCER HEAD-REST.

Figure 65: Illustration: E.M. Estabrooke. **Figure 66:** Illustration: E.M. Estabrooke.

Definition, then, being necessary to a perfect photograph, the question is how to obtain that quality … This can only be done by the aid of rests; for experience proves that it is impossible for the general run of sitters to remain perfectly still in a standing position for more than two or three seconds, or sitting for a very short time longer. Besides, the effort to be still has sometimes such an effect on the muscles of the face, that a haggard, anxious look takes the place of the amiable and cheerful expression usually most desirable.

Despite this, headrests aroused little enthusiasm in sitters, who submitted to them as a necessary evil. At best, they provided humorous writers, like Cuthbert Bede in 1855, with an opportunity for a little light satire:

I can call to mind how the Daguerreotyper fixed my head in a brazen vice, and having reduced me thereby to the verge of discomfort, maliciously told me to keep my eyes steadily fixed on a paper pinned against the wall and to think of something pleasant. I can well remember how the Daguerreotyper thereupon left me, and how I, feeling exceedingly uncomfortable, and being lamentably ignorant that the operation had commenced, released my head from the vice, and promenaded the room for some ten minutes, admiring the various designs in chimney pots which are usually to be studied with

advantage from a Daguerreotype studio. Then, hearing the sound of
returning footsteps, I mounted my platform, and resumed my seat and vice.

The spoilt result was the occasion for a show of impeccable politeness from
both parties:

I can call to mind my dismay when the Daguerreotyper took the plate out of
his camera, and his dismay, when, on development of the picture, he found
that it merely contained a representation of the chair-back and vice. But we
contained our real feelings under these speeches: – "We had not been quite
successful this time, sir! I must trouble you to sit again." – "Oh! certainly!"

Photographers were, of course, aware of the problem and sought out more
user-friendly designs. So when, in the mid-1860s, Oliver Sarony marketed
his improved headrest, it was given a warm welcome by both press and
practitioners. Under the headline 'Comfort for Photographic Sitters', the
North Wales Chronicle proclaimed the dawn of a new age:

Those who have sat for a photograph (and who has not?) cannot fail to
be annoyed with a contrivance yclept "head-rest" and to have noticed
how marvellously it was misnamed. There is, therefore, some pleasure
in announcing to those who fear this instrument, and who experience the
difficulty of sustaining a suitable pose for the requisite time, that the day of
their deliverance has arrived.

Having installed one of the new Sarony devices in his Ipswich studio, William
Cobb assured patrons that it supplied 'a want which has long been felt to
exist in the photographic profession'. Careful to call the appliance a 'Patent
Posing Apparatus' rather than a headrest, he announced the good news:
'Henceforth visitors to the above Studio need be under no apprehension
of being annoyed with that "horrid headrest" so often protested against,
and which, although hitherto indispensable, has in so many instances proved
fatal to success.'

Such details as Sarony's introduction of a rack and pinion mechanism
to replace a slide-bar and screw may have meant little to sitters. They were

probably more reassured by photographers who handled the equipment considerately, than by any improvements made to the rests themselves. In *A Popular Treatise on Photography* (1863) Désiré van Monckhoven advocated bringing the headrest into place only after the subject had assumed 'an easy, natural position', and advised that it should 'only lightly touch'. Nearly three decades later, and regardless of the advent of shorter exposures, Henry Peach Robinson was still making some use of the headrest. He believed that 'it is not the instrument that is at fault, but clumsy users of it', and he warned against heavy-handed use:

> *The rest should be a comfort instead of a nuisance. It should be adjusted to the head, and not the head to the rest ... The rest should be understood to be, and used as, a delicate support to the head and figure, not a rigid fixture against which the figure is to lean. As used in most studios, it is a great deal too heavy.*

Headrests were not recommended for all sitters. Estabrooke considered them 'indispensable except in the case of children', for whom they might be unnerving. More unusual was an unidentified London photographer who, according to an 1877 report in *The British Journal of Photography*, dispensed with the use of a headrest when making a portrait of a Baptist minister. 'We never fix the heads of teetotallers,' he assured his sitter. 'Our experience is that moderate drinkers need their heads fixed, but that the heads of total abstainers are always sufficiently steady without any support.'

Decreasing exposure times meant that headrests were less often employed from the 1870s onward. But, as the evidence of Robinson shows, use was still made of them by some photographers as late as the 1890s. Others, however, gave up such aids as soon as possible, and as early as 1864 Caesar Ferranti of Liverpool was promising 'the use of head-rest or screws absolutely dispensed with'.

While they were still in vogue, concealment of the stands was something of a problem. Women presented no difficulty, since their voluminous skirts were sufficient to hide even broad-based pieces of equipment, but men were less conveniently dressed. The upright stem of a posing stand was slim enough to be kept out of the picture, but the base was less obliging. One

common ruse was to pull across the bottom of a heavy studio drape and arrange it behind the subject's feet to cover the offending item. Sometimes no such contrivance was attempted, and the base was freely shown, yet not usually to the extent revealed in *figure 67*. Here, not only can part of the base be glimpsed, but also, just behind the customer's neck, a part of the head support is visible.

Of course, there was more to managing a subject than simply applying a headrest. Even at the end of the Victorian period, in 1899, when delays had been much reduced, posing the sitter was still acknowledged to require special skill. William Crooke, in a paper read to the Edinburgh Photographic Society, pointed out the unique challenges of portraiture:

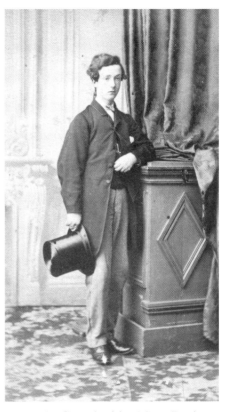

Figure 67: Carte de visite: Mayer Brothers, London.

Take any other object as a subject for the camera, and with sufficient technical knowledge the obstacles are by no means insurmountable; but what else in creation can compare with the human countenance for mutability and variety of change? Health, temper, frame of mind, or dress are but a few of the contending difficulties which meet the professional photographer.

A few months later, writing for the same magazine, photographer Frank Meadow Sutcliffe made his own assessment of the portrait artist's problems:

His proper work! What is that? Making pictures of his sitters. Of people he has never seen in his life before, and whom he will never see again. In fifteen minutes he and his sitter have to become acquainted; he must make his sitter

feel at home, no matter what his or her age may be, no matter whether he or she is all flesh or all nerves.

However much photographers talked of putting subjects at their ease, there was always the accusation that photography was more concerned with the stilted and artificial than with comfort or naturalness. The caption of a *Punch* cartoon summed up a popular perception:

Sitter. *"Oh, I think this position will do, it's natural and easy."*
Photographer. *"Ah, that may do in ordinary life, ma'am; but in photography it's out of the question entirely!"*

The simple truth was that some photographers were better at posing their subjects than others, but if, especially in the earlier days of photography, some portraits lacked a sense of everyday realism, it is hardly surprising. Clients, as already discussed, did not necessarily want portraits that captured a relaxed informality, nor was the market demand for stereotypes the only influence at work.

The limitations of early lenses had also to be taken into account, as Henry Morley and W.H. Wills explained to readers of *Household Words* in 1853:

In the present state of photographic art, no miniature can be utterly free from distortion; but distortion can be modified and corrected by the skilful pose of the sitter, and by the management of the artist. The lens of the camera being convex … the most prominent parts of the figure to be transferred – those parts, indeed, nearest to the apex of the lens – will appear disproportionately large.

The solution was to manoeuvre the parts of the body so that all were equidistant from the camera (and, incidentally, equally in focus):

The clever artist, therefore, so disposes his sitter, that hands, nose, lips, &c., shall all be as nearly as possible on the same plane in apposition to the lens. In a sitting figure hands placed on the knees would seem prodigious – placed on or near the hips, no more prominent than the tip of the nose, they would seem of natural size.

Henry Peach Robinson, writing for the *Photographic Journal* in 1858, was scornful of the kind of composition that this concern with planes produced:

> *A person unacquainted with photography … would suppose there was only one position in which a sitter could be placed, namely, the one elbow on a little round table, with the hand twisted as near the body as possible, the other placed on the knee with the elbow stuck stiffly out at an angle, the legs crossed and turned flat to the camera to satisfy the exigences of focus, the face quite full, and the eyes staring fixedly into the lens.*

Quite apart from the general theory of posing in plane, the photographer had much to think about; and the customer can rarely, if ever, have had individual limbs and features so closely scrutinised and directed. Legs might be arranged on the principle advocated by Marcus Aurelius Root in 1864: 'If portraying a gentleman cross-legged, avoid all long, straight lines or right angles and do not throw the limb nearest the camera over the other, but *vice versa*.'

Customers were especially uncertain of what to do with their hands, as the *Dundee Courier* pointed out in 1881: 'To hold a fan is stilted; to rest them in the lap is awkward, for the loveliest hands in the world look large in a photograph; and to fold them gives a white patch in the picture not at all artistic.' But problems were there to be overcome and Root, for one, had a number of suggestions:

> *One hand or arm may be laid upon a table, while the other hand may hold a book or some other object, if the sitter so choose … A thick hand should show the thumb in the foreground, with the fingers bent a little inward; while a long hand had best exhibit its back. A handsomely shaped hand, neither too long nor too short, should display full two-thirds of itself, with the fingers hanging easily and gracefully down.*

Occupying the hands by giving them something to do or to hold was commonly attempted, often with satisfying results (*figure 59*). *Figure 68*, however, is a much less happy example. The attempted confident pose of the subject's hand in his pocket combines with the curious grasp of his hat

to suggest he is about to throw the headgear across the studio or launch into a music hall song.

When it came to head, neck and face, there was even more to exercise the photographer's attention. Few professionals wanted the camera to tell outright lies, but many – probably most – were keen to disguise what they saw as imperfections in their sitters. This took some tact, and the subject occasionally saw through the ploy, as New York photographer Matthew Brady found, when Abraham Lincoln sat for him. 'I had great trouble in making a natural picture,' Brady recalled. 'When I got him before the camera I asked if I might arrange his collar, and with that he began to pull it up. "Ah," said Lincoln, "I see

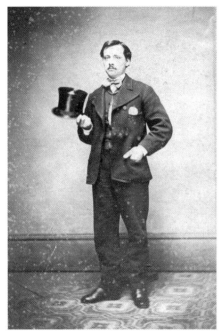

Figure 68: Carte de visite: Professor Muhlenbeck, Indianapolis.

you want to shorten my neck." "That's just it," I answered, and we both laughed.'

The impact made by facial shape and the size of features could be softened by choosing the best angle, and Root reminded his readers of the possibilities:

The portrait of a full, round face, with small eyes and nose and large mouth, should be taken in nearly half profile, so as to show one side of the face in full, with very little of the other side. A face of moderate fullness, with aquiline nose and handsome eyes and mouth, should be taken in three-fourths profile; while one having strongly pronounced features, should be presented nearly full in front view.

For William Crooke, writing thirty-five years later for *Anthony's Photographic Bulletin*, the concerns were still the same, though the language was somewhat

blunter: 'The ugliness of a face may be decidedly modified by choosing either full, three-quarter or side view, and the calling into requisition of the charm of light and the mystery of shadow, remembering that the naked truth is deceitful.'

In accepting the photographer's posing suggestions, few clients would register that they were being tacitly rated for ugliness. Most, presumably, would have lacked – or been spared – the wry self-awareness of Abraham Lincoln. They were probably more focused on responding to the photographer's direction than on questioning the reasons behind it. Some of them may have found that direction rather intrusive, since, in deciding how to achieve a desired pose, photographers had to decide whether or not it was acceptable to touch the sitter. Robinson thought physical contact should be avoided as much as possible: 'The less the operator handles his sitter, the better. It worries him, and oftener tends, except in very skilled hands, to stiffen the figure rather than add to its grace.'

Estabrooke took a similarly stern line and gave very practical reasons for it:

When making a position, the artist should avoid touching the clothes or person of the subject as much as possible … His fingers leave a stain wherever they touch, no matter how clean they look; besides, the hands are almost always wet or damp. To take, then, the head of a lady between the palms of the hands, as I have seen done, is an outrage.

Some photographers, however, were less particular. Affecting surprise that 'not a few subjects pettishly object to the slightest handling or interference by the artist with their drapery or hair', Root conceded that it was best to ask permission first. That given, he was prepared to countenance quite vigorous intervention:

If the party consents, the operant should loosen the cravat and spring away the collar, so as to give the utmost freedom to the neck and head. He should, moreover, adjust the coat, and draw the vest together, or else so raise it that it may partially cover the shirt-bosom … A lady's costume should receive special attention, in order to give it an appearance of amplitude and of falling from the figure in many graceful folds.

Camille Silvy, the darling of society clients in the 1860s, made handling his subjects a part of the theatre of the occasion. According to fellow-photographer Félix Nadar, he made great play of removing his snow-white gloves as the customer entered the studio, then tossed them casually into a waste-basket and slipped on an immaculate new pair in preparation for the task ahead.

Yet sitters were not always wholly biddable, and photographers could not rely on having things entirely their own way. Robinson complained bitterly about customers who thought they knew best:

A sitter will sometimes want to be taken naturally. His idea of being natural – "Just as I am, you know" – is to sprawl over the furniture. Perhaps he will put his hands in his pockets, sink low in the chair, and expect you to make a good head and shoulders of him. This is an awkward customer to manage. Possibly the best plan is to recommend him to go to the worst photographer he can find – one of those who advertise themselves loudly as "artists", without knowing the meaning of the word (there are plenty of them in every town), or to the peripatetic on the sands or common, who will let him have his own way entirely, so that he pays his sixpence in advance.

Some customers were quietly frustrated, like the anonymous woman writing for the *Derby Daily Telegraph* in 1890, who grumbled at 'the utterly inartistic way in which the majority of photographers pose their sitters':

I have frequently endeavoured to arrange my own drapery when sitting in the front of a camera, and have felt uncomfortable from the consciousness that the frill around my neck was out of place, or the skirt of my dress twisted, and perhaps showing too much of an obtruding foot.

Other clients, not content with mild remonstrance and a little corrective fidgeting, insisted firmly that their own ideas should prevail. The results, as the *Sheffield Daily Telegraph* noted in 1883, could be unfortunate:

You are constantly coming across the most extraordinary poses, the most astonishing expressions of countenance, the most melancholy groupings. It

is not the fault of the photographers; the sitters will have it so, and object to artistic arrangements … One young lady, in the resolution to look uncommonly pleasing comes out as though she had just been about to sneeze when her likeness was taken. An elderly lady of large proportions, quite ignorant of the law of photographic perspective, insists on sitting "so," and is represented like an elephant in a gown. People with turn-up noses, with very long noses, with no nose to speak of, delight in sitting en profile. On the other hand, people decorated with four or five chins, and a corresponding amplitude of cheek, love to present their full faces. A short man insists on being taken standing. A tall man will cross his legs, desiring to appear in an easy attitude, and by projecting his boot into the sphere of the lens is depicted as the possessor of a foot that should make his fortune in a travelling booth.

Faced with intransigent customers, photographers had to exercise such tact and persuasiveness as they could muster, and perhaps as a result they were all the more appreciative of compliant subjects. Robinson judged one frequent sitter as 'one of the best models I ever had' on the simple basis that she 'had the rare merit of never making the slightest suggestion.'

At times, clients brought companions with them to the studio, and while Robinson recognised that friends could give moral support, experience taught him that they often made 'ridiculous suggestions'.

There are some people who are quite irrepressible. They promise not to interfere, and mean to keep their promise, but for all that jump up just as the cap is about to be removed from the lens to alter a bit of drapery or set a lock of hair straight, or to make a brilliant suggestion, such as that the pose of the hands might be improved – when you are taking the head only!

Unsolicited assistance in the studio was particularly likely when children were being photographed. Robinson cast a weary eye over the range of likely attendants and their possible helpfulness to the photographer:

It is quite impossible to get on if children are accompanied by a troop of friends, especially lively grandfathers and grandmothers. A father may sometimes be admitted if he be of an exceptional sort, but even in his case

it is better to keep him in reserve for use if the usual means fail. Nine out of ten mothers are useful, but the tenth should be kept out of the studio. A nurse who knows her business is the best help you can have. Even she will sometimes want a standing portrait of a ten-month old baby, but it is easier to tell the nurse she is an idiot than the mother.

Unsurprisingly, parents sometimes felt their presence was resented. A 'Lady Amateur', writing for *The Photographic Journal* in 1872, felt that matters were only just beginning to improve. A few years earlier, she recalled, 'when the unfortunate mother, heading perhaps a small procession of, say, grandmamma, one or two aunts, a nursemaid, and "the baby," ventured into a photographic studio, she was not received very graciously.' This she attributed to the conviction of photographers that babies were impossible subjects. She was, no doubt, partly right in this belief, but she seemed unaware that the 'small procession' was, in itself, enough to cause considerable trepidation.

She did, however, acknowledge that young children were not the easiest of subjects:

It is hard work engaging their attention, particularly if mamma has been telling them beforehand that they are going to have their portraits taken, and must be quite still and good, sometimes even instructing them at home, and rehearsing the performance of sitting for a portrait beforehand.

Certainly, the patience of photographers was often sorely tried. James Pain, writing in *Household Words* in 1857, referred feelingly to spoilt children screaming in terror when faced with the camera, 'because they consider it to be a deadly weapon provided for their special destruction, which I have sometimes devoutly wished it was.'

The problems of photographing children were soon well enough known to become the subject of jokes. In 1864 *Punch* suggested administering a quick whiff of chloroform as an aid to posing. It then went on to suggest that, since all babies looked alike, photographers need only achieve one successful sitting, the result of which they could then reprint every time another baby was brought to the studio. This idea, fuelled perhaps by sharp

practice in some photographic dens, became an abiding myth. Even 30 years later, Robinson referred to the notion that photographers, 'as it is libellously said', were in the habit of making 'the negative of one of the species satisfy the yearnings of many mothers'.

The preliminaries had perhaps been protracted, but, whether the subject was young or old, accompanied or alone. a satisfactory pose would eventually be settled on, and the moment for taking the picture would at last arrive. It could, however, prove to be a rather long moment.

Exposure

It is widely understood that long exposures were necessary in early photography, but the time needed for the sensitised plate to react to the light was only one element in the picture-taking process. Even at the end of the Victorian period, when plates were bought pre-coated and ready for use, and when cameras themselves had benefited from 60 years of technical improvement, the business of focusing and plate-management added to the time the subject had to hold a pose.

Even in 1899, Frank Sutcliffe of Whitby was very conscious of the critical point when eyes glazed over and expressions became rigid:

Every portrait photographer knows too well that in the space of time that elapses between the removal of the focusing-glass and the squeezing of the ball of the pneumatic shutter, while the focusing-screen is bent or pushed aside and the dark slide put into its place, the tap of the shutter turned off and the front of the slide drawn, the sitter is rapidly freezing, and will require bringing to life again before the exposure can be made.

In earlier years, photographers had worked with clumsier mechanisms and, until the late 1870s, most had coated their own glass plates with sticky chemicals that were effective only while wet. Plates had to be prepared immediately prior to exposure and then processed quickly before they dried. Many operators had assistants to do the coating while they arranged the pose, but not all were so fortunate.

For photographers in general, and for one-man operators in particular, the actual taking of a picture was a period of intense activity. Once the pose had been arranged, the photographer ducked under a light-excluding black cloth at the back of the camera and viewed the scene on a focusing screen. The lens was, at this stage still uncovered or open, and the image, having passed through it, appeared upside down on the screen. It was now the photographer's task to make the adjustments that would bring the picture into focus.

Once this had been done, the lens was covered by a cap or closed off by a shutter, and the screen was slid out of the camera, to be replaced by a dark slide. This dark slide was a flat case into which the newly-sensitised plate had been slipped while still in the dark room. It was vital to keep light from the plate's surface until the moment of exposure, but once the dark slide was in place inside the camera, its front panel could safely be removed. The coated glass was thus in a position where focus was sharp and where light would hit it once the lens cap was removed or the shutter opened. Only now could light be allowed to pass through the lens and onto the photographic plate. Then, when the appropriate number of seconds had been counted off, the light was again cut off, the dark slide's cover was replaced, and the exposed plate was carried in its protective case back to the dark room for processing. There was much, therefore, to keep the photographer busy. But for the sitter, there was nothing to do but hold the pose while the ordeal continued.

It is not possible to be too precise about exposure times. They became shorter as the years passed, but they could also vary within any one day, according to the time, weather and lighting conditions. The very earliest daguerreotypes were of scenes rather than people and needed exposures of up to twenty-five minutes. For some years a myth took hold that exposures of this duration were also needed for portraiture.

A report on the Great Exhibition of 1851, looking back on the beginnings of photography, claimed wrongly that subjects used to 'sit without moving for twenty-five minutes in the glaring sunlight'. Humorist Cuthbert Bede scoffed at the notion:

We have not the pleasure of an intimacy with any one who ever performed this daring feat of salamanderism; but if the case was such as is represented, we

are surprised that this twenty-five minutes' sitting was not made profitable to the Daguerreotypist by placing eggs beneath the sitter, and converting him into an Eccaleobion, or patent hatching machine.

In fact any thoughts of human portraiture were at first out of the question. But soon after Daguerre made his method public, in 1839, Samuel Morse made his own attempts to photograph his wife, his daughter and some of his daughter's friends. These pictures were taken out of doors, on the roof of a building, in the full sun-light, and an exposure of more than ten minutes was necessary. This was still a long way short of routinely endurable.

By 1841, however, the daguerreotype method had been sufficiently improved for portraiture to become a commercial proposition, and the *Hereford Times* reported that exposures of a mere six seconds had been achieved in Richard Beard's Regent Street studio. This was far short of the norm, however, as the paper went on to acknowledge: 'During cloudy dull weather the operation may require from a minute and a half to two minutes.'

Realistically, even on a good day in the early 1840s, exposures of between fifteen seconds and a minute were probably to be expected. In the years that followed, exposures were further reduced, but subjects were still required to remain absolutely still for an uncomfortably long time. In 1852, writing for *The Photographic Journal*, T.L. Mansell referred to fifteen seconds as 'the usual exposure', while in 1872, the same magazine suggested five or six seconds as the absolute minimum time likely to be needed.

From the late 1870s onward, as photographers began to use the new pre-treated plates, they often reported shorter exposure times. William Grove (of Baker Street's Window and Grove) told Henry Baden Pritchard on a dull February day in 1880 that, with the new dry plates, 'cartes have required an exposure of from eight to ten seconds'. This represented a worthwhile time reduction in the winter months, but, Grove insisted, 'I shall get back to wet collodion when I can.' Other photographers espoused the new plates more enthusiastically, and Silvester Parry of Chester was able to assure clients in 1878 that children could be photographed 'in the short space of a second in the summer months'.

Many customers must have been attracted by the advertisements for 'Instantaneous Photography' that became common over the last two decades

of the century. 'Instantaneous' was, in the world of Victorian photography, a relative term, as when applied to pictures from pre-coated plates, it meant 'only a few seconds'. As artificial lighting methods became available, the word was once again called into service, and magnesium, gas and electricity were all in turn welcomed as accelerators of the photographic process.

But Victorian photographers would have to await the advent of electricity, which would prove to be the only thing that combined safety, reliability and versatility. Henry van der Weyde was so committed to his all-electric studio in London's Regent Street that, as Pritchard found in 1880, he excluded daylight entirely: 'There is not even a sky-light, lest the suspicion should gain ground that sometimes daylight is employed for photographic purposes.'

Certainly, for a variety of technical reasons, much shorter exposures were often being managed by the end of the 1880s, and the anonymous writer of a *Beginner's Guide to Photography* found it convenient to define 'instantaneous' in terms of lens management. 'For instantaneous work,' the author explained, 'the hand is not quick enough to uncap and recap the lens. A piece of apparatus called the instantaneous shutter, is therefore employed to do this work automatically.' Photographic writer Walter E. Woodbury pointed out just how much more accurately the word was being used by the mid-1890s:

In the very earliest days of photography this term was applied to what would now be considered very slow work indeed. We now usually apply this term when the exposure does not exceed one second. In some cases this only amounts to the one-thousandth part of a second.

It should not, however, be assumed that most portraits were made with such brief exposures at the end of the century. At the beginning of the 1890s Henry Peach Robinson referred to 'the few seconds' exposure that is … now necessary', and, in high-street studios, those few seconds were more usual than the millisecond referred to by Woodbury.

There were also occasional factors that could prolong exposures rather than shorten them. In the 1850s and 1860s there was a widespread belief that wind direction could affect exposure times. South and west winds were thought particularly favourable to photography, although the opening lines of an anonymous verse warned:

Whene'er the wind is in the East,
Use twice the seconds at the least.

Operator error, too, could lead to a more drawn-out experience for the subject. In 1876 the *Manchester Evening News* reported the case of a young photographer who tried to ingratiate himself with his future mother-in-law by taking her portrait. Though nervous, 'he got her fixed finally, with her eyes fixed glassily on a certain object, as is the custom. Then he drew the cloth, took out his watch, and counted off thirty seconds, restored the cloth, and drew out the case.' Unfortunately, he had forgotten to put a plate in the dark slide.

The old lady had to sit again, and she prepared for the ordeal, but with confidence in the operator considerably abated. He was more nervous than before, and it was some minutes before he had her arranged to suit the focus. Then the cloth was again removed, the watch again pulled out. He counted off the thirty seconds, removed the cloth, and drew out the case.

This time he had forgotten to draw back the cover of the dark slide. His prospective mother-in-law 'sprang to her feet, snatched up her hat and shawl, and pausing long enough to inquire whether he was drunk, shot out of the door.'

Few sitters can have been quite so unlucky, but whatever the exposure time (and even a second is long by modern standards), it was always imperative that the sitter should remain stock-still for its duration.

The problem of keeping still was at its most acute when young children were being photographed, and photographers did the best they

Figure 69: Carte de visite: Joseph Simpson, Tunstall.

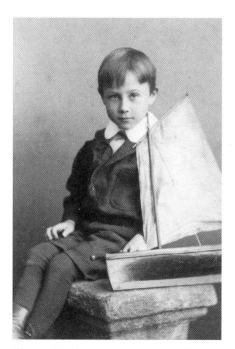

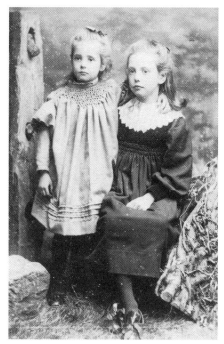

Figure 70: Carte de visite: W. & A.H. Fry, Brighton.

Figure 71: Cabinet print: J. Lowndes, Cheadle.

could to ease the situation. In the case of babies, an attendant relation could be used to hold and steady the subject (*figure 69*). With older children, who could support themselves, the main challenge was to engage their attention. Toys were often used (*figure 70*), either provided by the photographer for a child's perusal, or brought to the studio to be displayed by the proud owner.

Alternatively, some distraction could be provided to engross the sitter's interest at the crucial moment. Brightly-coloured objects, real or mechanical animals (including singing birds), musical toys and glove puppets all served their turn. In *figure 71* the attention of two young girls has been caught by some out-of-frame novelty, and they are quite still, rather solemn and definitely absorbed.

It was not only children who chafed at the enforced immobility required by the photographer. Whoever the sitter, the words 'Keep quite still' had, in Robinson's view, 'spoilt many a photograph'. It was all very well for Cuthbert Bede to insist, 'You must be a model of stiff propriety and rigid

deportment' when enduring the gaze of the camera. For the subject, the exposure (however short it was in reality) seemed to take an interminable time. As a writer for the *Photographic News* complained in 1874, before long 'you feel as if there was but very little left in this world to live for.'

To make matters worse, in the early days at least, it was sometimes necessary to maintain stillness in the face of disconcerting intervention from the photographer. Since dark clothing needed longer exposure, it was often found useful to temporarily cover up areas of white fabric. Root explained his method of achieving differentiated exposure in the 1860s:

> *A lady's white dress, or collar, or cape may be beautifully represented by covering the part exposed in strongest light with a black veil, or piece of dark muslin, and cautiously withdrawing it at the expiration of one-third or one-half the time of exposure required for bringing the figure fully out; and this, without disturbing the sitter or stirring the dress.*

Root's use of 'cautiously' made this sound a delicate operation, but the possible effect on the subject was suggested more vividly by journalist Edmund Dixon, when he described his visit to a French daguerreotype studio in 1852:

> *"And now," continued the operator, producing a piece of black silk, "look at this, and don't be afraid. It must cover your shirt bosom for a while; then I shall come and snatch it away; but you must not budge an inch. Some Englishmen spoil their portraits, by jumping up when I have to do this."*

On occasion, extreme measures were suggested for keeping customers still, though some were proffered with tongue-in-cheek. The proposed use of chloroform has already been mentioned, and laudanum was also recommended. Perhaps the most startling ploy, almost certainly apocryphal, was supposedly practised by an American photographer who produced a revolver at the key moment, and threatened, "Dare to move a muscle and I'll blow your brains out!" Though, in fact, customers were rarely if ever threatened with violence, they still experienced some difficulty in maintaining an agreeable expression.

Aware that posing was 'apt to produce a dull, meaningless look, from the fact that the sitter must be *perfectly immovable* during the action of the camera', Root called on practitioners to provide an antidote:

The operant ... should tax all his intellectual resources, both before and during the session, to summon into activity in his sitter those elements which shall stamp on the face the distinguishing soul. Conversation is the principal form in which those resources are employed, though much is done by the magnetism of his manners and presence.

This ability to beguile the sitter for the duration of a rigid pose with conversation, animation and charm was clearly the forte of Manchester's Augustus Lafosse, as Henry Baden Pritchard discovered:

Our kindly host insists on taking a portrait, so we sit down. When the picture is taken, however, we scarcely know, for there is such a humorous rattle the whole time, and all sorts of conjuring going on with a fan, and anecdotes about past sitters and present ones, that by the time we begin to compose ourselves, he says it is all over.

This sitting, however, took place in 1880, when a relatively short exposure might just capture a briefly relaxed expression. In earlier years, composing the features might need rather more planning. Root sometimes offered a mirror to help subjects compose their features. They might then 'with some effort, discern in that reflected face the expression wished for, and may endeavour to retain it unaltered for the few seconds required for its being arrested.'

It was also realised that speech animated the face, and, immediately before exposure, sitters were sometimes invited to pronounce words chosen for their expressive afterglow. In 1877 the *South London Chronicle* listed one photographer's selection of examples:

When a lady sitting for a picture would compose her mouth to a bland and serene character, she should ... say 'Bosom,' and keep the expression into which the mouth subsides until the desired effect in the camera is evident. If,

on the other hand, she wishes to assume a distinguished and noble bearing, not suggestive of sweetness, she should say, 'Brush,' the result of which is infallible. If she wishes to make her mouth look small, she should say 'Flip' but if the mouth be already too small and needs enlarging, she must say 'Cabbage.' If she wishes to look mournful, she must say 'Kerchunk'; if resigned, she must forcibly ejaculate 'S'cat.'

Though some words were certainly used in this way – rather as 'cheese' has been favoured in more recent times – it is tempting to suspect that, in this particular instance, the photographer was improving the corroborative detail. But 'Our Own Lady Contributor' assured readers of the *Dundee Evening Telegraph* in 1901 that 'bosom', brush' and 'flip' were still proving their worth. She also added 'prunes and prisms' to the list as a phrase 'infallible for curving mouths prettily'.

Eventually, whether or not firearms had been drawn, mirrors used or 'cabbage' intoned, the exposure ended. The lens was covered again, and the ordeal was over – except, of course, for those occasions when some kind of mishap necessitated a further attempt, or when, as was often the practice with cartes de visite, a second pose was to be arranged. Then the ordeal had to be endured all over again.

Chapter Four

The Finished Product:
The Customer Receives the Portrait

The plate had been exposed to light and the picture taken, but that did not necessarily mean that the customer would be able to take a photograph home with them. Though corners were often cut at the cheapest end of the market, for most photographers there was still much time-consuming work to be done.

One-off images on glass or metal could quite quickly be made ready for a waiting customer, but processes producing paper prints from negatives involved more stages of treatment; and then there were such finishing touches as trimming, retouching, colouring, mounting, framing or casing to be considered.

Photographers sometimes made a selling point of their ability to complete orders quickly, recognising the customer's natural impatience to see the results of a sitting. In 1857, E.D. Rogers of Norwich advertised portraits that could 'be taken, finished and delivered in a quarter of an hour'. For most clients, however, gratification was likely to be deferred, and they (or their servants) would return to the studio after an agreed interval. Sometimes that interval was extended, as on the occasion in 1860 (referred to in an earlier chapter) when another Norwich photographer, John Sawyer, felt obliged to make a public apology for lagging behind with his orders.

Eventually, though, the customer did have a finished product to admire, and the characteristics of that product varied as processes and presentation changed over the years.

A Picture in the Hand

The earliest sitters usually received a very attractive portrait, despite photography being in its infancy. During the 1840s the daguerreotype

(*figures 3 and 72*) was the only commercially viable kind of photograph, since the one alternative process was subject to prohibitive patent restrictions. The method devised by Louis Jacques Daguerre produced remarkably clear and precisely defined results.

As a skilled scene painter for his diorama exhibits in Paris and London, Daguerre was already in the business of devising accurate representation and realistic effects. His photographic process went a magical stage further, using light to create its own perfect picture without the intermediary of the painter's brush.

The image was formed on a sheet of copper that had been coated with a thin layer of silver, polished and treated with light-sensitive chemicals. The resulting surface was mirror-like, and the image it bore was pin-sharp. The daguerreotype was easily scratched, even by dust, but this problem was solved by glazing the picture and setting it in a case, which added to its consequence rather than detracted from its impact. In 1857 photographic writer Thomas Sutton admitted that the daguerreotype remained unmatched for quality of image: 'In point of microscopic definition and exquisite gradation of shade, there is no process which, in my opinion, can be compared with that of Daguerre, and for scientific purposes no other should be employed.'

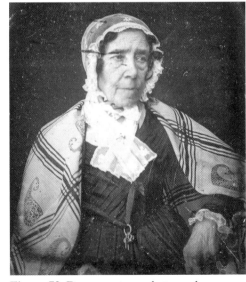

Wondrous though it was for early photographers, the daguerreotype format had limitations when used for portraits. It was a one-off image, so copies could not be made (except by re-photographing the artefact). The picture was actually a negative, with the dark areas appearing pale and *vice versa*; in fact, it only showed as a positive image when turned at just the right angle to catch the light. The subject captured was also reversed, a mirror-image, though this effect was unlikely to trouble the sitters, who habitually saw themselves in this way.

Figure 72: Daguerreotype: photographer unknown.

The daguerreotype's highly reflective surface could be distracting too, as art critic Clarence Cook remarked in 1881, when looking back to its heyday. He recalled with affection the 'silvery, refined pictures' with the 'delicacy and transparency of the shadows' and the 'exquisite refinement of the lines'. But the extremely shiny surface – described by Sutton as 'the shimmer of the plate' – was a little disconcerting, as in the wrong light it 'made itself a mirror, and you saw yourself when you wanted to see your friend.'

In the early 1850s an alternative process, the wet collodion method, became available and transformed the market. The process, as described in the last chapter, was laboured and messy, but crucially it was cheaper. Additionally, it gave photographers the opportunity to make and sell duplicates of an image; though not until the 1860s did this notion become irresistible to the customer.

The forerunner of collodion photography was not Daguerre's process; it was a method developed independently and contemporaneously by William Henry Fox Talbot, an English scholar and gentleman whose labours to capture an image been partly motivated by frustration at his own shortcomings as an artist. His calotype process formed a negative image on sensitised paper rather than metal. Since paper – particularly waxed paper – is translucent, Talbot found that it was possible to place the negative over a second sensitised sheet, expose that to light, and produce a new and positive version of the image. The translucent negative could then be used to make further copies, though the texture of its paper did reduce the sharpness of the finished picture.

Talbot fiercely protected his own process, but his negative/positive concept was pursued by Frederick Scott Archer, whose new method was (with quixotic generosity) made freely available in 1851. Archer's process took its name from collodion, the substance used to bind his chemicals to the glass that he used for a photographic plate. The resulting negative produced much sharper and faster results than waxed paper, so good additional copies could be made. Better still, the photographer had to buy no licence for the process. Unsurprisingly, the daguerreotype quickly lost its market dominance.

The customer of the 1850s, therefore, was increasingly likely to purchase a collodion photographic portrait, which could be printed out on paper, mounted and framed. Nevertheless, another possibility also found especial

favour with the public. This method sacrificed the opportunity to make copies, but, like the much-admired and socially distinguished daguerreotype, it offered a sharp and glossy image, enhanced by an attractive frame or case. It was referred to as a glass positive, a collodion positive or an ambrotype (*figure 73*).

The ambrotype was made from the glass negative, which was treated to give a positive effect: often bleached to make the dark areas paler, and coated with a black backing that would show through the transparent areas of the glass. As Thomas Sutton explained, the outcome was a sharp, clear picture, though the highlights often lacked brightness:

Figure 73: Ambrotype: William Boswell, Norwich.

A good glass Positive is much bolder in effect than a Daguerreotype, and is free from the objection of metallic shimmer. When the whites are good, the picture free from fog, and the half-tones brought out, a glass positive becomes a highly artistic production, and is entitled to rank with any other kind of photograph in this respect.

Moreover, he continued, the ambrotype was relatively cheap to make, which had 'the good effect of placing a photographic portrait within the reach of the humbler classes'. This expansion of the market had Sutton's unreserved approval:

Who would not wish the poor man to participate in that great domestic luxury – a photographic portrait of those near and dear to him? Photography, as applied to portraiture, is one of the greatest blessings of the age in which we live, and a real social good.

To be fair, photographs still seemed expensive to many people, but the adoption of the collodion process certainly allowed more of them to sit for a portrait. Its (often careless) use by itinerants and in photographic dens extended its reach even further down the social scale. These cheaper items were frequently of poor quality, however, and their image was often inadequately fixed.

Both daguerreotype and ambrotype needed protecting, for the delicate silvered surface of the one and the glass of the other were both vulnerable. Whilst the portraits varied in their dimensions, most were more or less pocket-sized and could therefore be conveniently housed in small cases. The image was usually framed by a brass matt or border (*figures 3 and 73*), placed under glass, and set in a frame with a hinged and padded lid.

The earlier daguerreotype cases were simple wooden constructions covered with leather or paper, but more ambitious designs soon became common. Moulded papier-mâché could give a more luxurious finish (*figure 74*) and, in the early 1850s, union cases were introduced. A union case needed no wooden skeleton, for the entire item

Figure 74: Daguerreotype case.

Figure 75: Union case for four ambrotypes.

was moulded in shellac-based thermoplastic material which allowed both a strong, rigid body and sumptuous surface decoration (*figure 75*).

Cases were a necessary addition, but there was also the optional extra of colouring for the customer to consider. Colour photography was not available to the Victorians, but throughout the period it was possible to pay an additional sum to have a portrait hand-tinted. As early as 1842 the *Morning Post* praised the colouring of daguerreotypes in Richard Beard's London studio: 'Of a coloured portrait we have also before us a favourable specimen. The blue of the coat, the varying shades of the black of the stock, and the flesh tints of the cheek and features, are distinctly apparent.'

Less fortunate customers were presented with crudely embellished images, but many had their portraits much improved by the light touch of a skilled colourist. In 1853 *Household Words* took its readers behind the scenes of a daguerreotype studio and into a colouring room, 'a tiny closet in which two damsels were busily at work'.

We pointed to a small box labelled "Sky," remarking that the fair painters were magicians, to carry the sky in a wafer-box. To which one of them promptly answered "Yes; and Ogres, too, for that pill-box contains gentlemen's and ladies' "Flesh." These terrific creatures – who had quite the ways of damsels able to eat rice pudding in an honest manner – then made us acquainted with a few dry facts. The colours used by them were all dry minerals, and were laid on with the fine point of a dry brush; pointed between the lips, and left to become dry before using. A little rubbing caused these tints to adhere to the minute pores upon the plate.

The possibility of added colour was first offered in the days of the daguerreotype, continued through the heyday of the ambrotype, and remained available in later decades, when paper had supplanted metal and glass as the favoured material for photographic images.

With the introduction of the collodion method, paper prints became a possibility, and large sizes were available. In 1859 Valentine Blanchard of Wisbech advertised – at three times the price of his basic ambrotypes – 'Large Photographs on Paper, 7s 6d'. In 1870 Robert Slingsby of Lincoln was praised by the *Lincolnshire Chronicle* for his portraits 'of large size and

perfect finish, admirably adapted for a wall picture'. But it was to be the much smaller paper pictures that really caught the customer's imagination, and cartes de visite were to become the most desirable photographic format of the 1860s and beyond.

Portraits for All – the Carte de Visite

The enormous customer appeal of the carte de visite (*figure 76*) has already been mentioned. In 1861, a leading article in *The Photographic Journal* noted the format's success with carefully moderated enthusiasm:

> *That size and style of photographic likeness now so generally recognised as the Album or "carte de visite" portrait has rushed into repute, and attained what would seem to be a permanent place in public favour with a celerity really marvellous. Little more than two years ago, it was just proposed to supply small photographs mounted on cards to be used in place of the conventional pasteboard for morning calls, notices of connubialism, &c. Vulgar and absurd as this notion was, it gave the idea of those little portraits which have since gained so great a success as to give constant employment to hundreds of people, and by means of which, if we are rightly informed, more than one photographer is famously feathering his nest.*

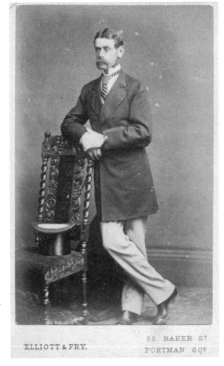

ELLIOTT & FRY. 55. BAKER Sᵗ
PORTMAN SQᴿ

Figure 76: Carte de visite: Elliott & Fry, London.

For the customer, no such grudging tones were necessary: the launch of cartes de visite was the start of an enduring love affair for the public. Their cheapness brought portraiture within the reach of many who had

hitherto been excluded from the studio experience, and their format, in dozen or half-dozen batches, made them ideal for distributing among friends and relations. They also fitted very neatly into the family albums that appeared on the market in the 1860s and which, by virtue of their alluringly empty spaces, encouraged a collecting habit. The carte de visite, therefore, quickly became the most likely purchase for the customer to make. Despite competition from other formats and a decline from its early peak, the carte remained hugely popular in the 1870s and was still selling in good numbers at the end of the century.

What the customer received on ordering a set of cartes de visite was a number of small identical paper photographs (each measuring about 3½ x 2½ inches or 9 x 6.5cm) pasted on a stout cardboard mount (of about 4 x 2½ inches or 10 x 6.5cm). The pictures had been taken on a camera designed to make several exposures on the same plate, and the positive print made from this plate could be cut up into a set of individual pictures. For the customer, the excitement of receiving a portrait was augmented by the pleasure of deciding how to distribute the duplicates and, often, the prospect of receiving others' likenesses in return.

Society photographer Antoine Claudet, writing in *The Photographic Journal* two years after it had offered a condescending welcome to the carte, showed a more generous understanding than the previous writer:

> *The introduction of the* carte de visite *may be said to have been the triumph of photography. Nothing can be more perfect and more natural. For this reason it pleases exceedingly, and in its diminutive proportions is well suited to the collection of those small albums, forming a most interesting pocket-picture gallery.*

Photographic writer N.G. Burgess took a similar line, finding cartes 'sharp and clear in outline' and 'beautiful in tone and softness of finish'. He also emphasised the value they offered customers, since they 'are capable of such multiplication, that when we regard their cheapness and portability, they become truly the *ne plus ultra* of photography.'

The dominance of the carte could not continue indefinitely, yet its main rival, the cabinet print (*figure 15*), took some time to gain ground after its

introduction in 1866. Not until the 1880s was it a really popular customer choice, and only in the 1890s did it finally topple the carte from market dominance. The cabinet print was like the carte but bigger (about 4 x 5½ inches or 10 x 14cm, with the mount measuring around 4½ x 6 ½ inches or 11.5 x 16.5cm). This provided not only a larger image, but also a more generous margin of mount below the print, which was useful when sliding the picture into an album.

Between 1860 and the end of Queen Victoria's reign, the customer's most common photographic purchase was usually a paper image on a card mount. Sometimes it represented a variation of a standard product, introduced in an attempt to reinvigorate the market. One such novelty was the diamond cameo carte, patented by F.R. Window in 1864 (two years before he hit, rather more successfully, on the idea of the cabinet print). This format (*figure 77*) fitted four small portraits into the space of a single carte and achieved modest popularity for a few years.

Other novelties were mounted paper prints of unusual dimensions – smaller than a carte, say, or forming a more elongated rectangle. Despite growing competition, it was the carte and the cabinet print that, between them, held the public's affection for a full 40 years until, in the Edwardian era, the postcard format (*figure 17*) usurped their role and took the major market share.

By 1895, most customers bought products that were in every way, apart perhaps from their size, basically the same as those on offer in 1865. The view of the sitter that the product offered did, however, undergo some changes. In the 1860s, subjects usually received a carte showing them at full length. They might be standing or sitting, but their feet would almost invariably be

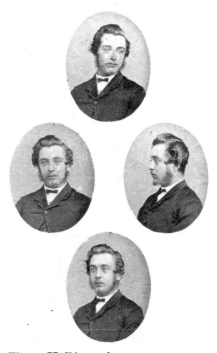

Figure 77: Diamond cameo carte: G. Langlois, Jersey.

included in the picture. During the 1870s and 1880s the camera came gradually closer, taking three-quarter or half-length portraits and thereby giving the face a larger share of the space available.

By the 1890s, whether on cartes or cabinet prints, close-ups were almost obligatory, although a full-length shot might still be used for a group or to show for instance the full splendour of a military uniform, or a new dress. What the customer now most often wanted was a head-and-shoulders image, and this was frequently vignetted, fading away at the edges of the print (*figure 78*).

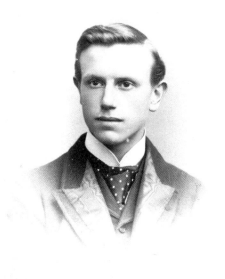

Figure 78: Carte de visite: T.C. Partridge, Sudbury.

By the later decades of the century the daguerreotype had long gone, and ambrotypes survived only as the cheap, hurried and murky grey products of itinerants. But two other types of non-paper photograph still endured. Of these, the opal print was the more distinguished. This was a photograph printed on translucent white glass. Of at least cabinet print size, and often larger, it was an item for framing and displaying on wall or mantelpiece.

The first opal prints in 1865 were greeted with some enthusiasm by photographers, as reports in *The Photographic Journal* bore witness: Mr G. Wharton 'exhibited a very charming example on opal glass' at a meeting of the North London Photographers' Association; the chairman of the Photographic Society of London thought an example by John Mayall 'was really a beautiful production'; and the magazine's representatives at the Dublin International Exhibition took pleasure in some 'excellent photographs on opal glass'. It was in the 1880s and 1890s, however, when carbon-based methods of printing could achieve a particular fineness of detail and richness of tone (*figure 79*), that opal prints won their share of customer appreciation.

The other non-paper photograph that found its way into many homes was the ferrotype, or tintype, which was a cheap adaptation of the wet collodion process. Ferrotype was the more accurate name, since the image was formed on a thin sheet of sensitised iron; tintype, though inaccurate, was the term that caught on in Britain, where the associations of an undervalued metal perhaps gave the term an undertone of scorn. Patented in 1856, the tintype was very successful in the United States and went on to share the popular market with cartes de visite. In Britain, it made little impact until the 1870s, by which time the carte was already unshakably established in the public's affection.

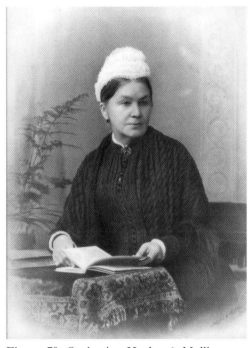

Figure 79: Opal print: Hughes & Mullins, Ryde.

The tintype became, therefore, the province of the cheap itinerant photographer, for whom its low cost and quick processing had obvious advantages. Customers who brought home a tintype had come not from a studio, but from a day at an open-air event or a trip to the seaside. What they held was a thin piece of metal, quickly snipped from a larger sheet, bearing an image in tones ranging from pale- or mid-grey to Stygian black. If they were lucky, it was presented in a matt and frame of pinchbeck – a cheap, thin metal that could be cut, folded and squeezed into shape (*figure 37*).

In America, where it was accorded studio respectability and processed more carefully, a tintype could become a pleasing portrait (*figure 80*). 'The most beautiful and brilliant effects are capable of being produced,' insisted New York photographer Edward Estabrooke, who claimed that his exhibits at the National Photographers' Convention in 1871 'excited the utmost admiration, and increased immensely the respect of some of the members for the Ferrotype'. A similar enthusiasm was shown by American customers.

They were as proud of their tintype portraits as Europeans were of their cartes de visite, as was incidentally shown by a supposedly comic anecdote in the *Los Angeles Herald* in 1883:

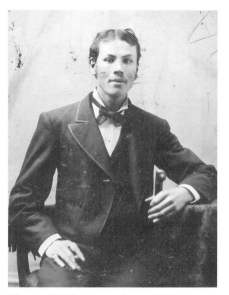

> *"By the way, Brown, did I ever show you this?" said Jinks, as he fumbled in the inner breast-pocket of his coat for something or other. "I don't know," replied Brown, turning a shade paler, "but if it's your tintype, taken at Bar Harbour, with a tennis racquet in your hand, please don't! Nine fellows have shown me theirs already this morning, and I can't stand seeing another!"*

Figure 80: Tintype, unknown US photographer.

In the Old World, however, the stigma attached to the process allowed the *Derby Daily Telegraph*, in 1896, to dismiss a suspicious character as 'evidently … a showman, quack or tintype photographer'.

Only in one niche of the British market did the tintype eventually gain a very humble level of credibility. In the late 1870s some studios offered, at the bottom of their range, the Gem Tintype. These were made using a camera that produced twelve identical postage-stamp-sized images on a single sheet of metal. These were then snipped apart and stuck into carte-sized mounts. But, as *figure 81* shows, the images and the care taken with the finish sometimes lacked distinction.

Paying for the Goods

Whilst customers often waited some time for their portraits to be processed, their patience was not usually tested when it came to settling the bill. At the Ebury Street studio of W. & D. Downey, as at several other of the distinguished studios visited by Henry Baden Pritchard in 1880, 'as a matter of course, the fees are paid before the picture is taken.' Not all photographers

could afford to be so uncompromising, and some made a virtue of the fact. Advertising in 1853, R.J. Syrett of Bury St Edmunds assured the public that 'No charge will be made until the Portrait is seen and approved of.'

The price of photographs varied, of course, over the 60 years of Victoria's reign. They consistently cost more in London than in the provinces; they were more expensive at the upper end of the market; they became cheaper with the introduction of new processes and formats, and also during periods of especially sharp local competition. Such generalisations are easy to make, but some sampling of actual prices might be appropriate.

When Richard Beard opened England's first daguerreotype studio in London in 1842, he charged 2 guineas or more for a daguerreotype,

Figure 81: Gem tintype: photographer unknown.

while his eminent rival during the 1840s, Antoine Claudet, asked between 1 and 4 guineas for a portrait. They were retailing novelty to the most select range of customers, and such prices could not long be commanded by photographers outside the capital. In 1844 T.H. Ely, Norfolk's daguerreotype licensee, set his fees at 'One or Two Guineas, either in Morocco Case or Frame' and offered reductions on family orders.

Yet by 1853, Susanna Smith was seeking custom in Norwich by providing a menu of options at different prices:

Prices. – Seven Shillings and Sixpence. No. 2, Half a Guinea. No. 3, Fifteen Shillings. With Cases complete at these prices, and so on upwards, to Two Guineas, on Large Plates, and can be fitted in outward gilt frames, at very low charges. Mrs. Smith does therefore hope, by offering … The

Daguerreotype or Sun Picture ... at such reduced and low charges, she will meet with that encouragement which will enable her to carry out the art to satisfaction.

In the same year John Sawyer, a local competitor, began to offer ambrotypes 'in handsome cases' at prices between 5s 6d and 10s 6d according to size. By early 1854, Susannah Smith had made herself familiar with the new collodion process and, offering it alongside her daguerreotypes, had reduced her lowest price by one third.

This sequence of falling prices certainly brought many more people into the category of prospective sitter. A skilled craftsman or a clerical worker, earning about £2-3 a week, might start to consider buying a bottom-of-the-range ambrotype. For a semi-skilled worker or labourer, the outlay represented more than a quarter of his weekly income and would still be very daunting. As for a live-in maidservant, she could only fantasise about a studio visit that would swallow up over a fortnight's pay.

Throughout the 1860s and 1870s, customers once again benefited from price reductions as cartomania took hold. Cartes were cheaper to produce, and photographers sought to win or retain a corner of the market by undercutting their competitors. In King's Lynn, in 1861, William and Sarah Dexter were charging 12s for a dozen cartes, while William Woodhouse, a more aggressive marketer, was asking 9s.

By the second half of the decade prices were dropping, and the town's photographers also quoted for half-dozens. J.A. Prout's six for 5s, in 1866, was broadly in line with earlier prices, but before the year was out Woodhouse was advertising six cartes for 3s. The Dexters soon responded by bringing their cartes down to 2s 6d for a half-dozen, while the more determinedly upmarket Edwin Bullock 'declined to enter into a reckless competition of prices with inferior artists'. In 1870, Woodhouse cut his fee to 2s per half dozen, and soon after Robert Wright was matching his offer. At this point there was a temporary lull in hostilities.

At these prices, a semi-skilled worker – earning about a pound a week – might have been tempted to visit a studio. Even a labourer – with a weekly income of around 10-15s – might wonder about the possibility, though his wage was already pretty well taken up by necessities, and 2s would take a lot of saving.

Ten years later, Henry Pritchard's tour of studios provided a useful source for comparing 1880 prices in the upper and middle segments of the market. By then, prices had generally risen since the cut-throat years of cartomania, but the charges made by fashionable London studios were high by any standards. Cartes by W. and D. Downey, Hills and Saunders, Valentine Blanchard and William Mayland were all selling at a guinea a dozen, while Alexander Bassano offered twenty cartes for 2 guineas.

Elliott and Fry's price of eighteen cartes for a guinea appeared self-denying by comparison. 'In these days,' argued Pritchard, 'when half that sum is charged at any fashionable theatre in town for a stall, we think it exceedingly reasonable.' But Elliott and Fry wanted an extra half-guinea for photographing children under eight. Pritchard approved, observing that 'Messrs. Elliott and Fry are, we believe, the first who have had the courage to make the announcement.'

Outside the capital, while the more upmarket photographers commanded slightly lower prices, they still charged more than most people could pay. The poorer inhabitants of Brighton could not consider the 15s asked for twelve cartes by John Mayall; they needed that money for a fortnight's rent. Faced with a choice between a dozen cartes by W.H. Midwinter and a new pair of boots, most of the inhabitants of Bristol would have spent their 10s on the boots. Worse still, there was the possibility of incurring extra fees: Midwinter wanted 50 per cent more for vignetting, and Mayall imposed the same premium for a group of two or more sitters. However, at the Brown, Barnes and Bell studio in Bold Street, Liverpool, prices were reassuringly lower, as might be expected of a large chain catering 'for the million, and not the few'. Their batch of twelve cartes de visite cost 7s 6d, though they too charged more for vignetting.

Photographic prices in the last two decades of the century seem to have remained fairly steady, but the figures quoted by Pritchard tend to be at the higher end of the spectrum. Even the Brown, Barnes and Bell prices could be undercut by small town operators or by the more aggressively-marketed city studios. In the 1880s an enterprising London business, the Jubilee Photo Company, was proclaiming a range of cheap deals (*figure 82*), such as twelve cartes at 3s 9d.

For the humble family living just above the poverty line on about £50-60 a year, that offer represented a little less than the sum they might usually

spend on a week's meat. But if 3s 9d seemed too expensive, the packages priced at 1s 9d (the sum typically set aside to keep a family in boots) or 2s 3d (the approximate weekly bread bill) might seem more manageable.

There were also, throughout the Victorian period, some mid-market photographers who were aware of the plight of less affluent customers and who devised ways of extending their customer base to include them. In 1866, Alexander Taylor of Dunfermline advertised what looked like special rates: 'Cartes, 6s. per Dozen. – *Brilliant! Delicate! Vigorous!* Every Portrait Warranted. To the Working Classes. – On Saturday Afternoons, the charge will be 3s. for Six Cartes.' In fact, he was merely offering to supply half-batches at the standard rate.

Figure 82: Carte mount: Jubilee Photo Co., London.

Lincoln's Robert Slingsby – one of the professionals visited by Pritchard in 1880 – made a more serious attempt to make concessions for the poorer customer:

He has two studios: they are on the same floor, and divided only by a laboratory. One – the further and larger one – is marked "Mr. Slingsby's Studio;" the other, "No. 2 Studio." In the first, our host himself is to be found; in the other, an assistant rules. In a city like Lincoln there is, naturally enough, a good deal of second-class work to be done, "and there is no reason," says Mr. Slingsby, "why I should turn sitters away." Everybody in Lincoln cannot afford to pay high prices; the second studio, therefore, suits a large number of customers, while those who desire the services of Mr. Slingsby himself are, of course, called upon to pay for them.

Another route to affordability became popular for buying large-format pictures. The club system, as practised by the large photographic chains, has been mentioned in an earlier chapter. A variation of the system, adding an element of lottery to the notion of easy payments, was tried by a number of independent studios. William Woodhouse of King's Lynn launched his club scheme in 1870: 'Portrait Club, for Life-size Portraits, in Water and Oil, by weekly payments of One Shilling, and as soon as enough is paid in the Club for one, a Draw will take place.' Once enough customers had signed up to make a club viable, a second club could be started up – which is why *figure 82* refers to 'portrait clubs' in the plural.

The likely income of prospective clients was not, however, the only factor that influenced prices, and Robert Slingsby was not the only photographer to operate a double tariff. In Ipswich, in the late 1880s, Joseph Kerby was charging much the same as his competitors during the daylight hours. Once he had invested in electricity, when the lights were switched on, a new price list applied with rates set about 50 per cent higher.

However much or little customers were expected to pay for their portraits, there were occasionally those who tried to avoid paying anything at all, as was illustrated by an 1859 report in the *Norfolk News*. Eardley Gideon Culling Eardley, a Cambridge student, was taken to court by photographer Edward Monson, to whom he owed £23 16s for several items, including portraits of two eminent scholars – Dr J.W. Donaldson and the Very Reverend Harvey Goodwin – and of Eardley himself.

Although aged 21, Eardley pleaded 'infancy' when called on to take responsibility for his debts. His father, the fiercely evangelical Sir Culling Eardley, declined to bail out his son and heir, whose total bills for 'such trifles' amounted to around £16,000. Some of the 'persons' who had supplied the youth with 'useless things', he added, had been persuaded to take them back. Monson's lawyer argued that portraits such as those produced by his client were 'reasonable necessities for a gentleman in Mr Eardley's position'.

Sir Culling's religious scruples, he continued, might reasonably have been offended if the defendant had 'adorned the walls of his sitting room with pictures of ballet girls and so forth'; but it was inconceivable that he should object to 'portraits of that high classical authority Dr Donaldson and the universally respected Dr Goodwin'. The jury found in favour of Monson

for the full amount claimed. Eardley, incidentally, persisted in his profligate ways, and in 1868 he was also tried for bigamy, found guilty, and sentenced to eighteen months' imprisonment with hard labour.

Customer Satisfaction

Despite falling prices, at any time in Victoria's reign there were customers for whom a portrait represented a significant financial outlay. Most of these people, when they saw the results, considered the money well spent. During the early years a sense of wonder and delight at photographs was natural enough. In 1843 poet Elizabeth Sheridan Carey wrote of a friend's daguerreotype portrait:

> *No false deceiving charms appear;*
> *But the fair face as Nature made it,*
> *So hath the regal sun portray'd it!*
> *The cordial, frank, old English air*
> *Sits nobly on the features there; …*
> *That is her turn – you may compare it, –*
> *And that her very glance – I'll swear it! …*
> *Most marvellous! So soft, so true!*
> *A priceless pearl – a rare bijou!*

Recalling the earliest days of photography in *Grandmother Lee's Portfolio*, American writer Anne E. Guild fictionalised an old woman's reaction to daguerreotypes of her grandchildren:

Why, Amy, it seemed as if Mabel and you were right before me – had happened in unexpectedly – you seemed so natural and so lifelike. I couldn't help calling you my little darlings, and kissing you ever so many times. I'm so happy! I keep them where I can look at them all the time, with the cases open, that your bright faces may be looking on me constantly; and at night, when I go to bed, I stand them open on the table side of me, where they may be the first things I shall see, as I open my eyes in the morning.

The sense of wonder at photography endured far beyond the pioneer days of the 1840s. In 1855, when daguerreotypes were fast becoming yesterday's image, the *Norfolk News* visited the Norwich studio of William Fisher and found likenesses 'transmitted to his silver plates, in the most life-like degree of perfection we ever beheld'. A year later the more metropolitan *Leicester Mercury* was equally appreciative of the collodion prints of John Beattie, praising the 'superior character of these portraits, and their superior finish', and urging readers to inspect the examples on show at Beattie's studio, 'where they will find much to gratify their artistic taste'. In 1858, on the eve of the carte de visite era, the *Leicester Journal* still believed that 'the rapid advance of the art of photography is one of the marvels of our age'.

In later decades, testimonies to the wonder of photography are harder to find. The higher ranks of society were becoming used to the process, and the lower orders, entering the studio for the first time, were less likely to make a written record of their feelings. In spite of this, the growing numbers of photographers and the huge market for cartes de visite provide clear evidence of sustained customer enthusiasm.

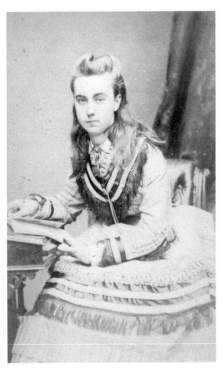

When one examines Victorian photographs today, it is often easy to understand the original owners' pleasure. The family of the girl in *figure 83*, for example, will have been very satisfied with her portrait, which presents her exactly as a young woman was expected to appear: thoughtful, demure, and beautifully turned out. She is not yet of age, for her hair is still falling about her shoulders, but she has a mature calmness, as if she really has just glanced up from the book in which she appears immersed. For her parents, it is a record of their

Figure 83: Carte de visite: Alexander Bassano, London.

little girl who is growing up into the right (and, most significantly at this time, a marriageable) sort of woman. The fact that it was taken in a studio with a fashionable name added weight to the authority of the image.

The young woman of *figure 32* may have been equally pleased, though possibly for very different reasons. The picture is by Camille Silvy, for whom only the best people sat. The pose is not especially comfortable, because the subject is leaning at a slightly awkward angle. But she is presented – in a way that boldly challenges convention – as a capable woman and a lover of country pursuits. The riding crop, the hat and the figure of the horse on the small table all reinforce the message that the subject is assertive, capable and given to outdoor activity. Yet, the tiny and tightly-corseted waist and hourglass figure defy any suggestion of mannishness. In addition, the use of the mirror turns the carte into a double portrait, thereby adding both to the drama of the image and to the sense of value for money.

Not all portraits were taken by such eminent practitioners; but all photographers had, to some extent, to learn how to manipulate the image to meet the subject's expectations and ensure a favourable response. The traditional assertion that the camera never lies rather misses the point. The scope for creative re-imagining came at a later point of the proceedings, when the plate had been removed from the camera. There was ample opportunity to improve a picture at the negative stage, and Victorian photographers were well aware of the fact. They responded to the customer needs implied by Mrs Lirriper (in Charles Dickens' 1863 Christmas story, 'Mrs Lirriper's Lodgings') when she complained, 'I consider photography wanting in mellowness as a general rule and making you look like a new ploughed field.'

Using a soft lead pencil, or stippling with a brush and wet pigment, a photographer could doctor a glass negative and remove such minor blemishes as spots, freckles and wrinkles. This cosmetic improvement of portraits was agreeable to customers, even when they were unaware it had taken place. From the 1870s onward, as the camera drew nearer the subject and faces were seen in closer detail, the practice of retouching negatives became more common – it even won a degree of respectability.

Some photographers disapproved of the practice of improving on nature. H.P. Robinson, for instance, was scathing about those of his fellow photographers who retouched indiscriminately. 'They neatly fill up wrinkles

and scars and soften shadows,' he complained, 'until they produce a face almost as smooth and quite as expressionless as a billiard ball. And, what is more, they are proud of the result!'

Nevertheless, he conceded that the technique had, by 1891, become an allowable process, and he made a reasoned case for its judicious use:

> *Retouching is legitimate where it does not falsify nature; it should be used only to aid the well known shortcoming of photography. In nature, we scarcely see a freckle on the face if we do not look closely for it; in the negative, the freckle is represented by a hole which prints much darker than the freckle appears in nature; it is legitimate to fill up this hole so that the result may better represent nature.*

'To know when to leave off,' he concluded, 'should be the aim of the retoucher.' Where Robinson manipulated the image quietly and with discretion, others drew attention to their interventions and hoped to attract custom thereby. In 1874, William Woodhouse of King's Lynn announced his 'new process of Stippling, known only to W.W.' All customers, he insisted, were 'not only satisfied, but … very much delighted with their portraits taken by the new Process.' He stopped short of spelling out exactly what stippling achieved, but Christopher Wallis and Victor Manders, who took over his studio three years later, were less coy. They declared that 'All negatives will be retouched, thus securing the beautiful softness so much admired … By their process of Stippling, all wrinkles, freckles, scars, &c., may be evaded.'

Wallis and Manders were not alone in seeking to please the customer in this way, and by the end of the 1890s the Angus *Evening Telegraph* was driven to complain:

> *A really good photographer should be able to do without retouching the plate; save, of course, to rectify and eradicate spots and those exaggerations of light and shade which are occasionally to be found in the most carefully developed plate; but nowadays there is a real craze for retouching and for entirely altering photographic negatives.*

The customer, as conscious or unconscious beneficiary of the practice, was unlikely to complain. Occasionally a photographer's intervention was obvious and therefore may have failed to please. It is questionable whether the subject of *figure 84* was entirely delighted with the pattern drawn around the hem of her dress and only partly accommodating to its folds. The woman in *figure 85*, on the other hand, is unlikely to have resented the stippled attempt to modify her waistline, though she may have wished it had been a little more expertly managed.

Despite the wonder of photography and the efforts of its exponents to make their customers happy, there were some people who viewed their portraits with grudging acceptance rather than untrammelled joy. Perhaps one of the problems was that photography shows us to ourselves as others see us, rather than offering the reversed image that we are more used to viewing in a mirror. This can be faintly unsettling, even today. This problem did not apply to all early photographs. The processes that gave a one-off

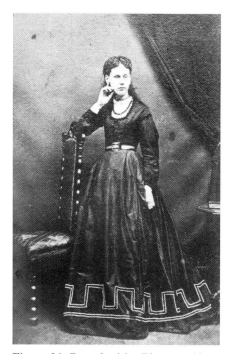

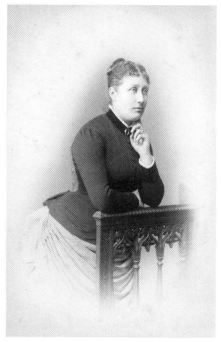

Figure 84: Carte de visite: Photographic Copying Company, Hull.

Figure 85: Cabinet print: Cosson Gustave, Le Mans.

picture – the daguerreotype, the ambrotype and the tintype – produced just the kind of mirror-image that we find more reassuring (unless the reversal was corrected by the use of a specially designed camera). Nonetheless, portraits on paper quickly became the norm and presented sitters with faces they knew to be their own, but which were, nevertheless, slightly unfamiliar.

Whatever the reason for unease, some sitters recognised that they were not best placed to judge their own portraits. 'I don't pretend to such a knowledge of my own face, as I claim to have of other people's faces,' admitted Charles Dickens, in an 1853 letter, and his fellow novelist Wilkie Collins confessed he had 'no claim to be an authority on this point'. Unfortunately, a subject's friends might be unable to offer a reassuring consensus. In 1871 two admirers of Dickens took very different views of recent likenesses. Novelist George Eliot regarded one photograph as 'a satisfactory refutation of that keepsakey impossible face' that Daniel Maclise had given Dickens in a painted portrait.

Kate Field, an American actress and writer, was not convinced:

If anybody thinks to obtain an accurate idea of Dickens from the photographs that flood the country, he is mistaken ... In his photographs Dickens looks as if, previous to posing, he had been put under an exhausted receiver and had his soul pumped out of him. This process is no beautifier.

It must also be noted that large numbers of run-of-the-mill portraits were produced. Writing for *Anthony's Photographic Bulletin* in 1899, photographer Frank Sutcliffe gave one reason why:

At present few photographers have sufficient capital to develop the artistic side of their business. The photographer may lay awake all night planning improvements in his studio and devising tasteful ways of "setting" his wares, but when daylight comes he seldom finds enough money in his trousers' pockets to buy the raw materials with.

Predictably, therefore, many routine images emerged from studios, offering something akin to the 'mug-shot' look of the modern passport photo. Smiling was avoided, but often no other expression appeared in its place. The fault was not always that of the photographer; some customers simply lacked

the assurance to project a suitable image of themselves, and their portraits implied no narrative because they had none to offer. Anthony Trollope identified the type, referred to it as the 'hobbledehoy', and knew that, as a youth, he had been one. In describing John Eames, a central character in *The Small House at Allington*, Trollope places him firmly in the hobbledehoy category:

> *They do not come forth to the world as Apollos, nor shine at all, keeping what light they may have for inward purposes. Such young men are often awkward, ungainly, and not yet formed in their gait; they struggle with their limbs and are shy.*

Such uncertainty was not, of course, confined to young males. Both subjects in *figure 86*, though dressed in their best clothes, are a little ill at ease: his left elbow sticks out uncomfortably, and neither appears relaxed about the placing of hands. Such uncertainty was not, of course, confined to the nineteenth century, but the discrepancy between the confident trappings of the Victorian studio and the uneasiness of a hobbledehoy is particularly noticeable. Such customers may not have been enthralled by the portraits they received; but given their diffidence, they may have looked for nothing better.

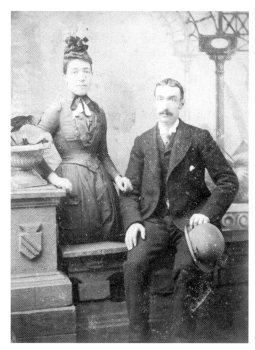

Hobbledehoys were not the only customers to entertain low expectations. The camera, many recognised, viewed its subjects with a cruel impartiality, however much the photographer tried to soften its gaze. Wilkie Collins was aware of this when he referred, in his novel *Armadale*, to 'the dreadful justice of photography',

Figure 86: Cabinet print: A.J. Bailey, London.

and later, in *The Moonstone*, to the camera 'doing justice without mercy'. When sitting for a portrait, understandably some subjects feared the worst. 'The camera, you know, will never capture you,' said Oscar Wilde. 'Photography, in my experience, has the miraculous power of turning wine into water.' Mark Twain agreed with him:

No photograph was good, yet, of anybody … It transforms into desperadoes the weakest of men; depicts sinless innocence upon the pictured faces of ruffians; gives the wise man the stupid leer of the fool, and the fool an expression of more than earthly wisdom.

Those pessimists who retained some sense of proportion were inclined to share the blame with the camera. 'Some people won't come out well,' conceded Anthony Trollope. 'Mine are always wretched'. Of one particular portrait he remarked, 'It looks uncommon fierce, as that of a dog about to bite; but that, I fear, is in the nature of the animal portrayed.' Nathaniel Hawthorne shared this sense of realism. 'Most of my likenesses do look unamiable,' he confessed, 'but the very sufficient reason, I fancy, is, because the originals are so.' It was Abraham Lincoln who stoically observed: 'There are no bad pictures; that's just how your face looks sometimes.'

It was quite possible for Victorian customers to view portraits with a degree of acceptance that varied from reluctant to fatalistic. Dickens' fictional Mrs Lirriper, looking back at her youthful portrait, voiced a view that had been tempered by time (if not by punctuation):

I am an old woman now and my good looks are gone but that's me my dear over the plate-warmer and considered like in the times when you used to pay two guineas on ivory and took your chance pretty much on how you came out, which made you very careful about how you left it about afterwards because people were turned so red and uncomfortable by mostly guessing it was somebody else quite different.

The most endearing example of cheerfully accepted imperfection may be a conversation overheard by American photographer H.J. Rogers, while he watched a series of people emerging, disgruntled, from a photographic

den. Most of them were complaining bitterly about the results, with one woman declaring that 'she would not let John see hers; she'd burn them up just as soon as she got home'. Another judged her pictures 'a perfect fright' and would go another time to a studio where 'comfort, cleanliness and convenience were regarded'. Two customers remained remarkably unruffled: 'An old gentleman, turning to his wife, said, "Betsey, we've seen a good deal of this world, but we've got humbugged again. Live and learn, Betsey. Ha! ha! ha!'

Perhaps, when considering customers' responses to their portraits, it is also wise to acknowledge the novelty of the experience, which might have made them oblivious of many shortcomings. Photography was not new only in the 1840s; it remained a novelty over a period of at least 30 years, as it became affordable to wider sections of the public. For many customers there was something unnerving about holding for the first time a piece of metal, glass or paper from which their likeness stared back at them. Their reaction, before it settled into delight, acceptance or disapproval, was often one of simple surprise. As Nathaniel Hawthorne put it, 'I was really a little startled at recognising myself apart from myself.'

This sense of shock sometimes took a little time to get over, and it was possible for the initially hostile to warm to photography when they became more accustomed to it. After his first encounter with the camera in 1841, an unimpressed Charles Dickens announced, 'The Sun is a great fellow in his way, but portrait painting is not in his line. I speak from experience, having suffered dreadfully.' Several years later, however, he was much more positive about another sitting, declaring that 'the little piece of business between the Sun and myself came off with great success.' Indeed, such was his enthusiasm that, within a few days, he wrote to the same correspondent, 'I cannot resist the temptation I feel to send you the result of the interview between myself and the Sun.'

Although the Victorians' delight in their photographs could sometimes be mixed with bemusement and uneasy acceptance, there was one further element in the mix: they were able to approach their portraits with a willing suspension of disbelief. When watching a play, we know that the king is really the elderly gent we saw nursing a pint of bitter in the nearby pub an hour before, and we are aware that his crown, like his castle, is made

of papier mâché. Yet, during our time in the theatre we choose to put that knowledge to one side and to believe in the fiction played out before us. So it was with Victorian photographic portraiture. Created in a studio setting that could look very much like a stage set, a photograph could tell a story about the dignity, respectability, elegance or virtue of its subjects.

The Victorians knew that grandfather did not really own such a stately mansion as appeared behind him, and that grandmother did not usually sit in a room of such apparently grand proportions. They knew that the pictured stone plinths and balustrades were really light and portable imitations, and still only rarely did they question the pretence. A correspondent of the *Taunton Courier* took issue with portraits of two of his neighbours in 1858. One, 'a gentleman who never looks in a bound book but his ledger' was 'taken sitting with the air of a professor, at a table covered with volumes, and one on his knee, his finger placed between the leaves, as though he were meditating upon some passage'. The other, 'whom I sometimes smoke a pipe with', was 'depicted with his eyes poetically upturned, as though he were composing a supplement to Young's Night Thoughts'.

Such satire was easy, but it failed to reflect the feelings of the age. As they looked at a picture, the Victorians went through the motions of belief, entering into an unspoken (and, probably, entirely unarticulated) compact with photographer and subject to go along with the imposture and accept fiction as a kind of reality. Nor was their suspension of disbelief necessarily foolish or dishonest. The studio trappings may have been no more than a stage set, but they stood for a kind of truth, insofar as they showed surroundings appropriate to the character and moral worth of the sitter, giving subjects the kind of environment that, symbolically at least, they felt their inner qualities deserved.

For this reason, the incongruities of portrait settings did not really matter. If a chair was oddly located in a woodland glade, if a head rest was not entirely hidden from sight, if there was no attempt to conceal where painted backcloth met solid studio floor, then it was not the end of the world. People knew about the contrivances of the studio, and they believed in them because photographic convention required them to withhold their disbelief. They fully understood what was pretence and what was reality, and they could hold both in mind at the same time. The Victorians' pleasure in

obviously fabricated portrait settings was not a measure of naivety; it was simply an example of a human ability to simultaneously hold two mutually contradictory beliefs.

Customer Dissatisfaction

Whilst most customers liked, believed in or, at least, accepted the results of their studio visit, there were always a few who were positively unhappy and who made their feelings known. American photographer Marcus Aurelius Root recorded in 1864 the case of one customer who was particularly insistent in her objections:

> *"O, Sir," said a disappointed mother, when the artist had finished a portrait of her child, "you have indeed done it beautifully, but it isn't in the least like my little boy!" "My dear madam," replied the far-seeing artist, "he will grow like it – astonishingly so!"*

Less willing to be put off was a New York photographer's client, who eventually faced litigation in 1875. The *Guernsey Star* followed the case with interest:

> *Each time that the artist emerged from the dark closet wherein he had poured out libations of nitrate of silver to the sungod, he brought with him a picture that was found unsatisfactory, and was compelled to offer to take a new one which would be more like the sitter. Seventeen times he strove to catch a faithful reflex of her features, and seventeen times he failed. Then he gave up in despair, and the question has to be decided as to whether he has to be paid for his time and trouble, or whether he is to go on taking pictures until the fair sitter is satisfied. The question is a difficult one to settle. If a photographer is bound to take likenesses until his "patient" pronounces a favourable verdict, some persons who do not see themselves as other see them will never be satisfied or believe that their faces are truthfully represented in ugly pictures.*

Not all photographers were so patient, and one Scottish customer found that complaints could be counter-productive. The *Leeds Times* reported the case in 1899:

A Perth photographer had a fastidious "sitter", who complained that the photos were not a bit like him; no one would recognise them, etc. The photographer took them back, refunded the money, and said "Good-day". Next morning the same sitter rushed in boiling with rage. "Why, confound you," he exclaimed, "you've got one of those photos you took of me in your show-case, labelled 'the biggest fool in Perth'."

My good sir," replied the photographer, "you yourself told me only yesterday that nobody would take that photograph for one of yourself, and that it is quite unrecognisable. Since the picture doesn't even faintly resemble you, what on earth are you growling about?"

These examples are perhaps extreme, but it was a fact of studio life that customers could be difficult to please. Indeed, some customers expressed dissatisfaction in a bid to get a wider choice of pictures for their money. H.P. Robinson made it a policy to destroy all rejected negatives and prints before agreeing to a re-sitting. 'This,' he explained, 'circumvents those unreasonable people whose only object – which they have to gain by untruths – is to have a large and varied collection to select from.'

Disappointment was not, however, confined to the more fussy and demanding customers. There were always new photographers appearing on the scene, and some were by no means the artists or technicians that they claimed to be. In a paper read to the Exeter Graphic Society in 1865, Dr Scott set out the case against the unskilled opportunists who were then setting up in business everywhere.

Men who now follow the calling for profit, especially in portraiture, seldom have more interest in it than for the gains which it brings. Of course there are exceptions, but as a general rule, photographic portraiture displays a most unfortunate lack of artistic knowledge, and one can only suppose this to arise from a want of artistic feeling, and an ignorance of the capabilities of photographic science. We cannot look at the great mass of photographic

portraits, without being struck by the utter absence of all artistic treatment which they display in their bad arrangement of lines, their want of subordination of parts, the distortion of features, and the total neglect of consideration as to what will be the effect produced by different coloured dresses on the photographic image.

Most members of the public were less concerned with aesthetics than Dr Scott, and those who did share his views probably took themselves to the better and more established studios. Artistic merit comes at a price, and for the majority of customers in the year of Dr Scott's speech, a photograph had only just become affordable. For them, the simple fact of owning a portrait was wonderful enough. Some sitters, perhaps, were disappointed by undistinguished results; most, though, knew that their finances wouldn't run to a visit to one of the grander businesses. Besides, the studio of a run-of-the-mill photographic plodder was less intimidating as well as less expensive.

Artistic instinct, however, was not the only thing some photographers lacked. Many were self-taught opportunists whose technical ability could be a little shaky. Poorly trimmed and mounted pictures were always a possibility, and fingerprints (impressed on the negative and reproduced on the end product) were not unknown, as close examination of the left side of *figure 87* – at about knee level – will show.

Most imperfections could be lived with and might even pass unnoticed. On the other hand, images that were too dark or too pale were unquestionably disappointing, and they could be disturbingly common in the earlier days of photography and, later on, in the hands of incompetent operators.

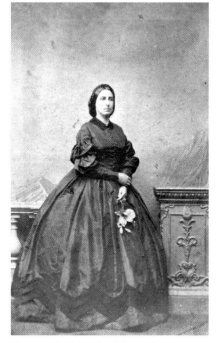

Figure 87: Carte de visite: Album Portraits, London.

Pictures of scarcely relieved blackness were often produced by the street-corner photographers to whom the poorest customers resorted. Such operators were repudiated by their more respectable colleagues. Hector MacLean, writing in *The Photographic Journal* in 1893, referred scornfully to 'the somewhat bibulous man of "shreds and patches", whose sixpenny portraits take the conceit out of the most malignant masher'.

The unskilled photographer's pictures were often a failure for the simplest of reasons: he didn't know what he was doing – and in some cases didn't much care. One such practitioner confessed as much to social investigator Henry Mayhew.

I never knew anything about taking portraits then, though they showed me when I bought the apparatus (but that was as good as nothing, for it takes months to learn). But I had the cards ready printed before I bought the apparatus. The very next day I had the camera, I had a customer before I had even tried it, so I tried it on him, and I gave him a black picture (for I didn't know how to make the portrait and it was all black when I took the glass out), and told him that it would come out bright as it dried, and he went away quite delighted.

If customers returned to complain, he continued, one possible ploy was to offer to dip the picture in 'brightening solution'. This was warranted to work very well as long as the photograph was carefully wrapped immediately after dipping and then kept protected from light for a few hours. (The 'brightening solution' was, in fact, water, and its apparent failure to work could always be ascribed to premature unwrapping.)

Extremely pale pictures were also known in the early years, because photographic images were liable to fade. Even if the exposure was correct and an acceptable portrait was produced, it might disappear in a short space of time. In 1847 *Punch* received a letter from a customer whose portrait, taken only a month earlier, had 'not a single feature left, excepting half a whisker.' That, too, *Punch* added (with a leaden pun) was 'gradually melting away into thin hair'. In another issue, the magazine printed a poem supposedly written by a young lady whose beau's picture had lasted only a fortnight.

Behold thy portrait! – day by day,
I've seen its features die;
First the moustaches go away,
Then off the whiskers fly.

That nose I loved to gaze upon,
That bold and manly brow,
Are vanish'd, fled, completely gone –
Alas! Where are they now?

The disappointments caused by excessively dark or pale pictures became less frequent in later years, though itinerant photographers continued to produce murky images throughout the century. Unfortunately, con-men of the kind who invented 'brightening solution' did not disappear. A few examples of their scams will show how they operated. In 1885 the *Tamworth Herald* related how a travelling photographer named Lewis had persuaded a fruiterer to order a dozen photographs of his shop. Lewis took four shillings for his work and went away to process the pictures he claimed to have taken. He failed to return. Despite leaving a false name and address with the fruiterer, he was tracked down by the police and committed for trial.

In 1886 Charles Bartlett and Alfred Williams of Bristol gulled Edith Wyatt, a farmer's daughter, out of three shillings. Claiming to be from the entirely fictitious Crown Portrait Company and naming as their employer Thomas Mower (who did exist, but knew nothing of their activities), they persuaded Edith, her brother and their friends to be photographed as a group. Like Lewis, they decamped with the money but supplied no photographs.

John Wilson of Halesworth was more ambitious. In 1893, according to the *Ipswich Journal*, he embarked on a sustained campaign of photographic fraud. He took money from the vicar of Walpole for pictures of his church and vicarage; he charged the schoolmistress of Huntingfield for photographs of the church and school; he had payment in advance from a Halesworth railway porter for three cabinet portraits; he defrauded three servants of the Mayor of Eye; and there were further complaints from victims in Bungay, Beccles and Ipswich. He then moved further afield, into Norfolk, and was finding would-be customers in the Sandringham area at the time of his

arrest. When his lodgings were searched, no negatives of the relevant people and places were found; and it was questioned whether his dilapidated camera was even capable of taking pictures. He was sentenced to three months' hard labour.

Wilson's efforts seem insignificant when compared to those of William Robertson, whose trial took place in 1899. According to the *Aberdeen Journal*, he had spent the summer and autumn of the previous year taking payment in advance for pictures that never materialised. 'He had received orders for photographs which he undertook to supply, and, as a result of his representations, over 170 persons entrusted him with orders.' Robertson claimed that all the negatives existed, they just hadn't been processed. He was, nonetheless, unable to produce a single one of them. He fared rather better than Wilson, though: he received a sentence of 21 days' imprisonment, but, since he had already spent that amount of time on remand, he was immediately discharged.

Despite the regular appearance of such fraudsters, photographers were in general honest, and most customers had nothing serious to complain about. Occasionally, however, disputes became dramatic. When, in 1885, Edward Lawrence and Lee Marriatt entered the studio of Arthur Mason they demanded a photo displayed on the wall, claiming it as theirs. Mason refused. Then, according to the *Sunderland Daily Echo*, Lawrence blocked the exit and called to Marriatt to give the photographer a 'dig in the eye' and to 'break his neck'. In the fracas that followed, Lawrence hit Mason, Mason pushed Lawrence with his foot, Marriatt struck Mason behind the ear, and a telescope stand was smashed. Eventually Mason managed to grab a stair-rod, with which he fended off his attackers while his assistant ran for the police.

The most bizarre customer complaint was perhaps an Australian case noticed by the *Dundee Courier* in 1891.

At the late general election a candidate ordered 1500 photographs of himself, and gave instructions to have one posted to every elector on the Parliamentary roll. But this little enterprise on the candidate's part was of no avail, for he was at the bottom of the poll. He swears the photographer is to blame, and refuses to pay the bill. He declares that, although the

original photograph was all right, his countenance became in the course of multiplication blurred in such a way as to give "a Satanic leer" to his physiognomy. The photographer denies that there is a leer about his patron's "physog," Satanic or other. But the patron protests that instead of being sued for the price of the caricatures he ought to sue the photographer for damages.

The paper concluded, wryly, 'It would be adding insult to injury to suggest that the election went against the candidate because the electors would think that the distribution of his photograph betokened a vanity incompatible with common sense.'

Most sitters, of course, ordered far fewer than 1,500 copies of their likeness – but they still had to find a home for them.

Chapter Five

Owning the Item:
The Customer Displays the Photograph

Once in possession of their finished portrait, the customer had to decide how to show it off to best advantage. In the early days of photography this presented no problem, since households owned few if any pictures, and so each one could be treated individually. Larger examples could be mounted and framed, while the smaller sizes of daguerreotype and ambrotype came ready-packaged in protective hinged cases, allowing them to be carried about the person or, opened like a book, displayed on a mantelpiece or sideboard.

Options for showing off single photographs remained possible throughout Victoria's reign and beyond. At one end of the scale, tiny likenesses were slipped into lockets and, at the other, heavily-framed portraits dominated a room. Pictures intended for wall-display were often given the most grandiose of settings. 'Do not overframe,' begged photographer H.P. Robinson in 1891, recalling the experience of unpacking photographs for an exhibition. One case 'was enormous, it filled the hall', and Robinson expected 'a few tons of very fine pictures here'. He was disappointed:

The parturient mountain brought forth a little mouse: the case was full of the most tremendous specimens of the carver and gilder's art, but there was very little art of any other kind. Amongst others, there was one large moulded frame, several inches in depth, and with a gilt matt inside; it contained seven cartes-de-visite in cameo form – that was all.

The grandiose framing of pictures was not confined to photography exhibitions, for families soon began to build up a collection of images, all competing for wall space.

Some of the early pictures were difficult to hang satisfactorily: daguerreotypes not only had a highly reflective surface, but also appeared as negative images unless viewed from the correct angle. Edward Monson addressed this problem by pasting instructions to the back of products from his Ipswich studio: 'Hang the Picture about the height of the eye, and let the top of it slant away from the wall. The objects portrayed can be most distinctly seen in a strong light.'

But with the move towards paper-based pictures and, in particular, with the proliferation of portraits in the carte de visite era, a new problem arose. Suddenly vast numbers of customers were having their likenesses taken, and those likenesses were being printed off at six or, more often, a dozen a time. The world was soon awash with photographs.

The Family Album

Frames designed to hold multiple pictures had their uses, and specially designed carte boxes were a handy way of carrying a selection of portraits in coat pocket or reticule. But a more ambitious solution to the storage crisis was required, and it took the form of the family album. When, in the summer of 1860, Mr Walters of Bold Street, Liverpool, advertised 'the great novelty of the season, "The Family Photographic Album",' he was part of a network of stationers and photographic suppliers launching what was quickly to become a national institution.

The new stoutly-bound albums were made up of thick card pages with pre-cut apertures into which two pictures could be slipped, back-to-back. The earliest examples were relatively simple, with plain pages each containing one or two apertures. Even these early examples, though, could have their refinements. The album used by Miss Jodrell for signatures, devices and pictures of her friends (*figure 28*) looks as if may be 'The Heraldic Album, for Crest, Portrait and Autograph, solid binding, 60s,' advertised by Harvey, Reynolds and Fowler of Leeds in 1862.

Just as the growing numbers of cartes had created a demand for albums, so the albums, with their set number of spaces to be filled, created a demand for yet more cartes. In 1862 the *Hampshire Chronicle* complained, 'Any one who has ever seen you, or knows any one that says he has seen a person who thought he has seen you, considers himself entitled to ask you for a

photograph.' Inevitably, this also led to the production of larger albums, and, once cabinet prints earned a share of the market, space had to be found for them, too. *Figure 88* shows pages of an empty album, opened to give a view of the varying shapes and sizes of aperture provided.

Figure 88: Album pages.

As the market for albums matured, the amount of choice became bewildering. An 1880 advertisement by W.D. Buckle of Bristol gave a flavour of the variety on offer. Bindings were not simply of cloth or leather: customers preferring leather were invited to select from 'Embossed Leather', 'Morocco Leather', 'Russia Leather' and 'Inlaid Calf'. Nickel or gilt trappings were available, and built-in locks catered for those who wished to control access to their album. Pages could be plain, tinted or illuminated. Botanical illustrations, it seems, were especially in vogue that year, on the evidence of products named 'Album Arbora', 'The Flower and Field Album', 'Album Lingua Floris' and 'L'Album de Fleurs'.

Though flower studies were popular as page decorations, rustic scenes and birds were also much in favour (*figures 89 and 90*), along with snatches of verse and quotations from Shakespeare. Brass and velvet were commonplace; gilt edging and initials were much in vogue; ingenious spring clasps were smiled upon; and the incorporation of a musical movement was not unknown. Robinson, perhaps predictably, was not impressed by all this show:

The very elaborate albums with sometimes beautifully designed and coloured leaves, forming borders for the photographs, destroy by their beauty the very thing they are designed to show off and honour.... (They) should be designed to assist the effect of those photographs in every way. They should be plain and good. I do not object to a line round the apertures, but I prefer them without.

 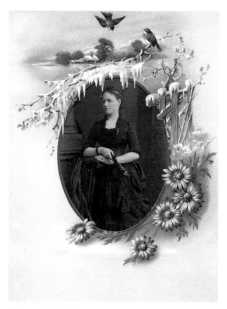

Figure 89: Album page with cabinet print: Mrs E. Moss, Ashton under Lyne.

Figure 90: Album page with cabinet print: Alexander Bassano, London.

Many albums, hefty and bound in black leather, looked like family Bibles, and the resemblance was perhaps no accident, since the two volumes had a function in common. Just as the flyleaf of the Bible was used to record the dates of a family's births and deaths, so the album provided a pictorial chronicle of its members and their milestones. This was, perhaps, of particular value in an age when emigration, migration from country to town and an expanding railway network all helped to put greater distance between relatives.

Yet, the album, as N.G. Burgess pointed out in his photographic manual of 1861, extended beyond the confines of the family and had 'almost become the text-book of our personal friends'. It quickly became such an essential component of domestic life that it was frequently chosen as a wedding present or a retirement gift. It was suitable for young couples, departing headmasters, long-serving clergymen and honoured Sunday school teachers. Albums even featured prominently in the lists of prizes awarded for scholastic achievement, archery contests and spelling bees.

The demand for pictures to fill all these albums could sometimes be trying. By 1862, when albums were still a relative novelty, the *Hampshire Advertiser* had already lost patience:

There is no compliment in it. The claimant does not care for you or your likeness in the least. But he or she has got a photograph book, and as it must be filled, you are invited to act as padding to that volume, and to fill a vacant space between Prince Max of Hesse Darmstadt and the amiable owner's third brother, as he appears in the comic costume of a navvie.

The problem persisted over the years, and in 1881 the *Huddersfield Daily Chronicle* could still complain:

Ever since the fatal invention of albums ... farewell peace! Whichever way you turn, requests for your portrait are levelled at you like so many guns. All is acceptable prey; indifferent features, respectable age, obscure position – nothing comes amiss to that greedy monster, album.

In 1868 the *Cheltenham Chronicle* recognised that people, 'having been presented with a colossal album, consider it incumbent upon them to fill it by hook or by crook', and it speculated on the satisfactions to be derived from the album's contents. For some sitters, it suggested, it was 'the possibility of being the hero or heroine of a hundred albums that gives the pleasure'. The second satisfaction, it continued, 'is that derived by friends or relations from the contemplation of the portrait of an absentee. This pleasure is one of those which is very much exaggerated.' The paper also spared a thought for the bored visitor who was expected to admire the album's contents:

Nothing affords a more pitiable spectacle than that of a person set down by the hostess of a hospitable mansion to look through a photographic album as a means of amusement. The victim, with an air of hopelessness combined with resignation, turns over leaf after leaf, looking at faces he has never seen before, and trying to find an interest in persons whom he does not know from Adam, until the last page is reached, and then, with a sigh of relief, the book

is closed. Sometimes the torture is intensified by the proprietor of the book
standing by and superintending the process, to give explanatory notes.

The tendency of owners to provide a running commentary was, it seems, particularly irksome. Decrying albums as 'the terror of all right-thinking people', the *Arbroath Herald*, in 1891, enlarged upon the topic:

The fact that "Mary Thomson is a half-cousin of Andrew Clark, that
married a sister of Mrs Davidson, who kept a patent mangle in Green Street,
and had a daughter with a lame leg that was run over by a cart belonging
to Peter Livingstone," may be interesting enough to the relatives and heirs
of the said Mary Thomson; but it is all hypocrisy for people to sit with an
album on their knees and pretend to be interested in fifty or a hundred such
Maries or Peters.

It was a short step from bemoaning the perusal of an album to mocking its contents. In 1881 the *Sheffield Daily Telegraph* referred dismissively to 'the photographs of uninteresting mediocrities in the family album', but in 1874 the *Saturday Falkirk Herald* had been much more specific:

The first picture is of an old gentleman with an expression of wary
cautiousness in his face as if he was engaged in dodging a wild bull, and
was somewhat doubtful of the result. Opposite him is the grandmother, a
patient-looking lady in a black dress, with a book in one hand, and a pair of
spectacles in the other. There is a feeble but well-meaning effort to look safe
in her face. On the next leaf is a middle-aged man looking as if he had been
suddenly shot through the roof of a starch factory, and had landed in the
middle of a strange county. Opposite is the picture of his wife, who, having
heard a rumour of the catastrophe, has made up her mind to be prepared for
the worst. Then follow the children – little girls looking so prim as to make
you squirm, and little boys with their eyes turned on their noses and with an
expression on their face of unearthly solemnity … Then there is the bashful
young man penned opposite an aggressive young lady, whom heaven and
some married woman have designed for each other.

It is not surprising, then, to discover that the family album became the subject of jokes, proving ample material for 'an excruciatingly funny song' performed by Dan Leno in the laundry scene of the Drury Lane pantomime of 1896, and generating the supposed exchange reported by the *Cambridge Independent Press* in 1890:

> *Visitor – Ah, you have a family album, I see.*
> *Lady – Well, yes, I suppose you might call it a family album. It contains the photographs of my deceased husbands. That large volume on the other table is my divorces, bound in morocco.*

Nevertheless, the photograph album was soon an essential part of family life, and it could also be referred to with a touching fondness. The *Aberdeen Evening Express*, in 1886, noticed how 'the old finger-marked album, lying so unostentatiously on the gouty centre table, points out the mile-stones from infancy to age', portraying 'the laughter and the tears, the joy and the grief, the dimples and the grey hairs of one man's lifetime'. There was poignancy, too, in the *Dundee Evening Telegraph*'s reflection in 1885: 'It is sometimes a terrible infliction, on looking through a family album of some years' standing, to come across one of your own portraits taken, say, ten or fifteen years ago.'

With the new century, the Victorian album experienced a slow demise. The new formats – the snapshot and the postcard – were not mounted, so they had no need of thick board pages to house them. Simpler albums, with lightweight pages and pre-cut corner slots, were introduced. But the old albums still had a few spaces to be filled, so the production of cartes and cabinet prints lingered on for a few years, and some early twentieth century photographs were tucked into apertures that were not designed for them. Then, enclosing evidence of Victorian life, taste and sensibility spanning up to 60 years, they began to gather dust.

Inheriting Family Photographs: Preservation Techniques

Despite their fragility, many of those albums and countless individual photographs have survived and been passed on to new owners. Not everybody

expected this to happen. An unidentified engineer warned in 1867 of the likely fate of the public's much-loved pictures:

Sad to relate, the votaries of the sun, who derive wealth and prosperity from his rays, have been for too many years supplying the public with moonshine, and it is high time that the general public began to sound the alarm in the sleeping camp of the photographers. The pictures on albumenised paper ['albumenised' refers to the egg white that was commonly used to bind light-sensitive chemicals to printing paper in the 1860s and 1870s], *which meet our eyes at every turn, will all fade. The much treasured photographs in the family album, the larger pictures which, in the dignity of frames, adorn the wall, will all alike vanish from our gaze, it may be ten, twenty, or even fifty years, yet fade they must.*

Fortunately he was mistaken about the time scale. Of course, some images did fade, but vast numbers of Victorian photographs have survived. All of them are well over a century old, some are more than half way through their second century, and many retain much or all of their original richness of tone. They are merely little pieces of metal or glass, or scraps of thin paper pasted hurriedly onto card, but they have lasted.

Nevertheless, they are vulnerable, and, having been preserved for so long, it would be sad if they were denied the best possible chance of seeing out another century – or two. It is therefore reasonable to consider their care in the hands of their current owners. Anyone minded to invest in archival-quality storage materials should, of course, be encouraged to do so, but private individuals may not aspire to professional standards. There are, however, a few simple dos and don'ts that are easy to follow and will give old photographs a useful level of protection.

Storage is the first consideration. A dry and well ventilated location is desirable, and marked fluctuations in temperature and humidity are to be avoided. In practice, this means keeping photographs within the living area of the house, rather than in a garage, a loft, or anywhere that cooking or washing takes place. Light and dust are also to be avoided, so albums or closed boxes are recommended.

It is worth being aware of the properties of storage materials. Most paper is made from wood, wood contains lignin, and lignin can promote discolouration. In practice, old wood, paper and card may well have passed their most dangerous period, so pictures in a Victorian album should probably stay there, unless they show worrying signs of deterioration. Pictures in a family album were often, in part at least, grouped according to relationships, so their original order may be significant and worth retaining. Where modern paper is used, for wrapping or as album pages, the better its quality the safer its contents will be. Best of all is paper made from rag rather than wood.

Many modern albums or filing systems use plastic, which must also be regarded with suspicion. Polyester, polypropylene and polyethylene are generally considered safe, but PVC is to be firmly avoided, since the chemicals used in its manufacture can be transferred to the surface it touches. Loose-leaf albums designed to take multi-pocketed polypropylene pages are, fortunately, not hard to find.

Adhesives of any kind can be damaging, as the stains from gum and sticky tape in many modern albums can testify. If photographs are to be fixed to paper pages in a modern album, corner mounting is the best option. Corner mounts are becoming harder to find in shops, and are not really designed to accommodate the thick and sometimes rounded corners of cartes and cabinet prints. Nevertheless, they offer a much safer option than the adhesive or magnetic leaves that some albums use to hold pictures in position.

Some kind of labelling or identification system is likely to be needed, and this should impinge as little as possible on the photographs themselves. Stickers on the back and the use of ink are taboo. If possible, any writing should be done on the page, envelope or wrapper. Where it is absolutely necessary to write on the photograph itself, the inscription should be minimal, should be on a back corner, and should be made with the softest possible pencil, using the lightest possible touch. In the course of such sorting and cataloguing, there is also a need for careful handling. The thick mounts of cartes and cabinet prints allow them to be held by the edges and corners, making it easy to keep fingers from touching the printed surface. Some modern owners make doubly sure of this by wearing cotton gloves.

If you wish to put a picture on display, the obvious course is to make a copy and to frame that, keeping the original away from the light in its protective box or album. In fact, copying is an excellent form of insurance with any valued photograph, however carefully the original is to be stored.

It may seem, at this point, that the discussion of Victorian photographs has turned into a sermon, but these portraits have already long outlasted their subjects, and they have earned a little consideration. Each one, however undistinguished, has its own story and its own significance, and it can be looked on in a variety of ways. It is a window into the past, with potential interest to specialists in areas including (but not confined to) local studies, social history, costume, military matters and family research. To a photographic historian it is an example of a process and a form of presentation; and to a collector it may be prized for its view of a military uniform, its studio of origin, or its inclusion of a dog.

The portrait also embodies another complex package of meanings. It is rooted in the subject's image of self – reinforced or modified by the person behind the camera. It results from a decision to be photographed and a choice of practitioner. It marks a moment – quite possibly a milestone – in a person's or a family's life. It records the business of being posed in a specific location and setting, of submitting to the camera's gaze, and of enduring the sometimes prolonged period of exposure. It is the outcome of a financial transaction, and it has brought the pleasure or, occasionally, disappointment of ownership. In short, it represents the rich and varied customer experience of a Victorian in camera.

Bibliography

Primary Sources

Bede, Cuthbert, *Photographic Pleasures*, (T. McLean, London, 1855).

Boden, Harry & Brantford, Bert, *You mustn't do that, naughty boy!*, (Shapiro, von Tilzer, New York, 1908).

Burgess, N.G., *The Photograph and Ambrotype Manual – a Practical Treatise*, (D. Trübner & Co., London, 1861).

Burgess, N.G., *The Photograph Manual – a Practical Treatise*, (Appleton & Co., London, 1862).

Cook, Clarence, *Home and Society*, in *Scribner's Monthly Illustrated Magazine*, Vol. 22, No. 1, (Charles Scribner's Sons, New York, May 1881).

Crooke, William, *Portraiture*, in *Anthony's Photographic Bulletin*, Vol. 30, No. 6, (E. & H.T. Anthony, New York, June 1899).

Dixon, Edmund Saul, *More Work for the Ladies*, in *Household Words* (ed. Charles Dickens), Vol. 6, No. 130, (Bradbury & Evans, London, 18 September 1852).

Estabrooke, Edward M., *The Ferrotype, and How to Make it*, (Gatchel & Hyatt, Cincinnati, 1872).

Estabrooke, Edward M., *Photography in the Studio and the Field*, (E. & H.T. Anthony, New York, 1887).

'Fellow of the Chemical Society, A', *Beginner's Guide to Photography*, (Perkin, Son & Rayment, London, 1883).

Martin, Paul, *Victorian Snapshots*, (Country Life Limited, London, 1939).

Mayhew, Henry, *London Labour and the London Poor*, (Griffin, Bohn & Co., London, 1851 & 1861).

Monckhoven, Désiré van, *A Popular Treatise on Photography*, (Virtue Brothers, London, 1863).

Morley, Henry, & Wills, W.H., *Photography*, in *Household Words* (ed. Charles Dickens), Vol. 7, No. 156, (Bradbury & Evans, London, 19 March 1853).

Pike, W. T. (ed.), *Industrial Great Britain*, (W. T. Pike, Brighton, 1893).

Pritchard, Henry Baden, *The Photographic Studios of Europe*, (Piper & Carter, London, 1882).

Robinson, Henry Peach, *The Studio and What to Do in it*, (Piper & Carter, London, 1891).

Robinson, Henry Peach, *The Elements of a Pictorial Photograph*, (Percy Lund & Co, Bradford, 1896).

Rodgers, H.J., *Twenty-Three Years under a Skylight*, (H.J. Rodgers, Hartford, Connecticut, 1872).

Root, Marcus Aurelius, *The Camera and the Pencil*, (J. P. Lipincott, Philadelphia, 1864).

Royal Photographic Society, *The Photographic Journal*, (Royal Photographic Society London, 1853 onwards).

Ryder, James Fitzallan, *Voigtländer and I in Pursuit of Shadow Catching*, (Cleveland Printing & Publishing Company, Cleveland, 1902).

Speight, James, *Diary, Volume 2, 1898-1900*, manuscript transcribed by John Frearson.

Sutcliffe, Frank Meadow, *Pictorial Portraiture*, in *Anthony's Photographic Bulletin*, Vol.30, No. 10, (E. & H.T. Anthony, New York, October 1899).

Sutton, Thomas, *A Treatise on the Positive Collodion Process*, (Bland & Long, London, 1857).

Thackeray, William Makepeace, *Roundabout Papers*, (*The Cornhill Magazine*, Smith, Elder & Co., London, 1860-1863).

Vogel, Hermann, *Handbook of the Practice and Art of Photography*, (Benerman & Wilson, Philadelphia, 1871).

Wilson, George Washington, *A Dialogue on Photography, or Hints to Intending Sitters*, (A. Brown, Aberdeen, c.1862).

Woodbury, Walter E., *Photographic Amusements*, (Scovill & Adams, New York, 1896).

Recourse has also been had to the following nineteenth century works of fiction:

Burnett, Frances Hodgson, *Little Lord Fauntleroy*, (Scribner, New York, 1886; Frederick Warne, London, 1886).

Dickens, Charles, *Bleak House*, (Bradbury & Evans, London, 1852-3).

Dickens, Charles, *Mrs Lirriper's Lodgings*, in *All the Year Round*, (Chapman & Hall, London, December 1863).

Collins, Wilkie, *Armadale*, (Smith, Elder & Co., London, 1866).

Collins, Wilkie, *The Moonstone*, (Tinsley Brothers, London, 1868).

Guild, Anne E., *Grandmother Lee's Portfolio*, (Whittemore, Niles & Hall, Boston, 1857).

Hawthorne, Nathaniel, *The House of the Seven Gables*, (Ticknor & Fields, Boston, 1851).

Thackeray, William Makepeace, *Lovel the Widower*, in *The Cornhill Magazine*, (Smith, Elder & Co, London, 1860-1861).

Trollope, Anthony, *The Warden*, (Longman, London, 1855).

Trollope, Anthony, *Barchester Towers*, (Longman, London, 1857).

Trollope, Anthony, *Orley Farm*, (Chapman & Hall, London, 1862).

Trollope, Anthony, *The Small House at Allington*, (Smith, Elder & Co., London, 1864).

Trollope, Anthony, *Phineas Finn*, (Virtue & Co., London, 1865).

Trollope, Anthony, *The Vicar of Bullhampton*, (Bradbury, Evans & Co., London, 1870).

Trollope, Anthony, *Sir Harry Hotspur of Humblethwaite*, (Hurst & Blackett, London, 1871).

Trollope, Anthony, *The Eustace Diamonds*, (Chapman & Hall, London. 1873).

Trollope, Anthony, *The Way We Live Now*, (Chapman & Hall, London, 1875).

Trollope, Anthony, *The Prime Minister*, (Chapman & Hall, London, 1876).

Newspapers and Periodicals

Source material has also been found in a number of newspapers and magazines:

Aberdeen Evening Express
Aberdeen Journal
Angus Evening Telegraph
Arbroath Herald
Bath Chronicle
Bristol Mercury
Burnley Express
Bury and Norwich Post
Cambridge Chronicle
Cambridge Independent Press
Carlisle Journal
Cheltenham Chronicle
Cheshire Observer
Daily Los Angeles Herald
Daily Telegraph
Derby Daily Telegraph
Dundee Courier
Dundee Evening Telegraph
Dundee, Perth and Fife People's Journal
Dunfermline Press
Exeter & Plymouth Gazette
Girl's Own Paper
Glasgow Herald
Guernsey Star
Hampshire Advertiser
Hastings and St Leonards Advertiser
Hereford Times
Huddersfield Daily Chronicle

Hull Daily Mail
Illustrated London News
Ipswich Journal
Leeds Mercury
Leeds Times
Leicester Chronicle
Leicester Journal
Leicester Mercury
Lincolnshire Chronicle
Liverpool Daily Post
Liverpool Echo
London Daily News
Lynn Advertiser
Manchester Evening News
Morning Post
Norfolk Chronicle
Norfolk News
North-Eastern Daily Gazette
North Wales Chronicle
Norwich Mercury
Nottingham Evening Post
Nottingham Review
Punch
Saturday Falkirk Herald and Linlithgow Journal
Sheffield Daily Telegraph
South London Chronicle
Spectator
Sunderland Daily Echo
Tamworth Herald
Taunton Courier
Western Daily Press
Western Times
Whitstable Times and Herne Bay Herald
Wisbech Chronicle
Wrexham Advertiser

Further information has been derived from a range of trade directories, civic yearbooks, photographs and photographic mounts.

Secondary Sources

A number of more modern works have also been consulted:

Adamson, Keith, *Early Provincial Studios*, in *The Photographic Journal*, (Royal Photographic Society, London, February 1987).

Adamson, Keith, *More Early Studios*, in *The Photographic Journal*, (Royal Photographic Society, London, January 1988).

Adamson, Keith, *More Early Studios (Part 2)*, in *The Photographic Journal*, (Royal Photographic Society, London, July 1988).

Aspin, Roy, *Lewis Carroll and his Camera*, (Brent Publications, Ilford, 1989).

Creaton, Heather, *Victorian Diaries: The Daily Lives of Victorian Men and Women*, (Mitchell Beazley, London, 2001).

Bayliss, Anne & Paul, *Photographers in Mid-Nineteenth Century Scarborough – The Sarony Years*, (Bayliss, Scarborough, 1998).

Burlingame, Michael, *Abraham Lincoln: A Life*, (J.H.U. Press, Baltimore, 2009).

Dimond, Frances & Taylor, Roger, *Crown and Camera: The Royal Family and Photography, 1842-1910*, (Penguin, Harmondsworth, 1987).

Frearson, John P.H., *The Speights of Rugby – Photographers*, (John Frearson Publications, Rugby, 2009).

Hall, N. John, *Trollope, a Biography*, (Oxford University Press, Oxford, 1991).

Harris, Russell, *The Lafayette Studio and Princely India*, (Roli Books, New Delhi, 2005).

Hardy, Colin, *Sunny Snaps: Commercial Photography at the Water's Edge*, in *Beyond the View*, ed. Ball, Rob, & Shepherdson, K.J., (Burton Press, Canterbury, 2014).

Haworth-Booth, *Camille Silvy, Photographer of Modern Life*, (National Portrait Gallery, London, 2010).

Heathcote, Bernard & Pauline, *A Faithful Likeness: The First Photographic Portrait Studios in the British Isles, 1841-1855*, (Heathcote, Lowdham, 2002).

Heyert, Elizabeth, *The Glass-House Years, Victorian Portrait Photography 1839-1870*, (George Prior, London, 1979).

Hudson, Derek, *Munby, Man of Two Worlds*, (John Murray, London, 1972).

Jones, Gillian, *Lancashire Professional Photographers, 1840-1940*, (PhotoResearch, Watford, 2004).

Lester, Valerie Browne, *Phiz, the Man who Drew Dickens*, (Pimlico, London, 2001).

Linkman, Audrey, *The Victorians: Photographic Portraits*, (Tauris Parke, London, 1993).

Linkman, Audrey, *The Photographic Multiple in the Nineteenth Century*, in *The PhotoHistorian, number 110*, (Royal Photographic Society, London, January 1996).

Linkman, Audrey, *Brown, Barnes and Bell*, in *The PhotoHistorian, number 111*, (Royal Photographic Society, London, March 1996).

Navarette, Fina, *Photographs and Family Albums: How do I Protect Them?*, in *How to Preserve Personal Archives in the 21st Century*, (City Council of Girona Department of Records Management, Archives and Publications, Girona, 2014).

Pepper, Terence, *High Society: Photographs, 1897-1914*, (National Portrait Gallery, London, 1998).

Picard, Liza, *Victorian London, The Life of a City, 1840-1870*, (Weidenfeld & Nicholson, London, 2005).

Pritchard, Michael, *A Directory of London Photographers, 1841-1908*, (PhotoResearch, Watford, 1994).

Taylor, Roger, *George Washington Wilson, Artist and Photographer (1823-93)*, (Aberdeen University Press, Aberdeen, 1981).

Triggs, Stanley G., *William Notman: The Man and the Studio*, (McCord Museum of Canadian History, Montreal, 2005).

Watson, Roger, and Rappaport, Helen, *Capturing the Light*, (Macmillan, London, 2013).

Wilson, A. N, *The Victorians*, (Hutchinson, London, 2002).

The following online essays have also been found helpful:

Jay, Bill, 'Cheap Portraits in Low Dens', (*www.billjayonphotography.com*).

Jay, Bill, 'Exposed to the Wind: Why the Wind Direction Affected Exposures in Nineteenth Century London', (*www.billjayonphotography.com*).

Jay, Bill, 'Infantry Tactics: Coping with Children in the Nineteenth Century Photographic Studio', (*www.billjayonphotography.com*).

Jay, Bill, 'Move a Muscle and I'll Blow Your Brains Out: Keeping Sitters Still for Early Portraits', (*www.billjayonphotography.com*).

Lewis, Paul, 'Photographs of Wilkie Collins', (*www.paullewis.co.uk*).

Simkin, David, 'Portraits of Charles Dickens (1812-1870)', (*www.photohistory-sussex.co.uk*).

Further Research

Any reader wishing to make further investigations into the world of Victorian photography will find three of the above titles particularly illuminating. If only one book could be recommended, it would have to be *The Victorians: Photographic Portraits* by Audrey Linkman. A taste for studying the first 30 years of photography would be further satisfied by Elizabeth Heyert's *The Glass-House Years*, while *A Faithful Likeness* by Bernard and Pauline Heathcote provides additional sustenance to a student of the pioneer years.

There are, of course, many other useful books on Victorian photography, of which the following are a small selection:

Briggs, Asa, & Miles, Archie, *A Victorian Portrait: Victorian Life and Values as Seen through the Work of Studio Photographers*, (Harper & Row, London, 1989).

Coe, Brain, *The Birth of Photography: the Story of the Formative Years, 1800-1900*, (Ash & Grant, London, 1976).

Gernsheim, Helmut, *The Origins of Photography*, (Thames & Hudson, London, 1982).

Gernsheim, Helmut, *The Rise of Photography*, 1850-1880, (Thames & Hudson, London, 1988).

Hannavy, John, *Victorian Photographers at Work*, (Shire Publications, Princes Risborough, 1997).

Hannavy, John, *Case Histories: the Presentation of the Victorian Photographic Portrait, 1840-1875*, (The Antique Collectors' Club, Woodbridge, 2005).

Macdonald, Gus, *Camera: Victorian Eyewitness*, (Batsford, London, 1979).

Wichard, Robin & Carol, *Victorian Cartes de Visite*, (Shire Publications, Princes Risborough, 1999).

Some readers may be keen to move from modern writings to nineteenth century sources. Of the works listed as primary sources, those by Edward Estabrooke, Henry Peach Robinson and Henry Baden Pritchard are especially full of first-hand information and insights. But it is within newspapers, magazines and journals of the period that a wealth of unfamiliar material awaits discovery. Many newspaper archives can be found on microfilm in local studies libraries.

For researchers wishing to extend their studies beyond their own area, however, an increasing amount of potentially useful material is becoming available online, and two websites deserve a special mention.

The British Newspaper Archive (at *www.britishnewspaperarchive.co.uk*) allows millions of newspaper pages to be searched by keyword, name, location, date or title. Searching is free, and though there is a charge for viewing the documents, a variety of payment packages gives reasonably priced access both for short-term browsers and for those conducting sustained research. Students of early photography can already locate a vast selection of potentially interesting articles and advertisements, and the site is set to grow enormously in the future.

The second site worth exploring is hosted by the Royal Photographic Society at *http://archive.rps.org*. The society has generously made its journal freely available online, and the archive dates from the very first number in 1853. Though much of the content has a technical focus, a little patient searching will turn up much material of more general interest.

Finally, there are the photographs themselves. Images and mounts both invite close attention: they are potentially informative documents, and they should not be overlooked.

Author Biography

R obert Pols grew up in Croydon, studied at Durham and Bristol Universities, and settled in Norfolk. After a career in further education and some years as an industrial journalist, he now concentrates on studying early photography. He has written on the subject for family history magazines, contributed to *The Oxford Companion to the Photograph*, and discussed old photographs on local and national radio.

Robert's books include *Family Photographs 1860-1945* (Public Record Office, 2002); *Dating Nineteenth Century Photographs* and *Dating Twentieth Century Photographs* (FFHS, 2005); *Dating Old Army Photographs* (Family History Partnership, 2011); and *My Ancestor was a Studio Photographer* (Society of Genealogists, 2011).

Robert runs the *Early Photographic Studios* website, which can be found at *www.early-photographers.org.uk*.

Index